Skin Fruit

Selections from the
Dakis Joannou Collection

Curated by Jeff Koons

New Museum, New York

First edition published March 2010 in conjunction with the
exhibition "Skin Fruit: Selections from the Dakis Joannou
Collection," curated by Jeff Koons.

New Museum
Exhibition dates: March 3–June 6, 2010

Editors: Jarrett Gregory, Sarah Valdez
Design: Purtill Family Business
Production and printing: Shapco Printing, Inc., Minneapolis

**NEW
235 BOWERY
NEW YORK NY
10002 USA
MUSEUM**
newmuseum.org

ISBN: 978-1-935202-19-6

Distributed by
D.A.P./Distributed Art Publishers, Inc.
155 Sixth Avenue, 2nd Floor
New York, NY 10013
Tel: 212 627 1999
Fax: 212 627 9484
www.artbook.com

Paweł Althamer
David Altmejd
Janine Antoni
Assume Vivid Astro Focus
Tauba Auerbach
Matthew Barney
Vanessa Beecroft
Ashley Bickerton
John Bock
Mark Bradford
Maurizio Cattelan
Paul Chan
Dan Colen
Nigel Cooke
Roberto Cuoghi
Nathalie Djurberg
Haris Epaminonda
Urs Fischer
Robert Gober
Matt Greene
Mark Grotjahn
Adam Helms
Jenny Holzer
Elliott Hundley
Mike Kelley
Terence Koh
Jeff Koons
Liza Lou
Nate Lowman
Mark Manders
Paul McCarthy
Dave Muller
Takashi Murakami
Tim Noble and Sue Webster
Cady Noland
Chris Ofili
Seth Price
Richard Prince
Charles Ray
Tino Sehgal
Jim Shaw
Cindy Sherman
Kiki Smith
Christiana Soulou
Jannis Varelas
Kara Walker
Gillian Wearing
Andro Wekua
Franz West
Christopher Wool

Director's Foreword
Lisa Phillips

In the vast realm of contemporary art, there are a few collections that stand far above the others. Dakis Joannou's is one such collection. After more than a dozen visits to Athens over two decades, it was clear to our staff that a truly exceptional person and resource was in our midst. We dreamt of bringing the collection to New York, and after much thought and consideration, approached Joannou to show the collection at the New Museum with artworks selected by a process our curators would determine and oversee. The decision was based on the staggering quality of the material, the collector's integrity and vision, and the courageous attitude the collection exemplifies.

Some of our curators had followed Joannou's activities since he founded the DESTE Foundation in Athens in the '80s and soon began presenting such seminal thematic exhibitions as "Artificial Nature" (1990) and "Post Human" (1992–93) that subsequently traveled to public institutions throughout Europe. Based in Athens, he was doing something public-spirited on an international scale—something few others were doing at that time. With a converted building designed exclusively to show the collection and major exhibitions presented annually, DESTE was an important precedent for the so-called "Miami model"; that is, private collectors establishing publicly accessible buildings on a museum scale devoted to their vast collections. But Joannou also had a strong civic commitment to Athens and supported local institutions there, like the Cycladic Museum, and more recently the Athens Biennial, sometimes partnering with them. He thought about how he could serve his city and encourage more excitement about contemporary art in Athens, while supporting international museums like the Guggenheim, the New Museum, and the Tate to create a dialogue with an international network of curators and directors. Athens did not have a contemporary art museum when Joannou started, but thanks to Joannou and a handful of other collectors, gallerists, and curators, Athens has now become a destination for seeing contemporary art.[1]

The collection as we know it today began when Joannou saw an early exhibition of Jeff Koons's work in the East Village. The womblike *One Ball Total Equilibrium Tank* (1985) was the start, the gestational work of Joannou's collection. With advice from friend Pierre Restany, Joannou had already established the foundation, but after seeing Koons's exhibition, Joannou decided to form his collection with a focused purpose: an understanding of the human condition through the representation of the body and new images of man. This interest has an obvious connection to the humanistic tradition of classical Greek culture—and in particular the creation of icons and idols that has defined anatomical representation for centuries and served as the fundamental vehicle for exploring human identity.

1. Jason Edward Kaufman, "Athens' Burgeoning Contemporary Art Scene," *The Art Newspaper*, August 25, 2009.

Joannou has built sub-collections within the collection as well—of contemporary Greek artists, works on paper, wall drawings, fashion, and design. He also has a strong interest in architecture and engaged Karim Rashid and, more recently, the Campana brothers, to build innovative hotels in Athens. He established the DESTE prize and exhibition for young Greek artists and regularly commissions artists to make new works—most recently using an abandoned slaughterhouse on the island of Hydra (which was inaugurated by Matthew Barney and Elizabeth Peyton last summer). Over the years, Joannou has encouraged a thought lab, inviting many curators, artists, and critics to curate exhibitions from the collection, write essays, and contribute to scholarship on contemporary art.[2] As some have already observed, with the DESTE Foundation, Joannou is among small group of private collectors who are dedicated to serious, scholarly activities and who are genuinely contributing to the dialogue in the contemporary field.[3] Joannou has created more than a private collection—he has established a serious, highly credible, and innovative institution in its own right.

Joannou's collection is also now one that rivals or surpasses many museum collections of contemporary art. He chose carefully, early, and well, and today it stands as one of the top contemporary collections in the world with a staggering concentration of iconic works, many of which are being seen in the U.S. for the first time. Functioning as a collector-curator Joannou has actively sought out young artists and supported their work early on, when they were emerging and unknown, helping many of these artists gain notice. From today's perspective, it is easy to overlook the risk, courage, and vision it took to assemble these works, including deep concentrations of many of today's leading figures like Koons, Maurizio Cattelan, Kiki Smith, Robert Gober, Charles Ray, Paweł Althamer, Paul McCarthy, and Chris Ofili among them.

For Joannou, collecting is about relationships: "…friendships and strong personal relations are central to my approach to art collecting. Collecting is not only about putting together an interesting group of works and making a statement. For me, it's also about involvement with the dialogue, understanding, and participation."[4] It was our feeling that the Joannou's ongoing conversation with artists should be reflected in the selection process and so we invited Jeff Koons to serve as guest curator. Koons, now one of the world's most influential artists, had his first museum exhibition at the New Museum in 1981 from his first body of work, "The New." Aside from being central to the formation of Joannou's collection, Koons is also an artist with a very strong and independent vision. Though he had never curated the work of other artists before, his artistic license gave him permission to act in ways that

push, even challenge traditional curatorship. Our curators were confident in offering Koons the platform to see what relationships he would draw and how his selection would reveal his own interests, his understanding of the collection, and his view on the work of his peers.[5]

In many ways, the 150-year history of American museums has been a history of public/private partnerships for the public good. Collectors have built, supported, and endowed museums; loaned and given works of art; created networks that extend audiences and opportunities; and even provided knowledge and information that has contributed to path-breaking scholarship. Where would our cultural legacy and public collections be today without the private resources of the Rockefellers, Guggenheims, Morgans, Gettys, Carnegies, Whitneys, Fricks, and so on? So many of our public institutions came about as the result of the excess capital of America's first Gilded Age. We have very few state-supported institutions in the United States and it has long been up to visionary individuals to carry the weight. As art historian Carol Duncan has noted about the entrepreneurial capitalism that gave rise to American museums: "…the motives of the American bankers and business tycoons who founded public art museums were both complex and contradictory, a mix of personal and public ambitions, elitist and democratic sentiments."[6]

Today the culture of museums is in the midst of a sea change, and the long tradition of public/private partnerships is evolving along with art-making, philanthropy, social attitudes, and technology. As the value of contemporary art has soared in the last decade, museums have lost their advantage in the marketplace and increasingly rely on gifts or support from private individuals to secure works of major significance. A growing number of collectors have created their own foundation museums for their extensive collections, where they can keep the work together, see it continually on view, and engage in an ongoing curatorial dialogue with it. Some collectors have questioned giving works to museums when they will most likely languish in storage, or possibly even be deaccessioned. While the accelerating trend of private museums was initially deeply troubling to established museum culture, it has now become an accepted fact of life. We've also come to recognize that many of these private spaces have enhanced communities, and may even be more open to experimentation than publicly funded institutions. Museums are challenged to consider how they can coexist and benefit from these new entities, to create new models, alliances, and partnerships.

These are some of the changes in the cultural landscape that the New Museum considered in thinking about

2. These include, over the years: Nancy Spector, Rosa Martinez, Carol Becker, Norman Rosenthal, Kenneth Frampton, Daniel Abadie, Paul McCarthy, Stuart Morgan, Bruce Ferguson, Martin Kippenberger, Joseph Kosuth, Peter Halley, and Lynne Tillman, among others.

3. See Lisa Ruyter's October 17th, 2009, comment in: Jonathan T. D. Neil, "Does Who Owns Art Change It?" *Artworld Salon* (October 13, 2009), http://www.artworldsalon.com/blog/2009/10/does-who-owns-art-change-it/.

4. Dakis Joannou and Jeff Koons, "A Conversation Between Dakis Joannou and Jeff Koons," in *Everything That's Interesting Is New: The Dakis Joannou Collection* (Athens: Cantz/DESTE, 1996).

5. Koons as curator continues the long, venerable tradition of artist-curators including Marcel Duchamp (First Papers of Surrealism); Andy Warhol (Raiding the Ice Box); Chuck Close (as part of Artist's Choice at MoMA); Mike Kelley (The Uncanny); and Bob Gober (Charles Burchfield), to name a few.

6. Carol Duncan, *Civilizing Rituals: Inside Public Art Museums* (London: Routledge Press, 1995): 54.

its own collecting future. The idea of the "Imaginary Museum"—a series of exhibitions devoted to leading collections from around the world—comes out of discussions we had, as well as extensive roundtable deliberations on the possibilities and challenges of a contemporary art museum such as ours forming a collection. Is it desirable, is it not? How should we address daunting challenges like space for storage, the costs of maintaining and caring for works, competition in the marketplace, and the need for an active exhibition program around a collection? Most importantly, how does a contemporary museum stay contemporary if it has a collection that is aging? What new models for collecting might we find? One thought was to work with a collection of collections—that are shared or borrowed, instead of owned.[7] We had been testing conventional wisdom in our internal conversations, and decided it was time to get it out in the open through the "Imaginary Museum."

The New Museum's mission is to support new art and new ideas not yet familiar to mainstream audiences. This exhibition fulfills our mission on both points. The New Museum has always exhibited a range of contemporary art from around the globe—from unknown and emerging ("The Generational," "After Nature," Arnout Mik, Nikhil Chopra) to midcareer (Ana Mendieta, Carroll Dunham, Elizabeth Peyton, Rivane Neuenschwander, Paul Chan, Mathias Poledna) to under-recognized senior figures (William Kentridge, Paul McCarthy, Leon Golub, Cildo Meireles, Mary Heilmann, Martha Rosler). The Joannou collection contains this entire range and is international in scope. This exhibition was intended to share one of the most important collections of contemporary art anywhere in the world, with our public. It was also intended to further a more vigorous dialogue, discussion, and debate about how public/private collaborations can work in the future to benefit growing audiences for contemporary art.

One thing is certain: there is much greater fluidity and hybridity now between practices in the public, private, and artistic realms, which naturally suggest new and exciting possibilities for museums in the twenty-first century.

Lisa Phillips
Toby Devan Lewis Director

7. Marcia Tucker and I had many conversations on collecting and the delicate balance that the New Museum must strike to maintain its commitment to new art and new ideas. A collection of shared or borrowed works was one that Marcia herself had also contemplated.

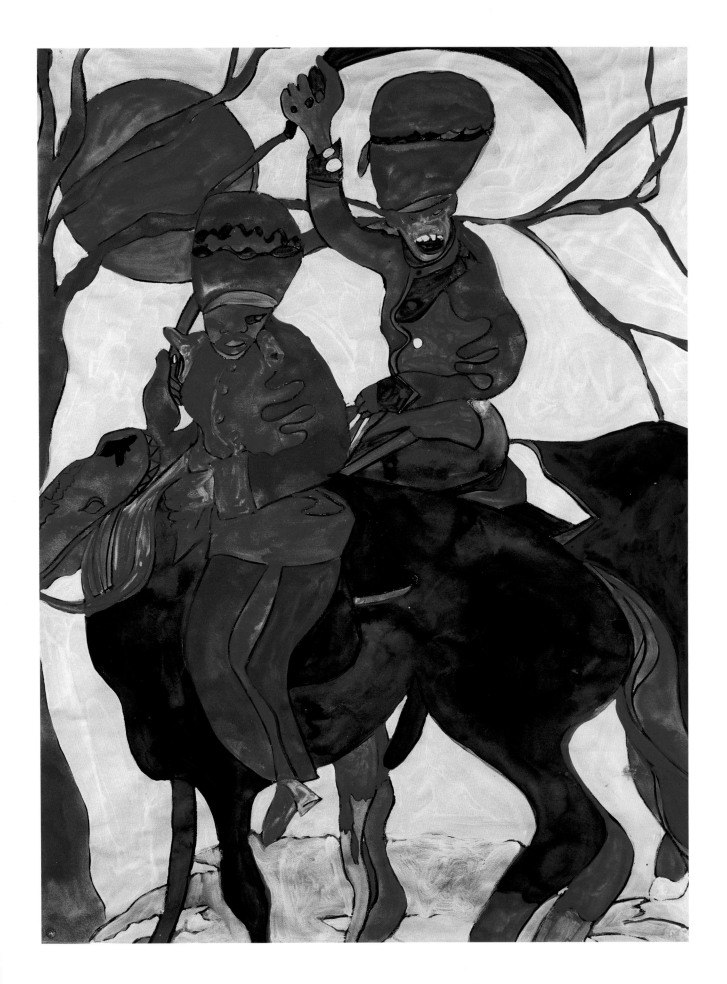

Chris Ofili, *Blue Riders Bass*, 2006. Gouache and charcoal on paper,
40 1/5 x 31 1/8 in (103 x 79 cm)

Interview

Jeff Koons and Lisa Phillips

Lisa Phillips What do you think makes the Dakis Joannou Collection so distinctive and special?

Jeff Koons In general, what makes the collection special is its vastness. I think it's one that challenges our ideas about existence and our participation in existence. And it deals with a vocabulary that people can respond to. It's not esoteric in that you can't get involved in the language. The language might be strange, and might be one that people aren't so familiar with, but that doesn't mean that it's not accessible. The base of the collection is about dealing with the body, dealing with the self. Take Tim [Noble] and Sue [Webster]'s piece, *Masters of the Universe* [2000]. I mean, that's a very primitive piece. But there's an optimism where [the prehistoric apes] are looking forward, and in a way the collection is about looking forward and looking back. It looks back into the body. A lot of the collection deals with this kind of internal looking back. It's kind of like a devolution.

LP So what qualities or emotions did you want to bring out in your selections from the collection?

JK I would say I tried to choose iconic pieces and was intuitively trying to listen to works that seemed to have a really strong voice, works that really have a desire to try and present themselves.

If you look at somebody like Chris Ofili, this tends to be more optimistic, even the blue ones, I like these darker blue ones because I think they're very dreamlike. There is a balance that takes place in the collection between looking backwards, and forwards, and an enjoyment about understanding the base of human motivation.

LP I'm really interested in your idea of the iconic and that you gravitated towards iconic works. What do you think makes something iconic?

JK An iconic work is something that functions on the level of an archetype, and it has communication and a dialogue taking place there. This vocabulary is very important to us, and therefore we're drawn to it. It has an importance because it comes from a certain state of consciousness, whether it's a kind of physical consciousness or something that's carried without complete mental understanding, or whether it's a completely abstract idea.

Dakis is open to an understanding of why people look at sexuality the way they do, or why they look at themselves, through their own relationship with their feces as a child, up to this moment. What is that motivation? Is it coming to grasp with materialism and a sense of self and pleasure? And so he looks at these things with courage and curiosity.

I think that if something's iconic, it's a communication platform, and it makes people aware of their own kind of philosophic consciousness and inquiry and questioning of life. It makes them aware of circumstances they find themselves in life, what its possibilities or unrealizable aspects are. The iconic comes from a realization of a vaster vocabulary than what one normally finds oneself interacting with. So artists are more able to open up, bring in, and be in contact with those different vocabularies, bring them together, and make different connections. It's like acting as a "medium."

LP The collection gravitates very heavily towards the human form.

JK Dakis collects contemporary art, and so contemporary is more of a constant moment, but there are other things taking place. Dakis has work in his collection also from the '50s and '60s, and there are things from the '70s, '80s, and things that are made today. When you collect within the time of your own life, you confront your own mortality, and things that you respond to. But when you connect into these vocabularies, and you enter into these iconic dialogues, you enter into the metaphysical aspect of art and art history. The vocabulary is not just linear, it's like how light bends in time. History bends in time. And a collection bends in time. And it bends it into one moment. And it makes the vocabulary united. Nonlinear but united. It bends time. So something iconic and archetypal bends this circular time.

The collector's own life, in this case Dakis's, leads to the way he or she responds. Things you become aware of start to define your existence, and that's part of it too. Including celebrating the controlled and chaotic aspect of collecting and life experience.

LP You see that in your own collecting?

JK Just in what you can control in your life, and the things that you have an interest in, how you open that up and try and have more of that. But also things just come from other angles and you have to be open to that too.

LP What about the fact that Greece was the seat of civilization for so long. Do you think that comes into play?

JK I think maybe it does in Dakis's love of the contemporary, and the celebration of community. As soon as you're involved in the contemporary, things of this moment, you have this interaction with the community, with people that are alive, not just with vocabularies that people have developed who are no longer here. You affect individual lives in the community, you affect maybe the food they have on the table, the education they're receiving, their children are receiving, so there's this vastness and a truly philosophical aspect of your position in a community and everything that comes into play. And I think that has a connection with the absolute high points of Greek culture and how the highest levels of art have this relation with the community, but I'm sure it also brings back this absolute joy in the aspect of chaos and things that can be unstructured and the openness to that. I thought John Bock's work had an important role in just this collection. I guess I've always enjoyed the optimistic aspect, the joy of sexuality in the work, and the play with and celebration of materials.

I don't think that Dakis has really collected cynical work. Dakis hasn't collected work that is making judgments about people. If there are judgments in the work, they're about judgments of the self, not directed towards others. They are about the human condition. You hear the word "cynical" thrown around a lot in relation to some of the '80s and '90s work Dakis has collected. I always believed that there was a lot of misunderstanding of that word. I look at "cynical" as presenting yourself as knowing more than you give: the sense that I know more, and then therefore you know more, than what we're actually presenting here. And that's cynical because if you

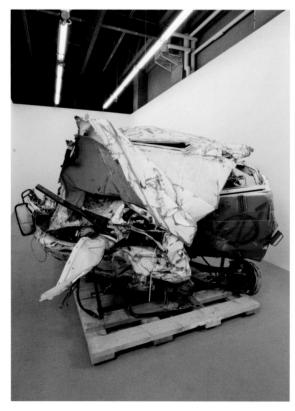

John Bock, *Maltratierte Fregatte*, 2006/07. Installation of mixed mediums, video *Maltratierte Fregatte*, 66:41 min; and video *Untergang der Medusa*, 9:37 min, dimensions variable

really know more, be courageous enough to go to your limitations. And I think that the collection is constantly going to those limitations and the artists are going to those limitations.

And cynicism is a protective mechanism, which is like Oz behind a curtain, you know?

Cynicism is the opposite of empowerment, and Dakis's collection is based on empowerment. You really do hit a wall when you come to the cynical. It's the humanistic aspect that motivates Dakis.

LP You mentioned community before in relation to the iconic. I'm just wondering how you think Dakis's activities have affected the community in Athens. Have you seen an impact? Have you seen a contribution and dialogue?

JK I first met Dakis in 1985 when he saw my "Equilibriums" exhibition in the Lower East Side, and acquired *One Ball Total Equilibrium Tank* [1985]. Jeffrey Deitch brought Dakis to the exhibition. So Dakis immediately invited me to Greece, and I went there as a young artist. I was always very wary of collectors, coming from a bohemian background, and felt artists shouldn't mingle with collectors or something. I was totally disarmed by Dakis and his generosity. When I say generous, I'm not talking about financial generosity, but he is so generous in life spirit, and community, and interest, and support, and I mean it really changed my life and made me open up further to a wider community in the world. Because actually, you know, artists can shut themselves off. And so it really helped to open me up. When Dakis started collecting again, started to organize exhibitions at the DESTE Foundation, he started to have these exhibitions and they were tremendous shows, very international in their power. They were really thought out, well conceived, they would have catalogues and just incredible works. So there was always this global dialogue taking place, because Dakis is interested in the world, not just in regional aspects of Greece, or regional aspects that could be happening in a particular area of Europe or the United States. It's been a way of connecting the cultures, opening artists up to a wider world, and also opening the contemporary culture in Greece and of this part of Southeastern Europe, to an international dialogue. That embraces a global interaction.

Dakis will also speak about moments in his own life that changed his life, and one story he'll speak about is when he was running around doing all this work and becoming mentally and physically exhausted. He ran into one gentleman at a hotel, I think a Nigerian gentleman, and he just said to Dakis, he just looked at him and said, "What are you doing to yourself?" And Dakis was able to open himself up and communicate with this individual and he says this man changed his life and he decided at that point that he was going to look at his life and kind of re-engage himself with his interests and desires and not just be caught up in some life that he did not have consciousness of. And I think that the collection is a celebration of that too, because this is a vastly different possibility.

LP *One Ball Total Equilibrium Tank* is the one work of yours that you selected for the exhibition. Can you talk about what it means to you?

JK It's interesting because even having this opportunity to look back at the collection now, I included this one work in the show because I really wanted to have a dialogue and look at the work of other artists. But this aspect of external and internal is there also in the tank. I always thought of the tank as being very womb-like, being this return to the womb, but also of course, it's really kind of external and very analytical and I can look at the collection and continue to see these interests about internal life and the importance in understanding it, and also this aspect of the external and how one moves through the external world and what the possibilities of the external are.

LP Let's talk about the floor plan of the exhibition for a minute, because the content of the individual works is one

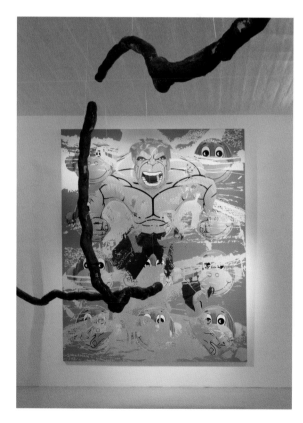

Foreground: Urs Fischer, *Mackintosh Staccato*, 2006. Epoxy resin, pigment, enamel, approximately 98 1/2 x 356 x 97 1/2 in (250 x 904 x 248 cm).
Background: Jeff Koons, *Hulk Elvis Monkey Train (Blue)*, 2007. Oil on canvas, 107 7/8 x 83 7/8 in (274 x 213 cm)

thing, but then connecting it to the others is another thing when making an exhibition. Let's talk a little bit about your thoughts about connections and proximities and maybe the dramaturgy of the exhibition. What would you like the public to experience?

JK I always respond in a very intuitive way. When an artist creates an installation, they're thinking of how people respond to it emotionally, and also, their own conceptual ties to it. As an artist, you want the viewer to be involved both physically and mentally. I think I was also trying to balance aspects of color and different surfaces, and trying to maintain a quality to the work.

So I tried to take advantage of the opportunity to use works with color. Like the Ofilis, or even the color that's generated in David Altmejd's work. I enjoyed having Franz West's work there because it kind of straddles both sides—there's a physical aspect, which is quite externalized in his work, and at the same time these forms themselves tend to have an internalized quality.

On the fourth floor, there is *Revolution Counter-Revolution* [1990/2010] by Charles Ray. It has a sense of looking back, or aspects of this tension in the collection of external/internal, but the carousel has very much an external feel to it; you're very aware of seeing it, but also of looking back in time and of your own internal memory. It's almost like time is an interface between both this external, very externalized world, and this internalized world.

I think that Kara Walker's work also captures this aspect about looking backwards and trying to find some way through this. It's like looking for answers, thinking about what happened to you as a child. There's curiosity, but maybe not a belief in this kind of possibility. In these works, looking back into the history of sexuality with blacks, is also like looking back into one's own history, our own sexual vulnerabilities or history with our bodies. It is like how a child deals with guilt and shame, and my work has always dealt with guilt and shame in a very externalized way, and a lot of the work also continues the dialogue of some relationship with guilt and shame in some internalized way, without fear. You know what's really interesting is that the Eve, from *The Expulsion from the Garden of Eden* [1426–28] by Masaccio, is the same pose as Praxiteles's Aphrodite [c. 350 BC]. And one is a symbol of openness and sexuality, and the other one is about guilt and shame.

LP What would you hope the public would experience coming to this exhibition?

JK I believe that the value of art is how it functions in your life, how it presents the opportunity of what your human existence can be like. So I would have to say it's successful if it leads to a sense of understanding of self, and of one's position in community. This type of awareness is the underlying thing here, that there's this aspect of having a moral understanding, a communal understanding. I really think there's a consciousness of self and an understanding that the self is very interesting, but the self's relationship to the external world and mostly the external relationship to other people is a vaster experience, a richer, more rewarding, higher-consciousness experience.

LP Have you ever curated an exhibition before?

JK I've curated my own work, and I think every time that you make a work you're kind of curating, you're making conscious decisions of following certain interests. In my own exhibitions I've always done that. But no, I never curated work by other people.

And Lisa, can I just say, too, it's very difficult. I really believe in embracing everything, and I don't believe in judgments. I believe certain things you may find at a certain moment more significant, there are so many works that aren't here that I think are absolutely fantastic. And I would love to just be around that work every day. But this particular installation, or the points that are trying to be communicated, just didn't support this momentary view. I mean there are many works that I think are absolutely fantastic, I think they're iconic, I think they're incredible. But for this particular architectural situation and this particular grouping, it just couldn't, at this moment, be there.

This is only one view of the collection, and it's not a complete view. And there are works that are absolutely as good, or better, that aren't even on view.

LP So did the process of doing this have its rewards for you? What did it make you think about?

JK I think it made me look more at other artists' work, and gave me a sense of how I can see a continuation of interest and interaction. And I do believe that the community is more important than the individual, but I think the individuals make the community. And Dakis has helped to celebrate that in his life and in the collection and I hope that this is in some way a continuation of that.

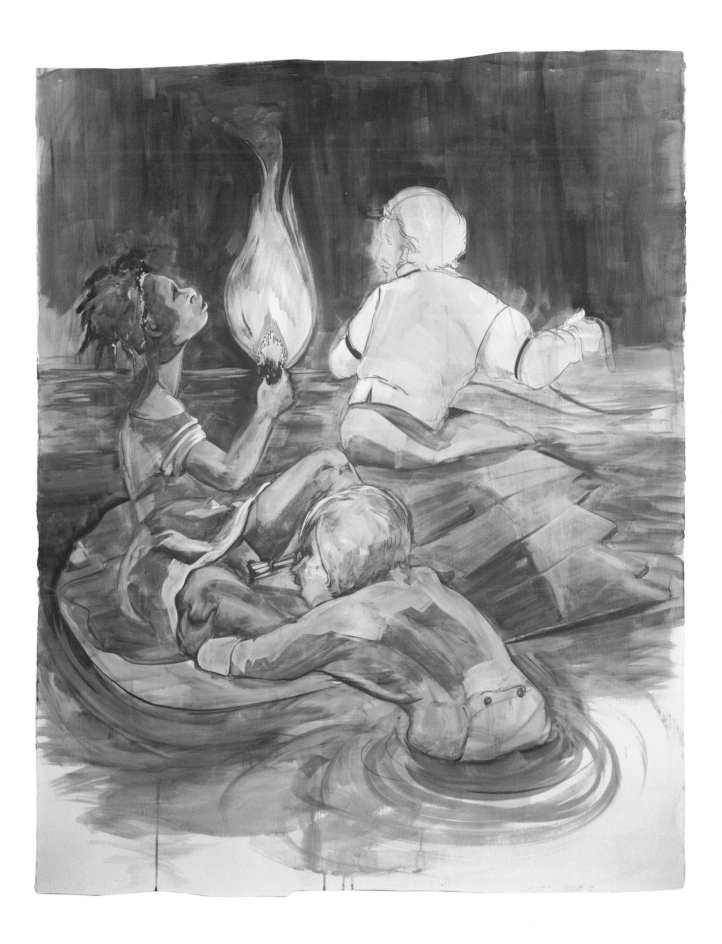

Kara Walker, *Allegory*, 1996. Gouache on paper, 63 3/4 x 51 1/2 in (162 x 131 cm)

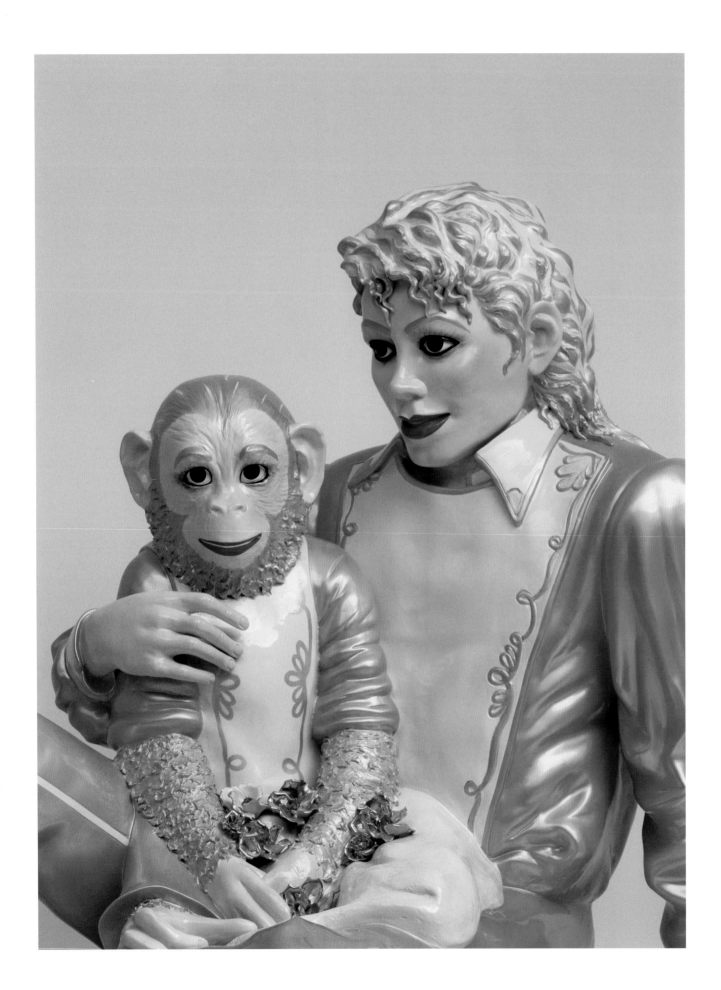

Jeff Koons, *Michael Jackson and Bubbles* (detail), 1988. Porcelain,
43 1/4 x 72 7/8 x 34 5/8 in (110 x 185 x 88 cm)

Eyes Wide Shut:
Notes on the Margin of Seeing
Jeff Koons Seeing

Massimiliano Gioni

Don't be a fool, keep your eyes open.

—Jeff Koons[1]

The entire oeuvre of Jeff Koons is permeated by an obsession with vision, a desire to see more, or more clearly. Koons's work is driven by the need to see everything, and by the capacity to see all at once. This super-vision, however, does not necessarily correspond to a more extensive form of knowledge: transparency and clarity do not entail a more complete understanding of the world, let alone help us interpret the artist's intentions. Actually, the hyper-vision enacted in his work could translate into a form of acute opacity.

Since his first inflatables—such as *Inflatable Flowers* (1980)—Koons has employed mirrors and reflections to literally multiply the presence of his objects. His entire stylistic evolution could be described as a path in which the reflective power of the materials progressively migrates from the outside to the inside of the work. In the earliest inflatables, the objects are placed on top of mirrors: the mirror serves as a pedestal. Then gradually, the pieces themselves begin to become mirrored. The stainless steel surfaces of the "Luxury and Degradation" series (1986) give way to the Rococo mirrors of the "Banality" series (1988). In the sculptures in this series, even the porcelain achieves an almost mirror-like limpidity: the gilded uniform worn by Michael Jackson in *Michael Jackson and Bubbles* (1988)—that golden calf of contemporary art—absorbs and radiates light like a Baroque altarpiece. The polished steel surfaces of the "Celebration" series (1999) are mirrors whose flawless reflections were developed by Koons with maniacal care.[2] Works like *Balloon Dog* (1994–2000) symmetrically invert the basic principles of the early inflatables: the sculpture itself has become a mirror, while the pedestal is opaque. The sculpture self-multiplies; it is elevated to a force.

The concept of mirroring—both literal and metaphorical—occupies a central place in the often paradoxically obscure and opaque vocabulary Koons uses to describe his own work. The stainless steel introduced for the first time in the "Luxury and Degradation" series reflects both the artist's ego and the "mass ego."[3] "Embracing" is another key term in Jeff Koons's coded language: "I wanted to make works that embrace everyone's own cultural history and made everybody feel that their history was perfect just the way it was."[4] In turn, however, the artwork was meant to embrace the viewers: the mirrored material makes room for them within the work, but also imprisons them. More than once, Koons has stated that *Balloon Dog* is a Trojan horse, and elsewhere, more explicitly, that "to me, it's about using the public as a ready-made."[5]

As it was for Duchamp and Picabia, for Koons, art is largely a question of optics and hydraulics: communicating vessels, desiring machines, and lustful gazes channeled

1. Jeff Koons interviewed by Katy Siegel, "'80s Then: Jeff Koons talks to Katy Siegel," *Artforum* 41, no. 7 (March 2003), 253.
2. In 1999, Jeff Koons was supposed to finally deliver *The Moon* to the Dakis Joannou Collection after years and years of waiting and a series of financial vicissitudes that nearly bankrupted the artist and many supporters of the now-legendary "Celebration" series (an exhibition of these works was to have been held in 1996 at the Guggenheim Museum, but was cancelled because the artist was not yet ready to let the works go; many are still unfinished to this day). After organizing transport of *The Moon* from New York to Athens—a task that made it necessary to stop traffic on Washington Bridge and change the course of a Lufthansa cargo flight between the two cities—Koons cancelled the delivery a few hours before the show was to be open, because the "reflections on the moon were not parallel."
3. Angelika Muthesius, *Jeff Koons* (Cologne, Germany: Taschen, 1992), 21.
4. Merit Woltmann, ed., *Jeff Koons Retrospective* [exhibition catalogue] (Oslo: Astrup Fearnley Museet for Moderne Kunst, 2004), 67.
5. Anthony Haden-Guest, "Jeff Koons–Anthony Haden-Guest Interview," in *Jeff Koons*, Angelika Muthesius, ed. (Cologne, Germany: Taschen, 1992), 24.

through tubular contraptions and other mechanical devices with a biomorphic appearance. But while in Duchamp the gaze is veiled, in Koons, everything is immediately visible: Koons slams open the door to Marcel Duchamp's *Étant donnés*.[6]

It is no coincidence that Koons's first solo exhibition was held in a shop window (or in a *Fresh Widow*, should we say?). In 1980, Koons retrofitted the window of the New Museum at 65 Fifth Avenue into a space that could easily have been mistaken for a commercial appliance store rather than an art installation. Like the famous Rembrandt used as an ironing board, Koons's window seems stripped of all artistic ambition; his vacuum cleaners aspire to be themselves, to become everyday objects. There is nothing to see, for there is nothing to hide, to borrow one of the most Duchampian mottos of Italian artist Alighiero Boetti.

There are no obstacles in Koons's world. Emptiness is the state of existence that characterizes his art. And in the void, things can be seen more clearly: our eyes touch every surface, without impediment. Our gaze seems to be sharpened. The vacuum cleaners in the series "The New" (1987) are themselves preserved in the vacuum of Plexiglas cases—their vacuity enhanced by the fluorescent tubes, which illuminate only because they are devoid of oxygen. The vitrines of the *Equilibrium Tanks* are stylized voids. The ceramic figures of the "Banality" series and the inflated balloons of the "Celebration" series are hollow. The inflatables of the "Popeye" series (2003–08) also have nothing inside. And "ethereal" is the adjective paired with the paintings in the "Easyfun" series.

Koons's art is inebriating because it exists in a vacuum, in a world without oxygen.

Is the air thin in heaven?

The paintings featuring porn star Cicciolina from the series "Made in Heaven" (1992) take the concept of vision to a further level of transparency. All is revealed: this immaculate conception introduces the viewers to a state of pure visibility. "I had to go to the depths of my own sexuality, my own morality, to be able to remove fear, guilt, and shame from myself," the artist explained. "All of this has been removed for the viewer."[7] The bride literally stripped bare.

Much has been said, in the legends surrounding Jeff Koons, of the supposed influence his father's furniture store had on the way the artist presents his objects. Techniques of commercial display play an important role in Koons's world, but the origin of his obsession with the mise-en-scène cannot be ascribed only to the biographical motivation of his father's job. Koons says that what

he borrowed from his dad's shop was "a sense of static, a sense of order…a respect of control."[8] Koons talks about interior design the way Winckelmann talked about classical art: the power of display in Koons is closer to the "noble simplicity and quiet grandeur" of antiquity than to furniture-shop aesthetics.

Koons is a committed collector and art lover, whose curiosity ranges over different eras, spanning from Greek and Roman sculpture to Salvador Dalí, by way of Poussin and Courbet—a lineage that seems to point to a form of hypermental realism, as curator Bice Curiger has baptized it in a seminal exhibition.[9]

Koons says he collects art "to have a world besides my world, to have another field of experience."[10] But in this universe as well, Koons reveals his radical scopophilia, his desire to see more. After acquiring the Nicolas Poussin painting *Jupiter and Antiope*, Koons noted that the anatomy of the figures was somehow off; he thus had the canvas X-rayed to reveal a rather explicit erotic scene hidden beneath the layers of oil paint. With the aid of a restorer, Koons brought the concealed elements back to light, annexing a new territory for the gaze.

For the first time, with the exhibition "Skin Fruit," Jeff Koons took on the task of curating and installing the work of other artists, drawn from a collection—Dakis Joannou's—with which he has a deep familiarity and strong bond. With its forty-eight works by Jeff Koons, Dakis Joannou's collection is in turn a mirror of Koons's art. The pieces by Koons not only constitute its backbone, but its origin: the collection got its start in 1985 with the purchase of the *One Ball Total Equilibrium Tank*. For over twenty-five years, Joannou has followed Koons's career, buying his work only on the primary market, and choosing many of what would turn out to be the artist's consummate masterpieces. And in turn, Koons has followed the growth and evolution of the collection, occasionally suggesting artists and witnessing the expansion of a unique gathering of works, all acquired directly in the heat of the moment, at the source, when hierarchies and historical priorities had not yet settled—Joannou's collection, after all, is also a question of gazes, a testament to an keen, critical eye.

The exhibition "Skin Fruit" is installed so that most of the work is visible at the same time, a strategy that Koons also used throughout his career, from his first solo shows to his most recent retrospective at the Museum of Contemporary Art in Chicago.[11] It is a panoramic—or even panoptical—vision that is at the heart of Koons's aesthetics. In the end, this is the same approach that Koons uses in his most recent paintings: large canvases—*grandes machines*, as they were called in the nineteenth century—with superimposed

6. Francesco Bonami, "Koons 'R' Us." *Jeff Koons* (Chicago, IL: Yale University Press, 2008), 10.
7. *The Jeff Koons Handbook* (London: Anthony d'Offay Gallery; New York: Rizzoli, 1992), 130.
8. Peter-Klaus Schuster, "Peter-Klaus Schuster in Conversation with Jeff Koons," in *Jeff Koons: Celebration*, Anette Hüsch, ed. (Berlin, Germany: Hatje Cantz, 2008), 84.
9. "Hypermental: Rampant Reality 1950–2000: From Salvador Dalí to Jeff Koons," November 17, 2000–January 21, 2001, Kunsthaus Zurich. Curated by Bice Curiger.
10. Schuster, 88.
11. "Jeff Koons," Museum of Contemporary Art, Chicago, May–September 2008. Curated by Francesco Bonami. During the stages of installing the Joannou collection at the New Museum, Koons begrudgingly accepted a few architectural divisions requested by some artists.

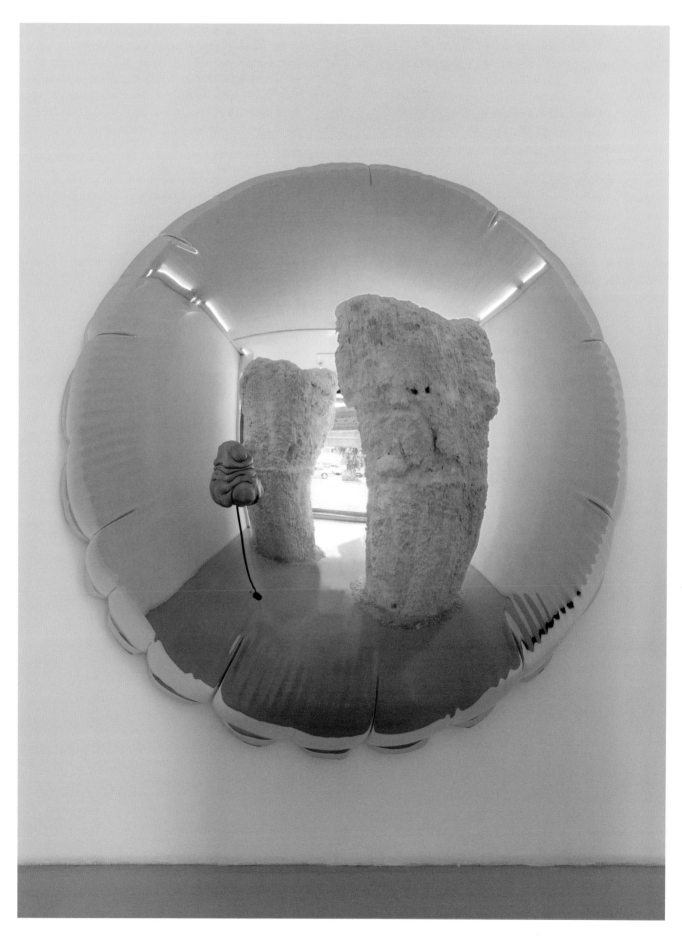

Jeff Koons, *Moon*, 1994–2000. High chromium stainless steel, 131 1/4 x 131 1/4 x 40 3/8 in (333.3 x 333.3 x 102.6 cm) (reflecting: Ashley Bickerton, *F.O.B.*, 1993; Terence Koh, *Untitled (Chocolate Mountains)*, 2006)

figurative fragments from different original and appropriated images: commercial photos, stylized details from Courbet paintings, comics, and cartoons. Seeing more also means seeing everything at the same time: the hyper-vision that dominates Koons's world translates, in his latest paintings and exhibitions, into an increasingly complex quest to strike a balance between disorder and form, between noise and music.

When applied to the Dakis Joannou collection, this vision highlights several key characteristics. The frequent shifts in scale and unconventional juxtapositions created by Koons in the exhibition treat the museum space as a large collage. The title "Skin Fruit"—a collage in itself—seems to allude to bodies that are revealed, membranes that are probed open, interiors that are exposed—bodies that rot and ripen like fruit. It is again as if Koons were imagining a gaze that can go through solids, that can skin a person alive. Or—playing along in the game of free associations that is key to Koons's universe—one could also think of skin and fruit as the ultimate synthesis of the original sin. In a radically condensed history of humanity, skin and fruit would appear as the two main actors in the Genesis: skin and fruit, seeing and desiring, one leading to the other and back again; fruit and skin…

We might be carrying the biblical metaphor too far, but how far is enough for an artist who has titled a self-portrait in his pornographic series *Jeff in the Position of Adam* (1990)?

The exhibition "Skin Fruit" is not just a decayed Garden of Eden. Koons has installed it as a dollhouse, a chamber theater where role-playing games and dramas are staged. Guards sing "This is Propaganda"; actors reenact religious rituals; voracious creatures eat themselves and each other while other bodies are buried or frozen. Icons and deities seem to abound, and they are in turn adored and dethroned. Kids play with toys, adults with idols.

Dakis Joannou's collection is built around a core of primarily figurative works. From the first, now-legendary exhibitions "Cultural Geometry," "Artificial Nature," and "Post Human,"[12] Joannou has focused above all on collecting work that presents a new image of man. It is no coincidence that a collection developed in a cultural setting such as Greece, where Classical sculpture defined the Western canon of anatomical representation, should have as its nerve center the representation of humanity. It is another game with mirrors, another intersecting gaze; most of the works in Joannou's collection are images of bodies, reflections of ourselves.

The entire evolution of the Joannou collection could be summed up as the passage from the hyper-technological,

aseptic, glacial humanity of "Post Human" (1992–93) to the much more contorted, expressive, and wounded creatures presented by today's artists.[13] From the mutant perfection of Charles Ray to the flaccid, haggard bodies of Urs Fischer, from the utopian dream of a flawless humanity to the much more sadly realistic image we have become accustomed to in this new unstable, asymmetrical century, when bodies are not admired, but blown to bits.

It is, after all, a progression similar to the one we could trace in Koons's work: from the glacial perfection of the *One Ball Total Equilibrium Tank*, a womb that is also an eyeball and globe of the world, to the recent paintings, with their unbalanced, hysterical overload of visual information. It is the passage from seeing everything to seeing too much.

12. The exhibitions "Cultural Geometry," "Artificial Nature," and "Post Human," all curated by Jeffrey Deitch and all originated and produced by the Dakis Joannou Collection/DESTE Foundation, were accompanied by catalogues designed by Dan Friedman that radically transformed the graphics of art books. Starting with the first of these shows—"Cultural Geometry"—the DESTE Foundation also introduced the practice of bringing in artists for the installation and curation of exhibitions. "Cultural Geometry" was installed by Haim Steinbach, and from 1985 to the present, Maurizio Cattelan, Roberto Cuoghi, Urs Fischer, M/M, and Josh Smith, among others, have collaborated as curators and designers of exhibitions and catalogues at DESTE. 13. This trajectory was first described by Jeffrey Deitch in the exhibition "The Fractured Figure" (DESTE Foundation, 2008) and its accompanying catalogue.

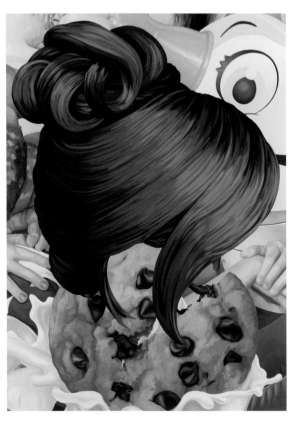

Jeff Koons, *Hair*, 1999. Oil on canvas, 42 1/2 x 31 in (274.3 x 200.6 cm)

Plates

Paweł Althamer, *Schedule of the Crucifix*, 2005. Oak, leather, and metal
with performance, Cross: 98 1/2 x 78 3/4 x 6 in (250 x 200 x 15 cm);
Ladder: 86 5/8 in (220 cm) high. (Installation view, Chiesa de San Matteo,
Lucca, 2002)

opposite: Paweł Althamer, *Nomo*, 2009. Metal helmet, wooden spear,
metal structure covered with sponge and dressed in old clothes, ski boots,
and golden paint, approximately 90 1/2 x 27 1/2 x 27 1/2 in
(230 x 70 x 70 cm)

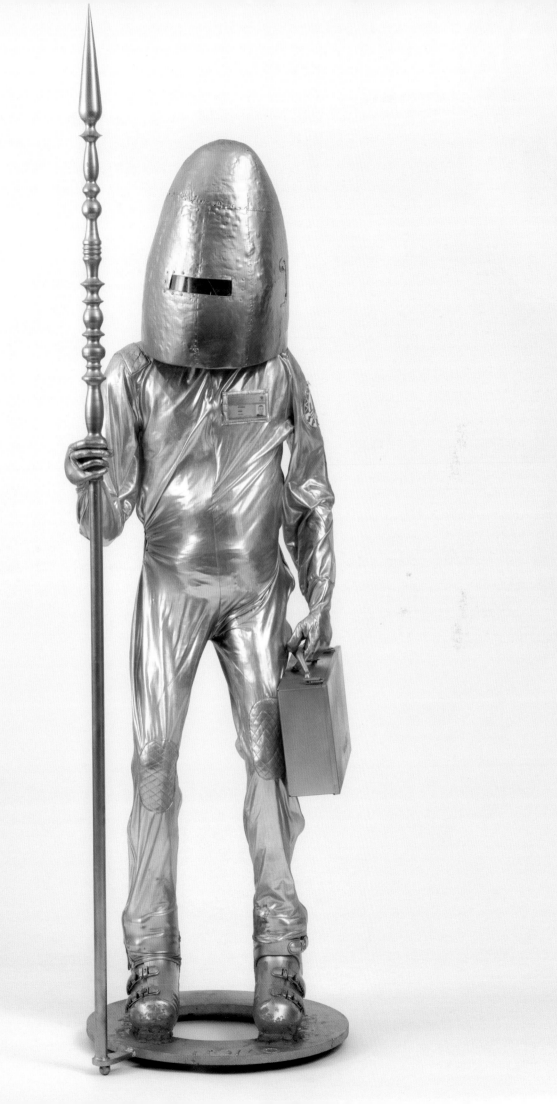

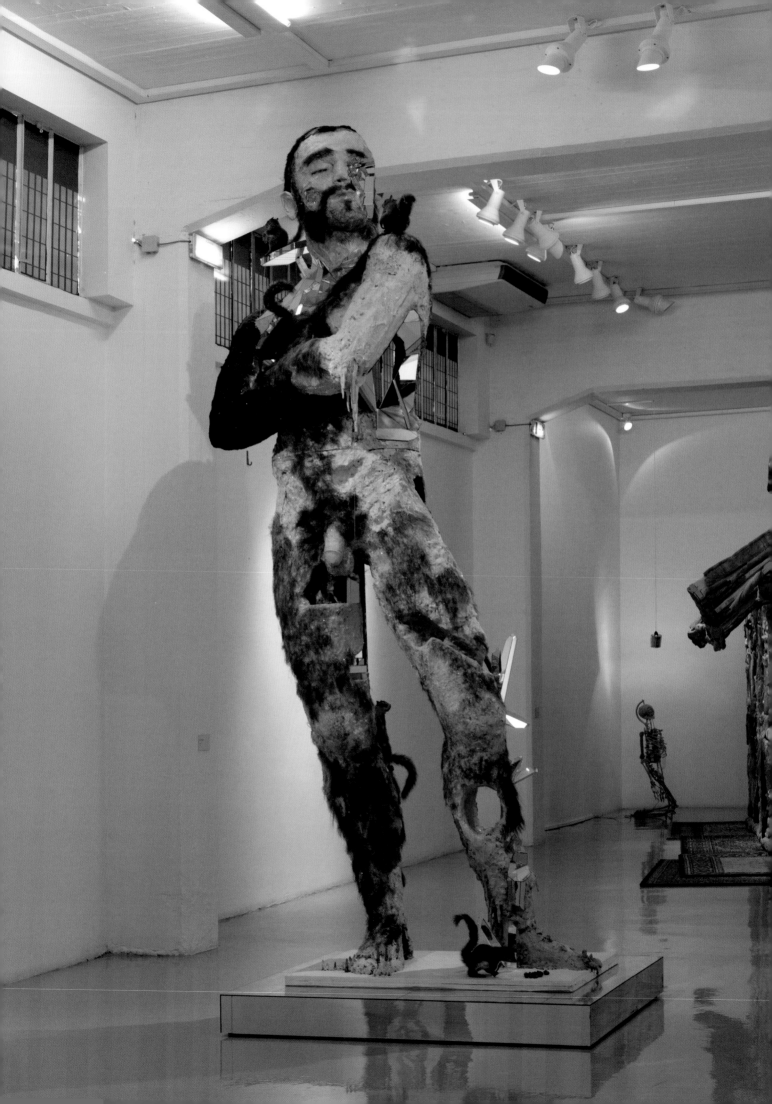

opposite: David Altmejd, *The Giant*, 2006. Foam, resin, paint, fake hair, wood,
glass, decorative acorns, and taxidermy of 3 fox squirrels and 4 grey squirrels,
114 1/8 x 59 7/8 x 40 1/8 in (290 x 152 x 102 cm). (Installation view,
"Fractured Figure," DESTE Foundation, 2007-08)

David Altmejd, *The Cave*, 2008. Wood, mirror, paint, and glue,
187 x 36 x 36 in (475 x 91 x 91 cm)

Janine Antoni, *Saddle*, 2000. Full rawhide, 25 1/2 x 32 1/2 x 78 1/2 in
(65 x 83 x 199 cm)

Opposite: Assume Vivid Astro Focus, *Tom Cruising* (detail), 2005.
Wallpaper installation, dimensions variable

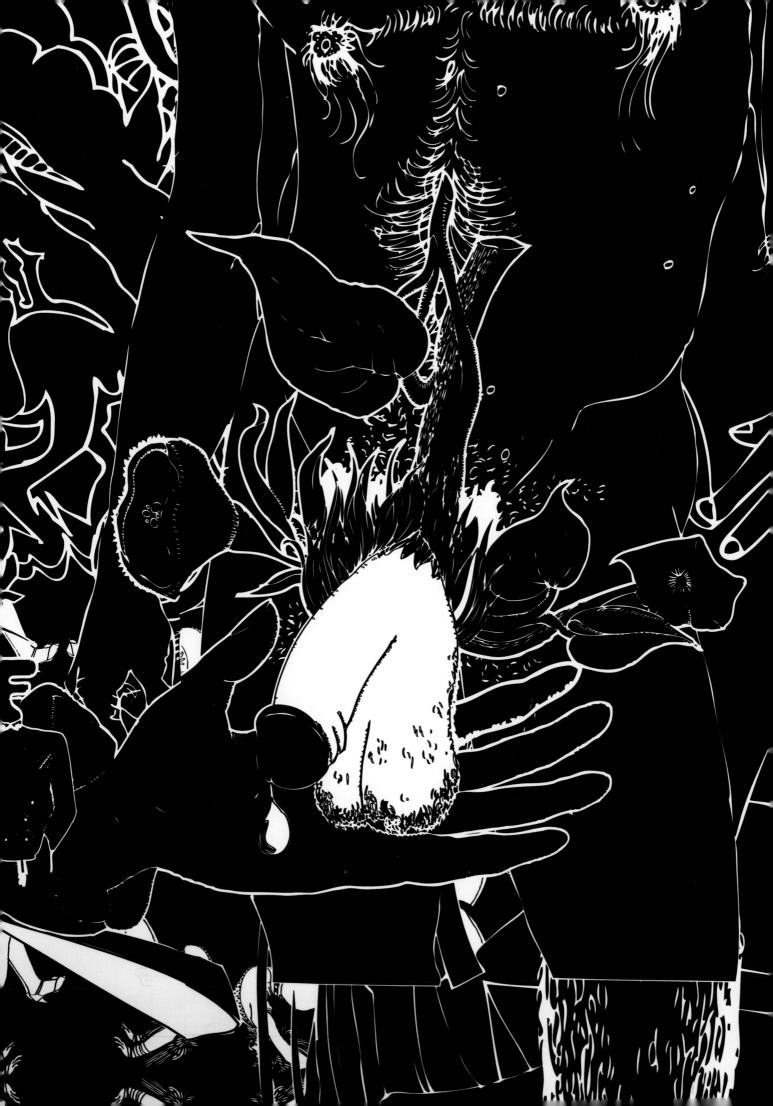

Assume Vivid Astro Focus, *Untitled/Untitled (Brown Sound)*, 2005. Ink on acetate,
12 x 9 in (31 x 23 cm)

Dick Fruit

Assume Vivid Astro Focus, *Untitled/Dick Fruit*, 2005. Ink on acetate, 12 x 9 in (31 x 23 cm)

Overleaf: Tauba Auerbach, *Crumple VI* (detail), 2008. Acrylic and inkjet print on canvas, 96 x 128 in (244 x 325 cm)

Matthew Barney, *Cremaster 1 Choreographic Suite* (detail), 1996. Acrylic, Vaseline
and pencil on paper, with vinyl floor tile, and patent vinyl within self-lubricating plas-
tic frames, suite of 12, each 18 3/4 x 17 5/8 x 2 3/4 in (48 x 45 x 7 cm)

Vanessa Beecroft, *Ein Blonder Traum*, 1994. 2 Hi8 tapes, 2 VHS tapes, and
13 Polaroids taken during performance, dimensions variable

Opposite: Ashley Bickerton, *F.O.B.*, 1993. Fiberglass, enamel paint, and
steel, 82 x 31 x 29 in (208 x 79 x 74 cm)

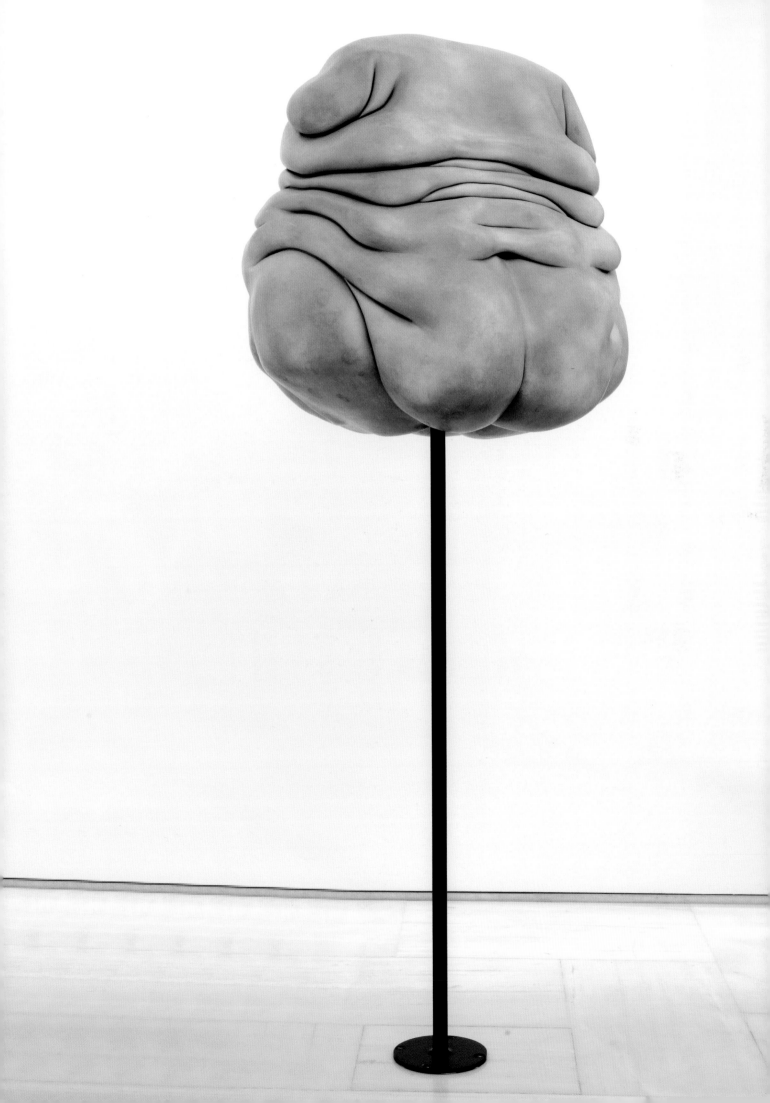

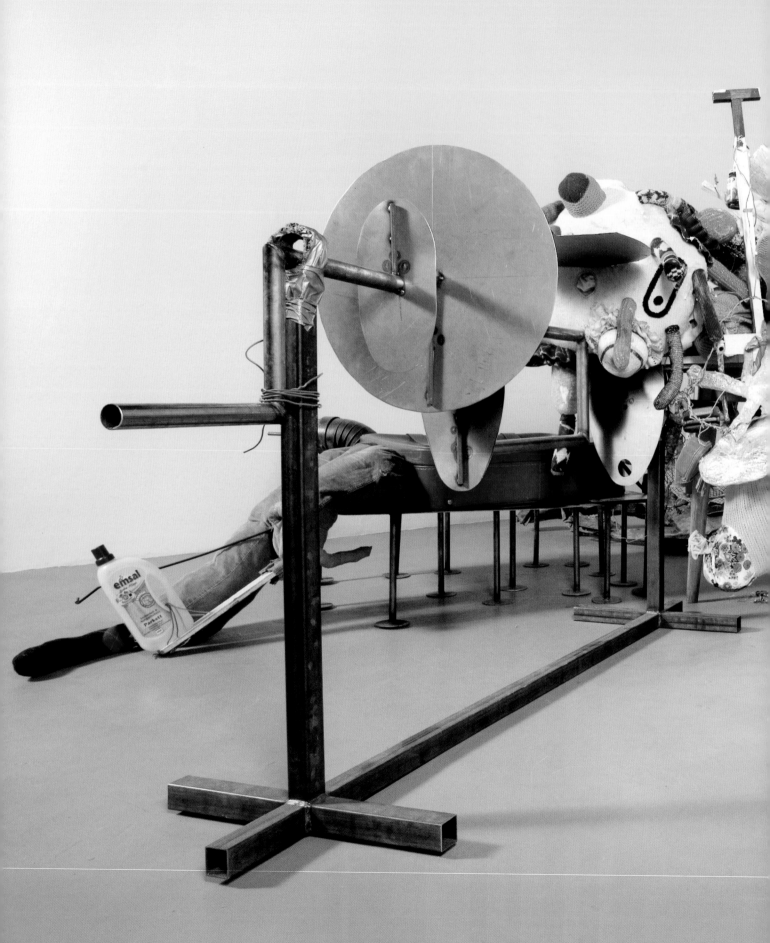

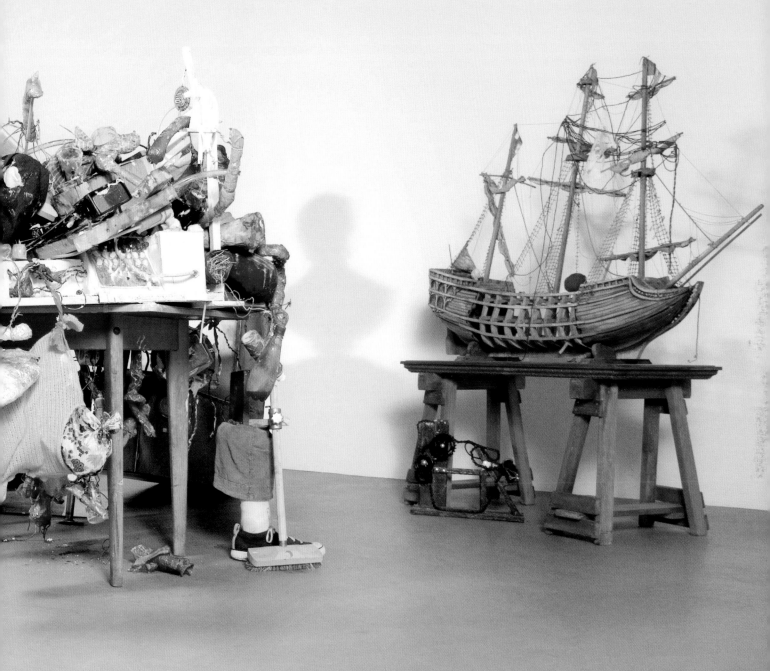

John Bock, *Maltratierte Fregatte*, 2006/07. Installation of mixed media, video *Maltratierte Fregatte*, 66:41 min; and video *Untergang der Medusa*, 9:37 min, dimensions variable

Mark Bradford, *Let's Make Christmas Mean Something This Year*, 2007.
Mixed medium collage on canvas, 102 x 144 in (259 x 366 cm)

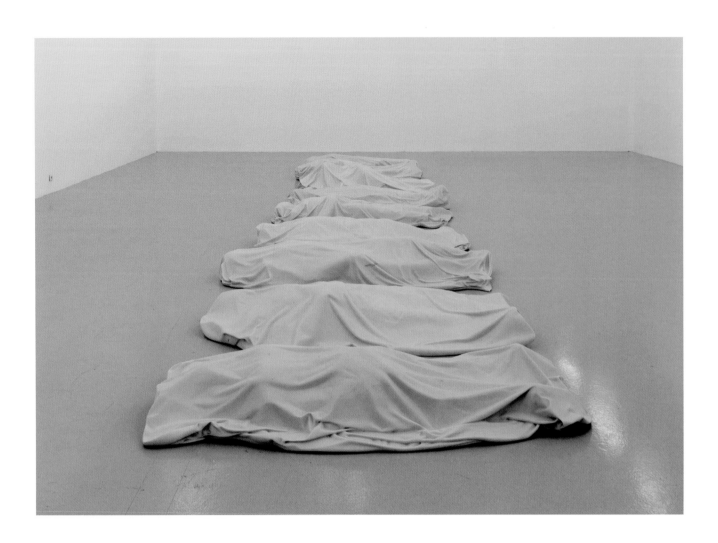

Maurizio Cattelan, *All*, 2007. White Carrara marble, 9 parts,
each 11 7/8 x 39 3/8 x 78 3/4 in (30 x 100 x 200 cm);
overall 11 7/8 x 78 3/4 x 339 1/2 in (30 x 200 x 862 cm)

Opposite: Maurizio Cattelan, *Mother*, 1999. Gelatin silver print,
44 3/4 x 39 3/8 in (114 x 100 cm)

Opposite: Maurizio Cattelan, *Now*, 2004. Polyester resin, wax, human hair, clothes, and wood, 33 1/2 x 88 5/8 x 30 3/4 in (85 x 225 x 78 cm). (Installation view, Chapelle des Petits Augustins of the Ecole nationale superieure des Beaux-Arts, Paris, 2004)

Paul Chan, *Buildings as Monuments as Graves I*, 2003. Archival inkjet print,
44 x 78 in (112 x 198 cm)

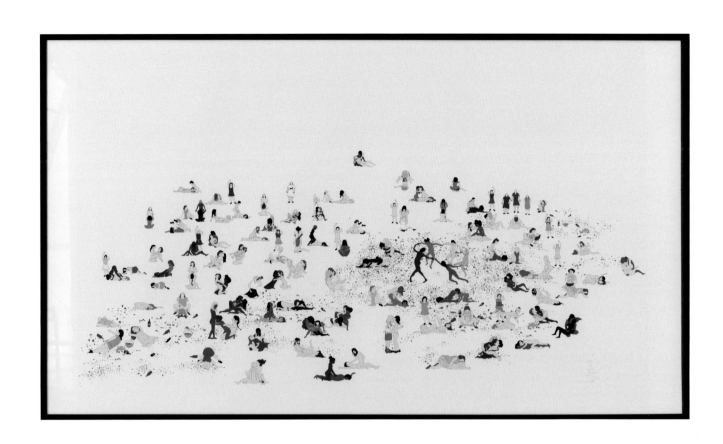

Paul Chan, *Orgy Before Man and Storm*, 2003. Archival inkjet print,
44 x 78 in (113.8 x 83.8 cm)

Opposite: Dan Colen, *Nostalgia ain't what it used to be (The Writing on the Wall)*, 2006. Oil paint, acrylic paint, acrylic medium on papier mâché, Styrofoam, and Polyfoam on MDF base with burkas, approximately 94 7/8 x 46 7/8 x 46 7/8 in (241 x 119 x 119 cm)

Dan Colen, *Holy Shit (Mirror)*, 2006. Oil on wood, 48 x 35 1/2 in (90 x 122 cm)

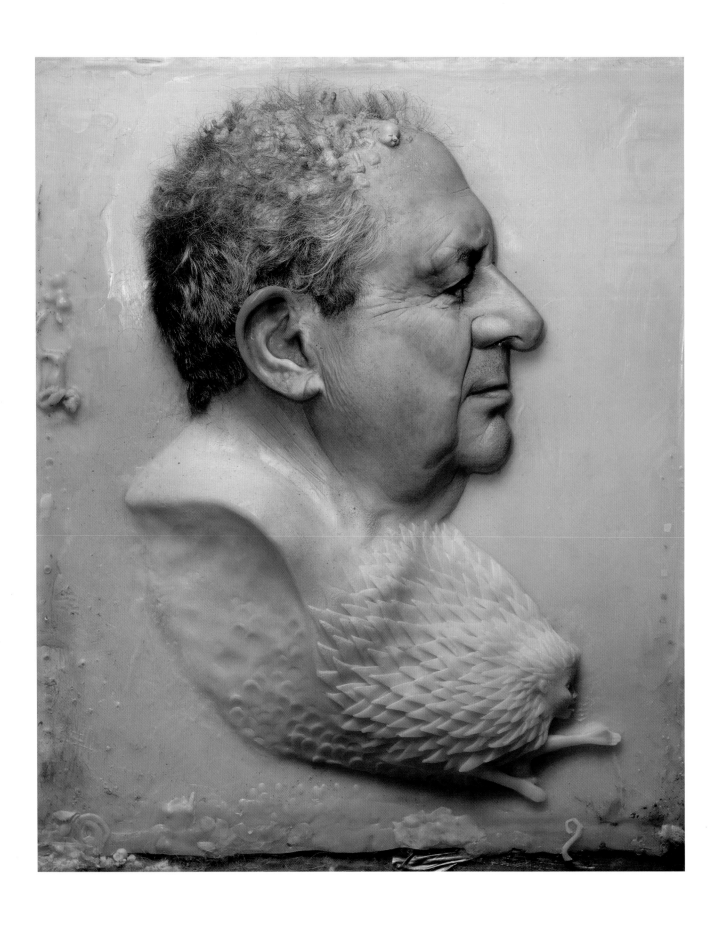

Above: Roberto Cuoghi, *Megas Dakis*, 2007. Print on cotton paper, unframed, 21 1/4 x 17 1/5 (54 x 44 1/2 cm); with frame, 28 3/4 x 25 in (73 x 63.5 cm)
Opposite: Roberto Cuoghi, *Pazuzu*, 2008. Epoxy, solvent varnish, fiberglass, polystyrene, and steel, 234 1/4 x 116 1/2 x 98 1/2 in (595 x 296 x 250 cm). (Installation view, Castello di Rivoli, Turin, 2008)

Overleaf: Nigel Cooke, *Silva Morosa*, 2002–03. Oil on canvas, 72 x 96 in (183 x 244 cm)

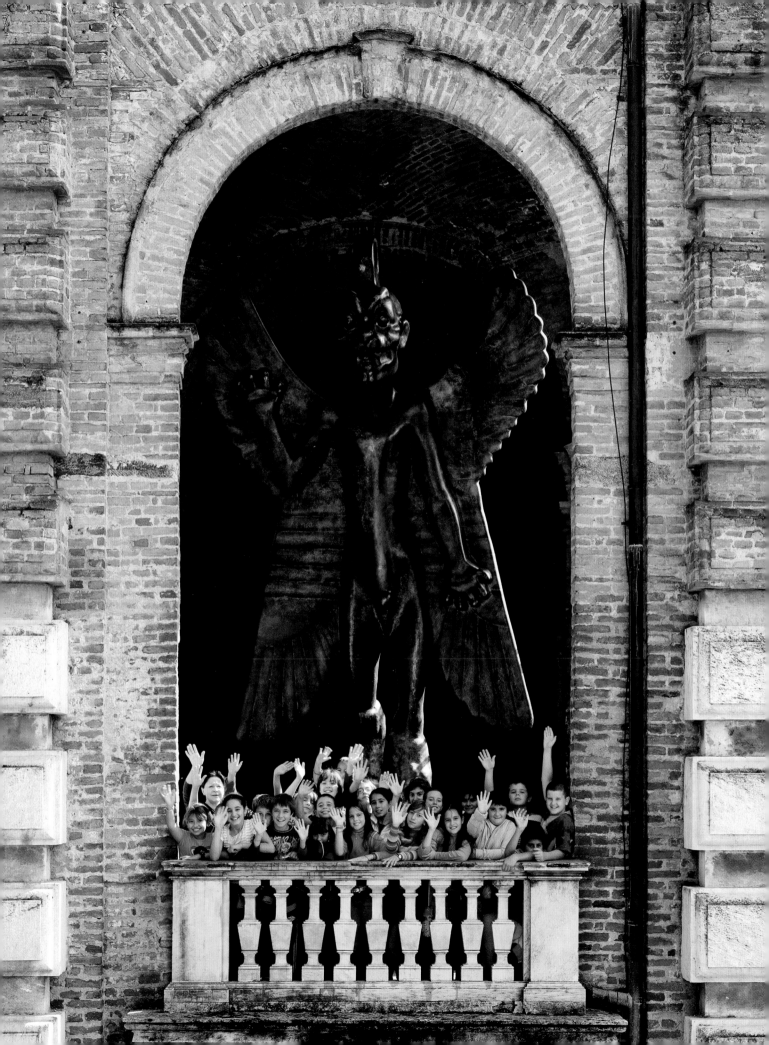

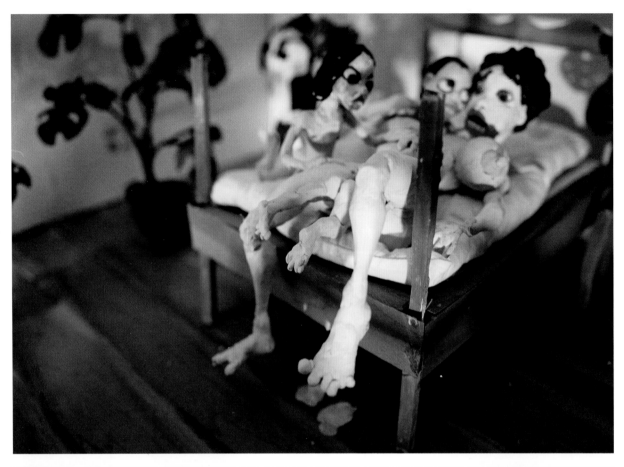

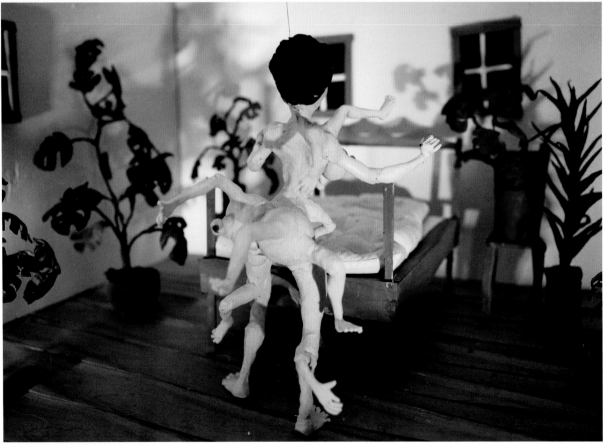

Nathalie Djurberg, *It's the Mother*, 2008. Clay animation, video,

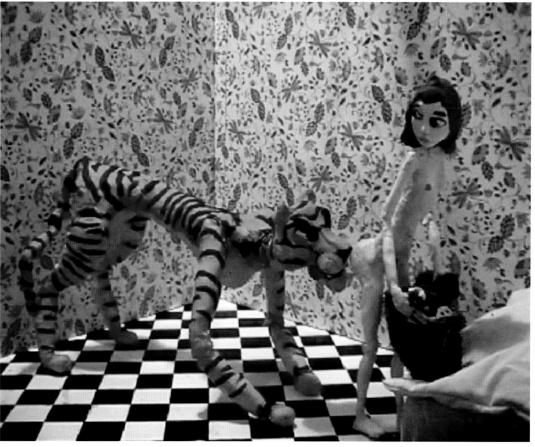

Nathalie Djurberg, *Tiger Licking Girl's Butt*, 2004. Video, 2:15 min

Haris Epaminonda, *Nemesis 52*, 2003. Video, 13:07 min

Opposite: Urs Fischer, *Noodles*, 2009. Oak, aluminum composite panel, screws, gesso, ink, and acrylic, 96 x 72 x 1 1/4 in (244 x 183 x 3 cm)

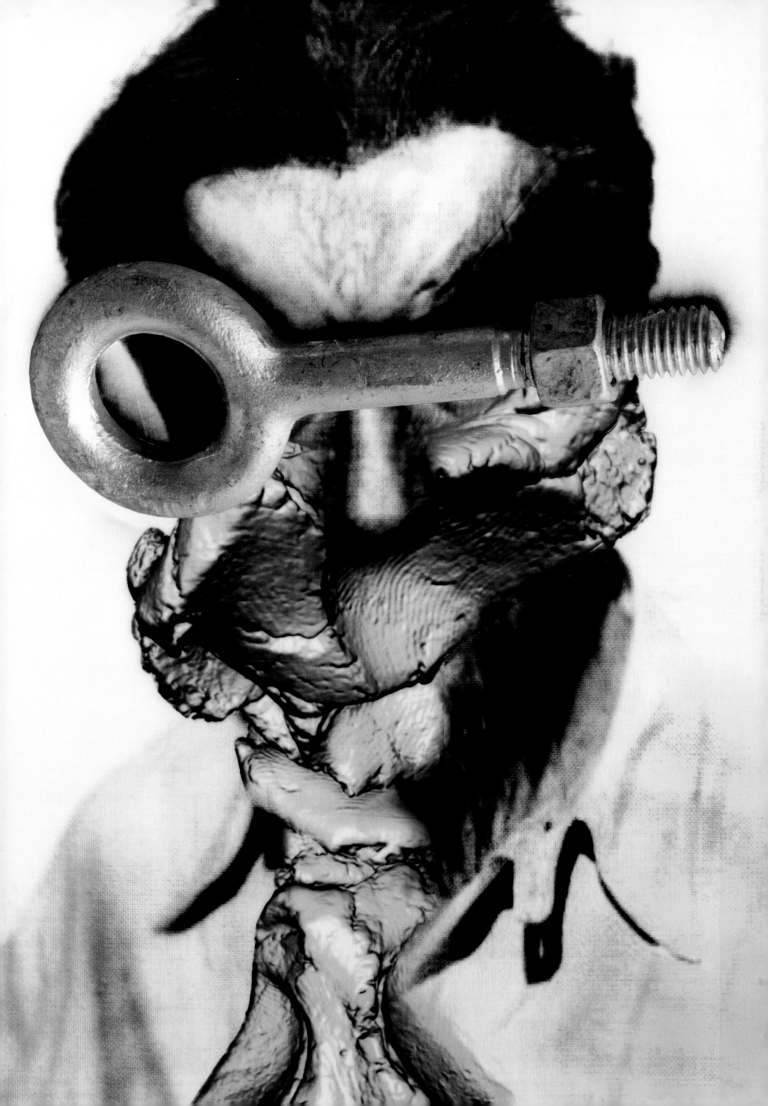

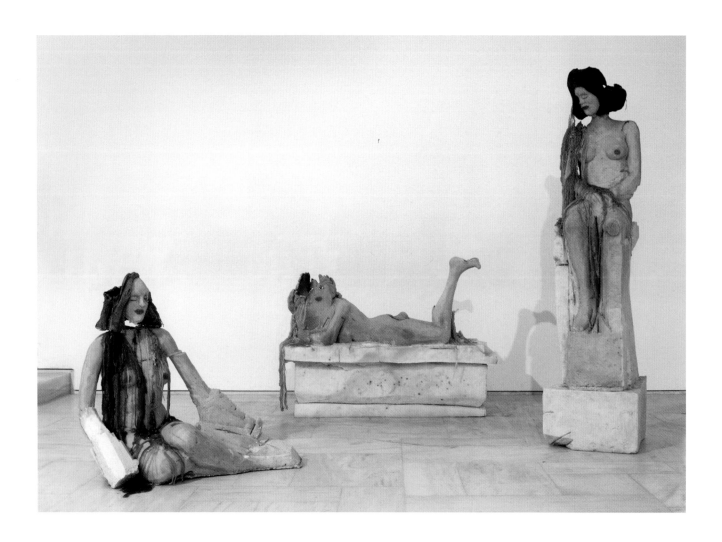

Urs Fischer, *What if the Phone Rings*, 2003. Polychromed wax, dimensions variable

Opposite: Urs Fischer, installation view of *Abyss/Debauched Oratorio/ Roadshow/Abyss*, 2007; *Mackintosh Staccato*, 2006; and *Spinoza Rhapsody*, 2006. Epoxy resin, pigment, and enamel, dimensions variable

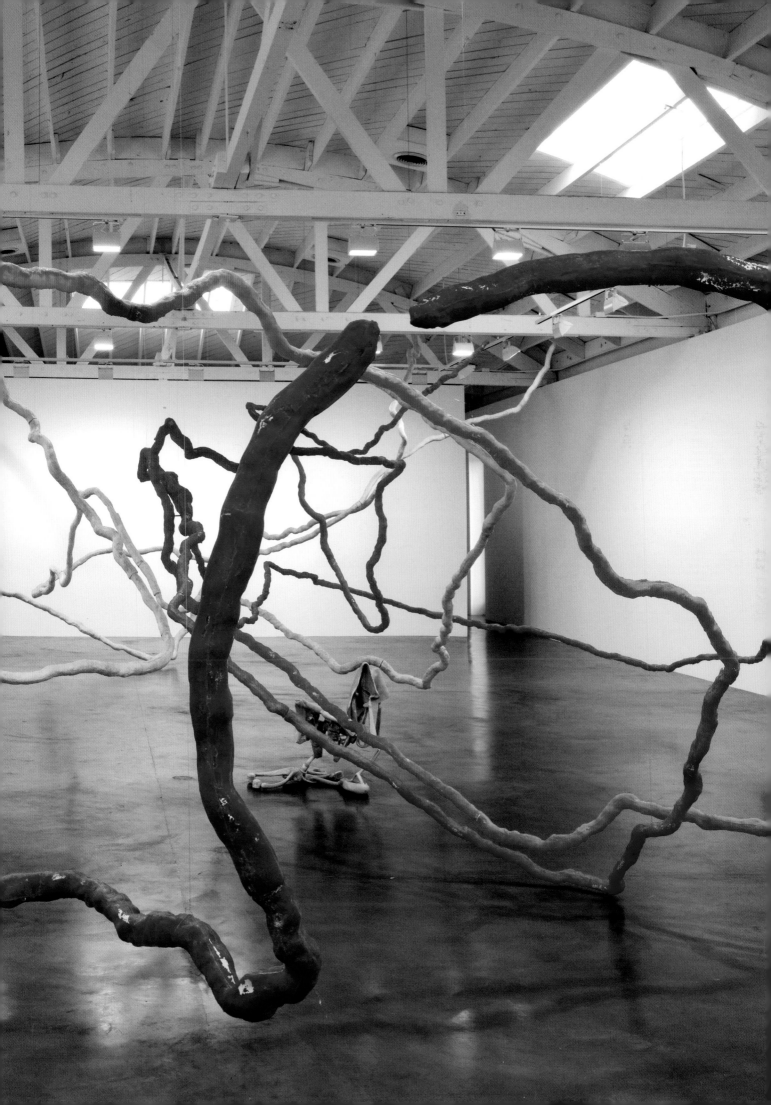

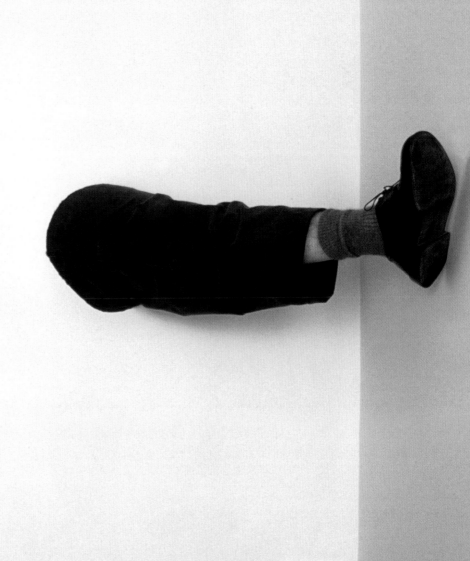

Overleaf: Robert Gober, *Two Spread Legs*, 1991. Wood, wax, leather, cotton, human hair, and steel. 11 x 35 x 27 1/4 in (28 x 89 x 70 cm)

Robert Gober, *The Scary Sink*, 1985. Enamel paint on plaster, wire lathe, wood, and steel. 62 1/4 x 55 1/5 x 55 1/2 in (158 x 141 x 141 cm)

Robert Gober, *Corner Bed*, 1987. Enamel paint, wood, cotton, and wood,
43 3/4 x 76 3/4 x 41 3/8 in (111 x 195 x 105 cm)

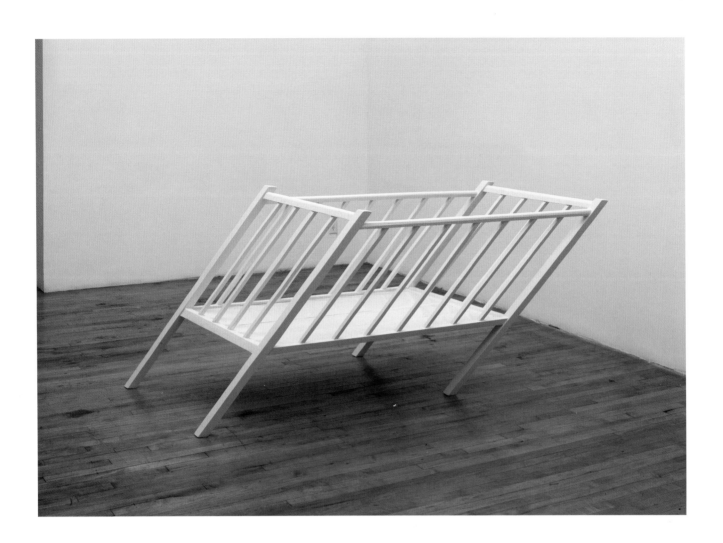

Robert Gober, *Pitched Crib*, 1987. Enamel paint on wood,
38 1/4 x 73 1/4 x 50 1/2 in (97 x 186 x 128 cm)

Opposite: Robert Gober, *Untitled*, 2009. Beeswax, cotton, leather, aluminum,
pull tabs, human hair, and oil paint, 28 x 22 x 19 3/4 in (71 x 56 x 50 cm)

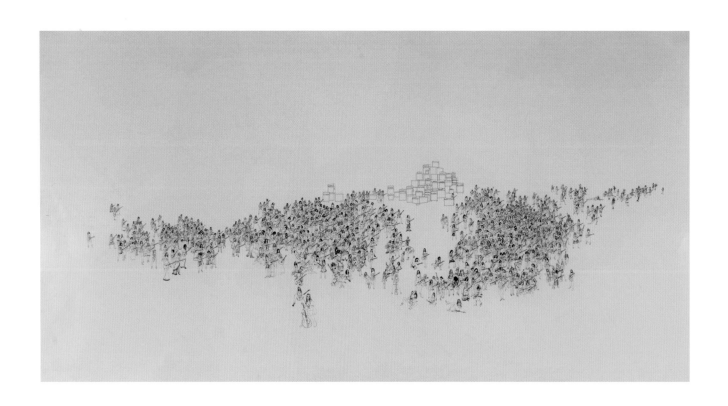

Overleaf: Matt Greene, *That We So Not Appear to Fly is of Little Consequence*, 2006. Acrylic, ink, and collage on canvas, 96 x 120 in (244 x 305 cm)

Matt Greene, *666*, 2004. Ink on paper, 45 x 85 in (114 x 216 cm)

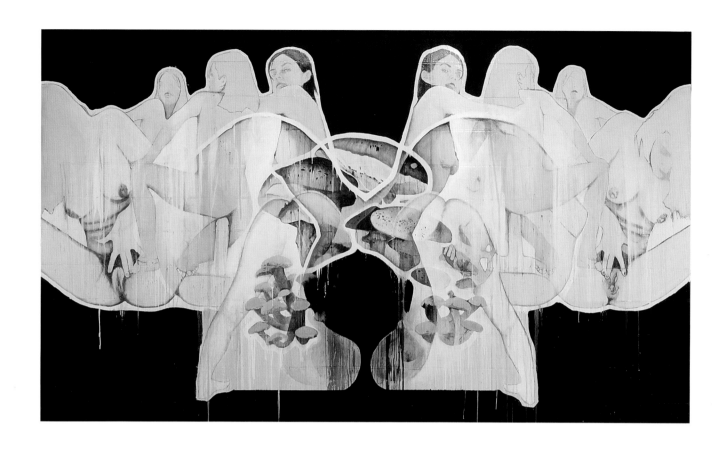

Matt Greene, *The Orifice*, 2006. Oil, acrylic, enamel, and graphite on canvas, 70 x 120 in (178 x 305 cm)

Opposite: Mark Grotjahn, *Untitled (Creamsicle 681)*, 2007. Colored pencil
on paper, 64 1/2 x 47 3/4 in (164 x 121 cm)

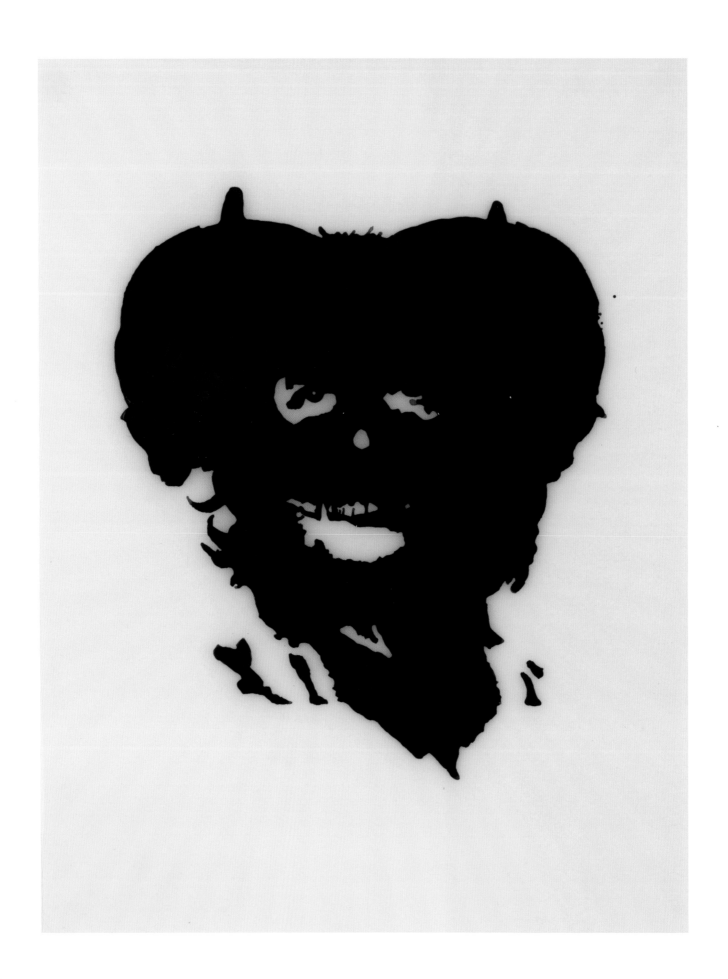

Adam Helms, *Untitled*, 2007. Ink on Mylar, 14 1/2 x 12 in (37 x 30 cm)

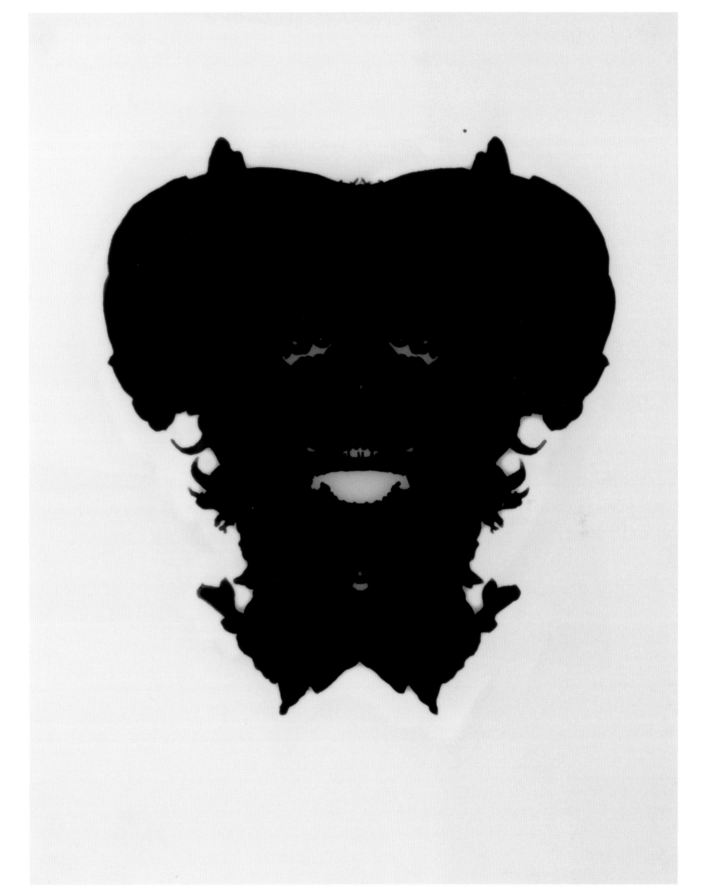

Adam Helms, *Untitled*, 2007. Ink on Mylar, 14 1/2 x 12 in (37 x 30 cm)

Jenny Holzer, *Selections from the Survival Series*, 1984. LED sign, 6 x 60 x 7 in
(15 x 152 x 18 cm). © 2010 Jenny Holzer, member Artist Rights Society (ARS), New York

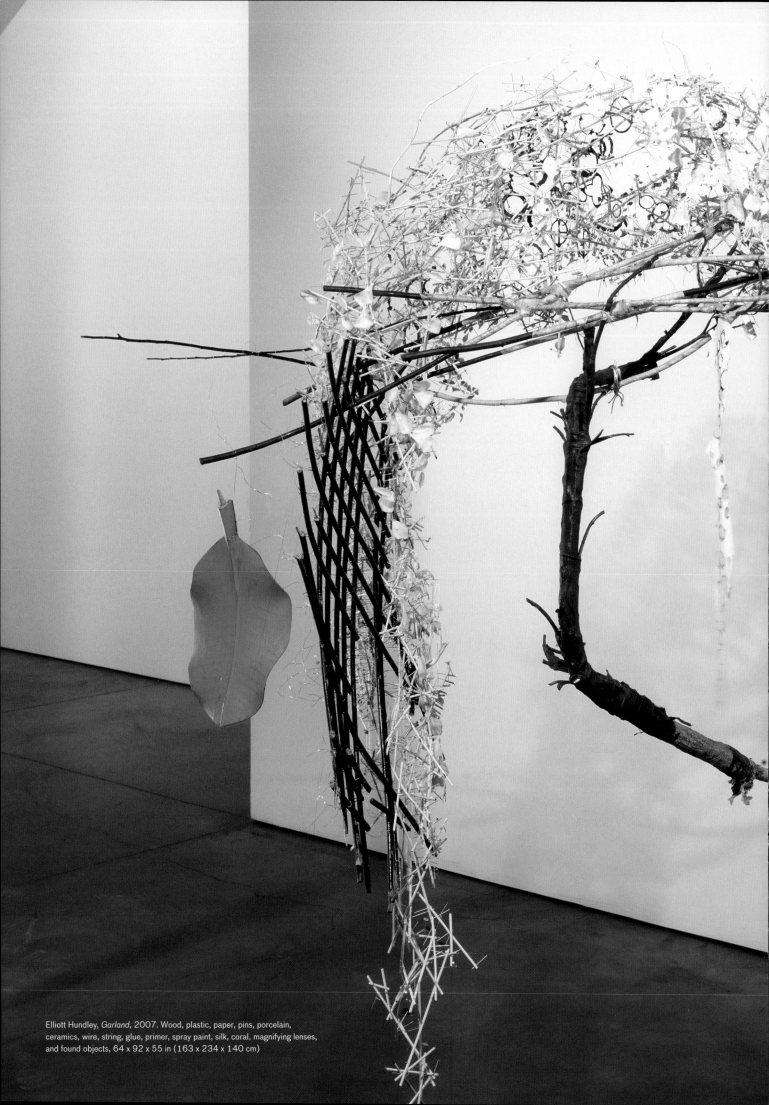

Elliott Hundley, *Garland*, 2007. Wood, plastic, paper, pins, porcelain,
ceramics, wire, string, glue, primer, spray paint, silk, coral, magnifying lenses,
and found objects, 64 x 92 x 55 in (163 x 234 x 140 cm)

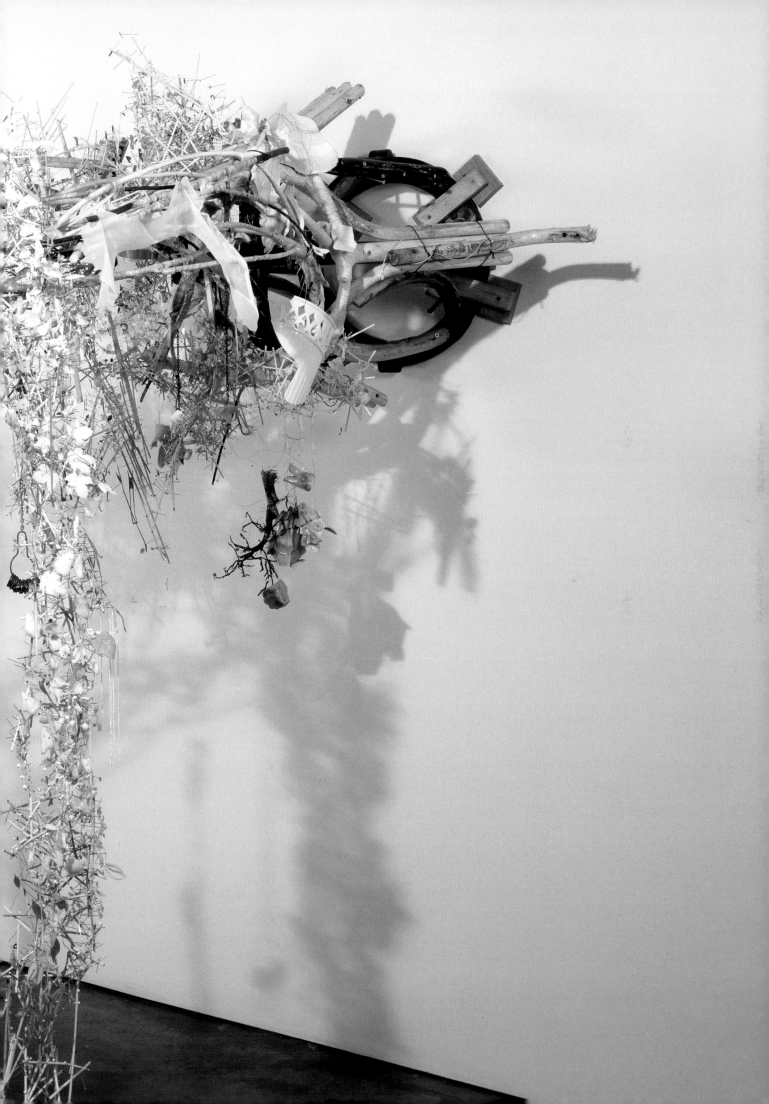

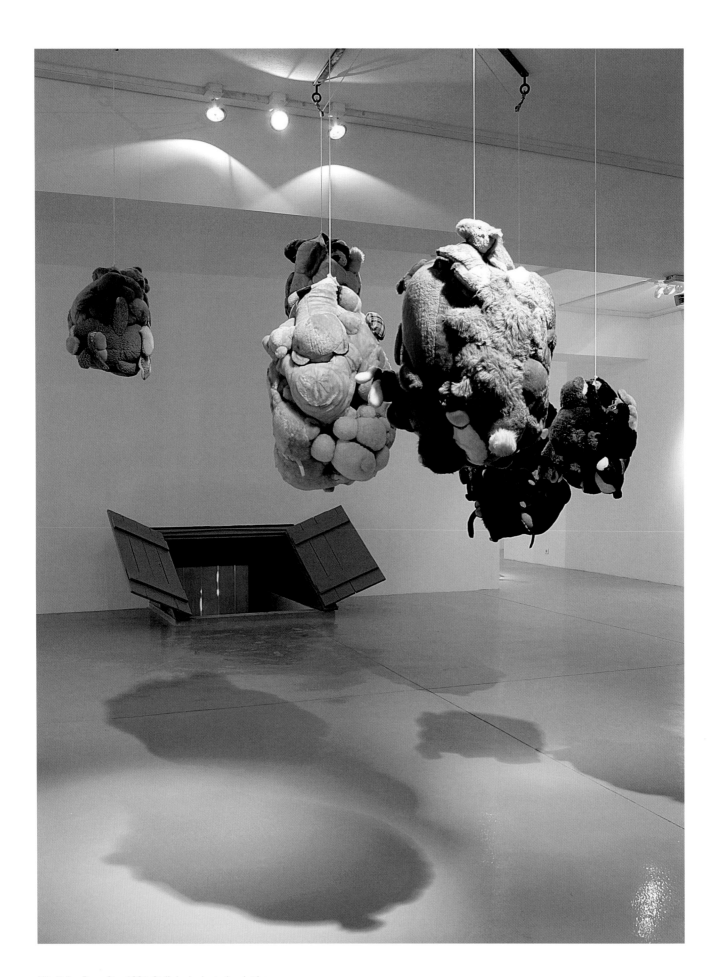

Mike Kelley, *Brown Star*, 1991. Stuffed animals, steel, and string,
dimensions variable. (Installation view, "Monument to Now,"
DESTE Foundation, 2004-05)

Mike Kelley, *Cave Painting*, 1984. Synthetic polymer on twelve sheets
of paper, each 8 5/8 x 48 in (22 x 122 cm); overall 144 x 192 in
(366 x 488 cm)

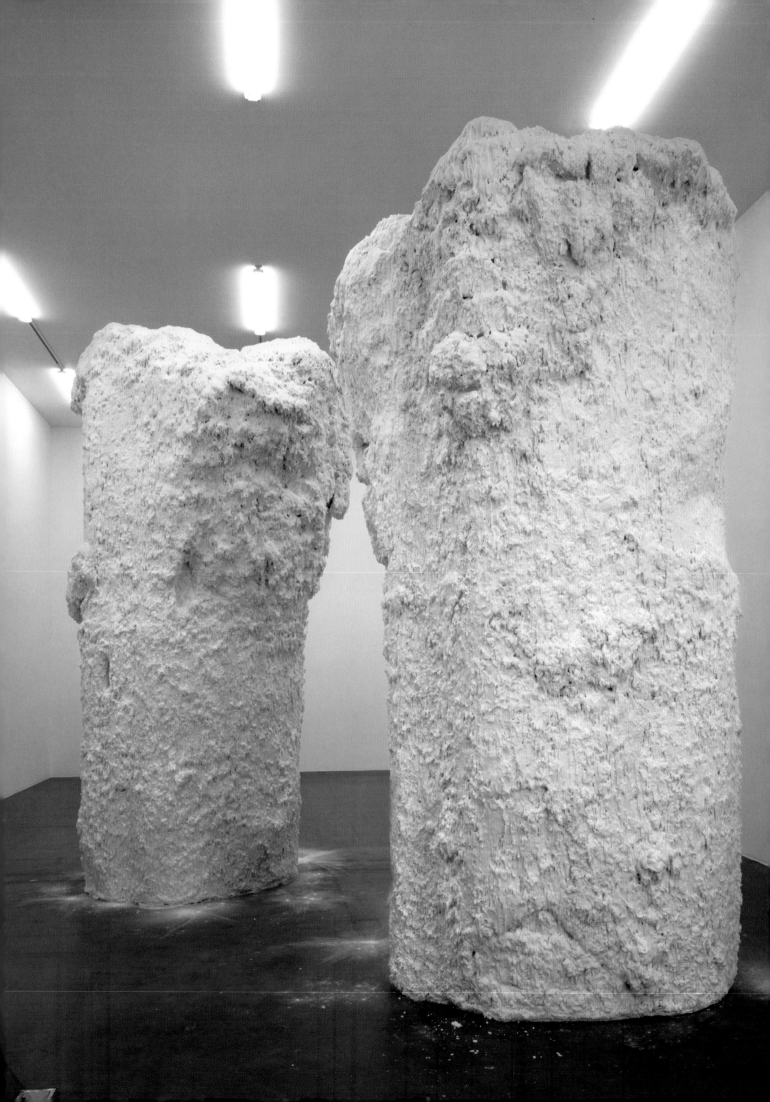

Opposite: Terence Koh, *Untitled (Chocolate Mountains)*, 2006. Styrofoam, fiberglass, and white-chocolate icing, 141 3/4 x 70 7/8 in (360 x 180 cm) (2 parts)

Opposite: Jeff Koons, *One Ball Total Equilibrium Tank*, 1985. Glass, iron, water, and basketball, 64 1/2 x 30 1/2 x 13 1/4 in (164 x 77 x 34 cm)

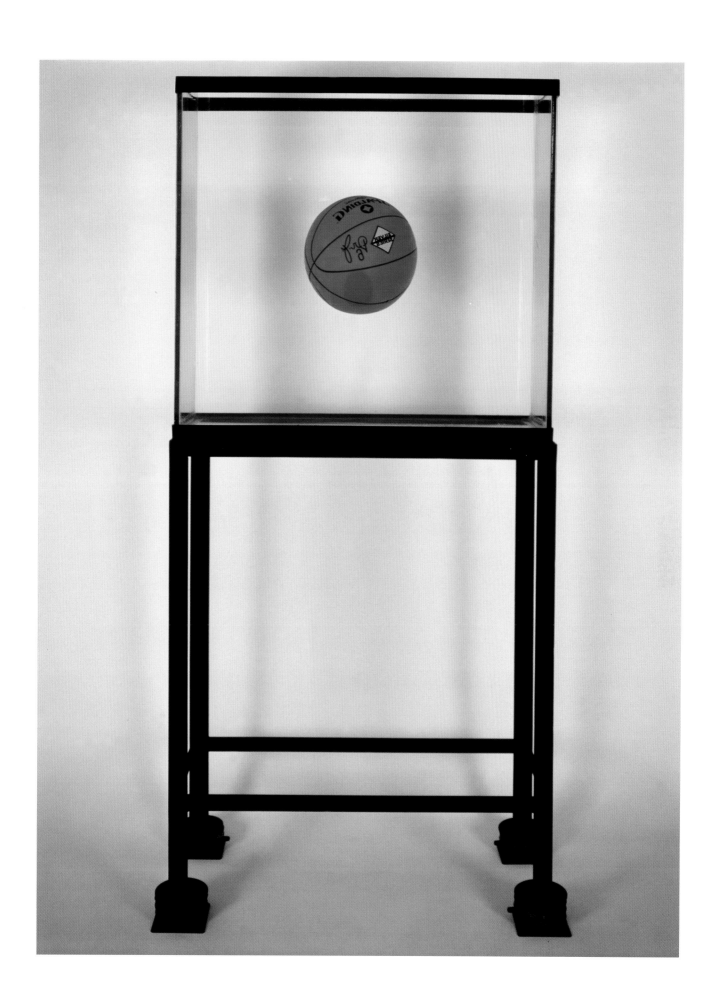

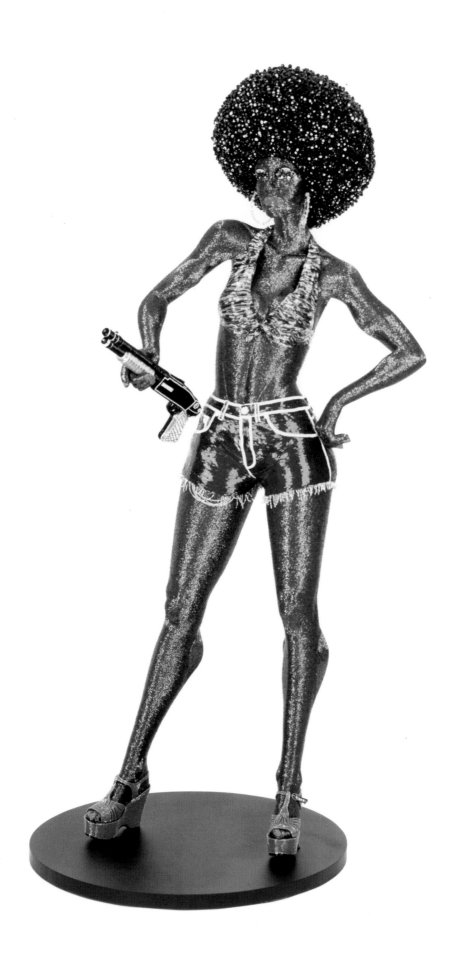

Liza Lou, *Super Sister*, 1999. Cast polyester resin and glass beads, 82 3/4 x 35 x 34 in
(210 x 91 x 86 cm)

Nate Lowman, *Black Maxima*, 2005. Silkscreen ink and latex on canvas, 38 in (96 cm) diameter

Mark Manders, *Wednesday Box*, 2002. Mixed mediums,
11 7/8 x 85 7/8 x 39 3/8 in (30 x 218 x 100 cm)

Opposite: Mark Manders, *Unfired Clay Figure*, 2005–06. Iron chairs,
painted epoxy, wood, and mixed mediums, 59 x 118 x 88 1/2 in
(150 x 300 x 225 cm)

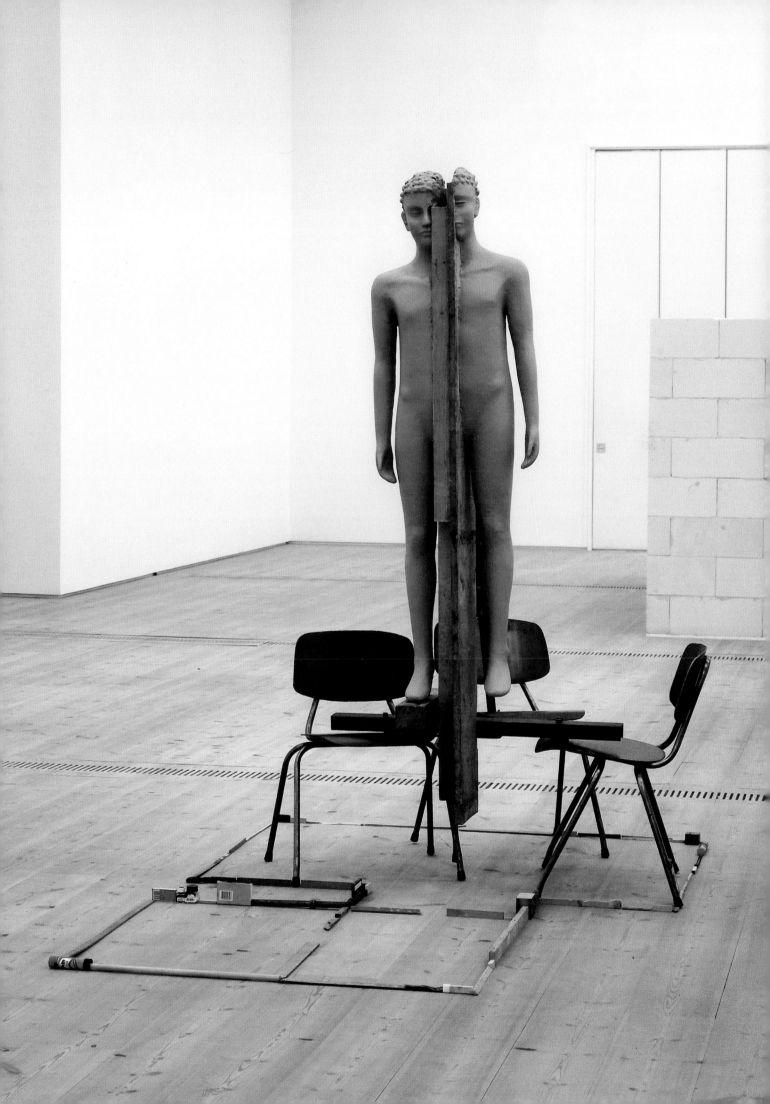

Opposite: Paul McCarthy, *Untitled (Jack)*, 2002. Red silicon rubber,
23 5/8 x 23 5/8 x 18 1/8 in (60 x 60 x 46 cm)

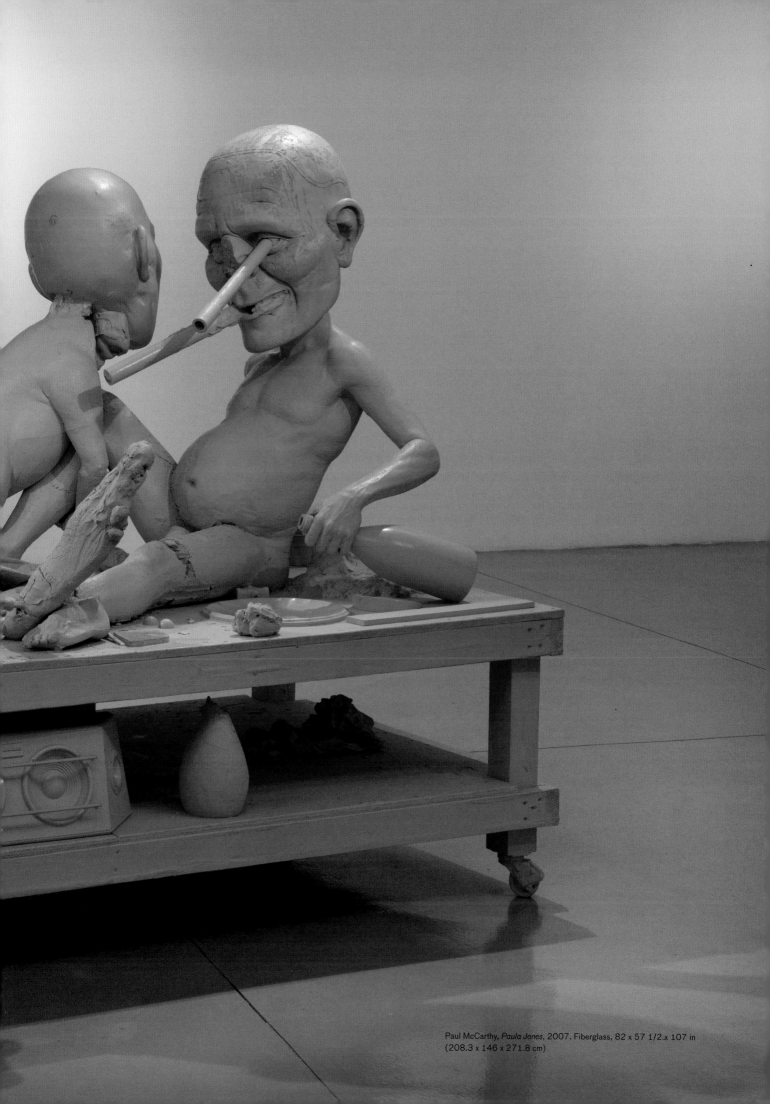

Paul McCarthy, *Paula Jones*, 2007. Fiberglass, 82 x 57 1/2 x 107 in
(208.3 x 146 x 271.8 cm)

Dave Muller, *January 2007, According to NY Times (with the Beatles)*, 2006.
Acrylic on paper, 83 1/2 x 79 1/2 in (212 x 202 cm)

Opposite: Takashi Murakami, *Inochi*, 2004. Fiberglass reinforced plastic,
steel, and lacquer, 55 1/8 x 23 x 11 1/2 in (140 x 58.4 x 29.2 cm).
Image Courtesy Blum & Poe. ©2004 Takashi Murakami/Kaikai Kiki Co., Ltd.
All Rights Reserved

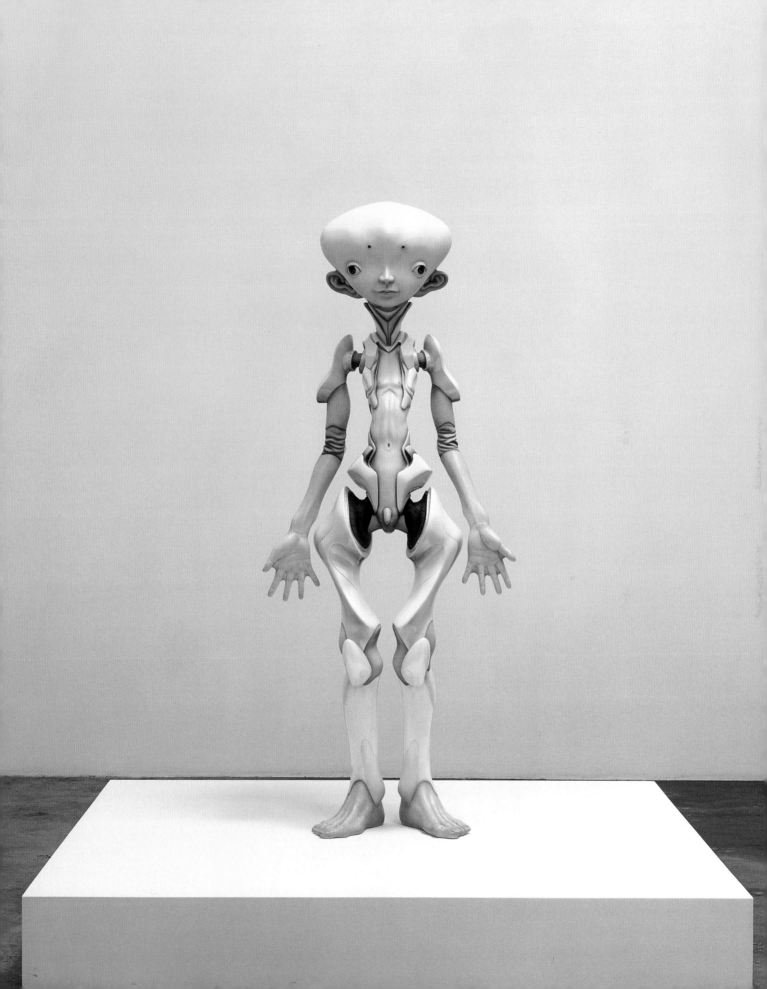

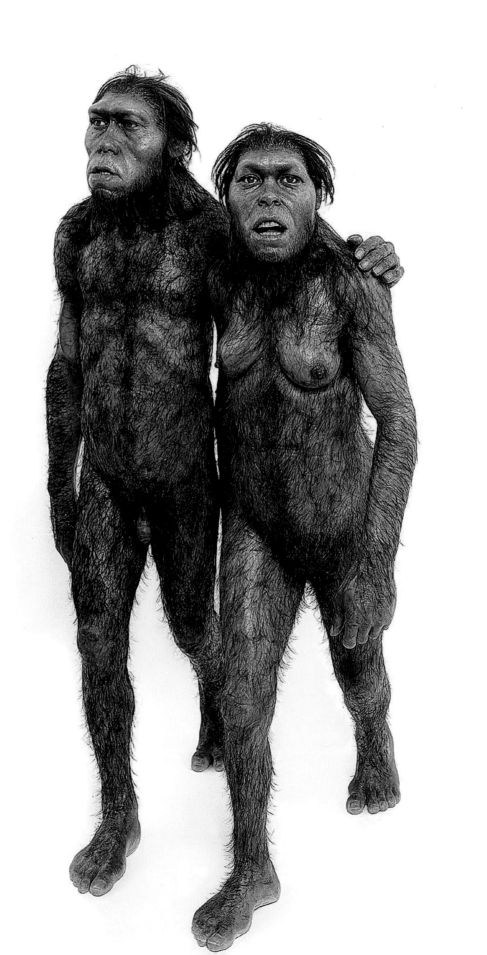

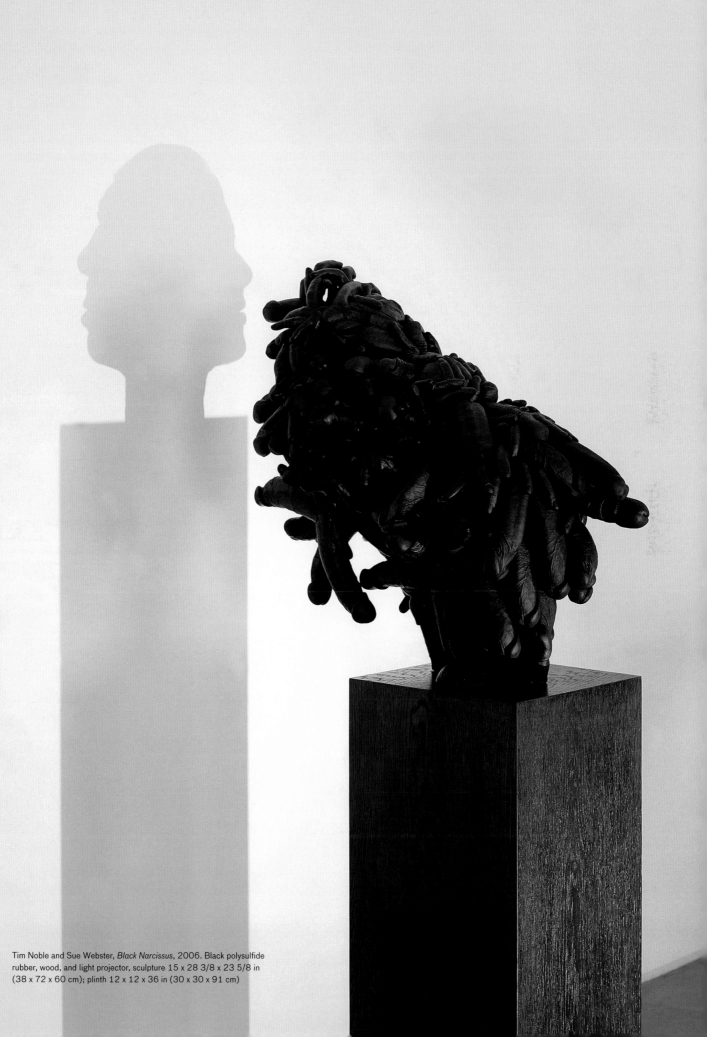

Tim Noble and Sue Webster, *Black Narcissus*, 2006. Black polysulfide
rubber, wood, and light projector, sculpture 15 x 28 3/8 x 23 5/8 in
(38 x 72 x 60 cm); plinth 12 x 12 x 36 in (30 x 30 x 91 cm)

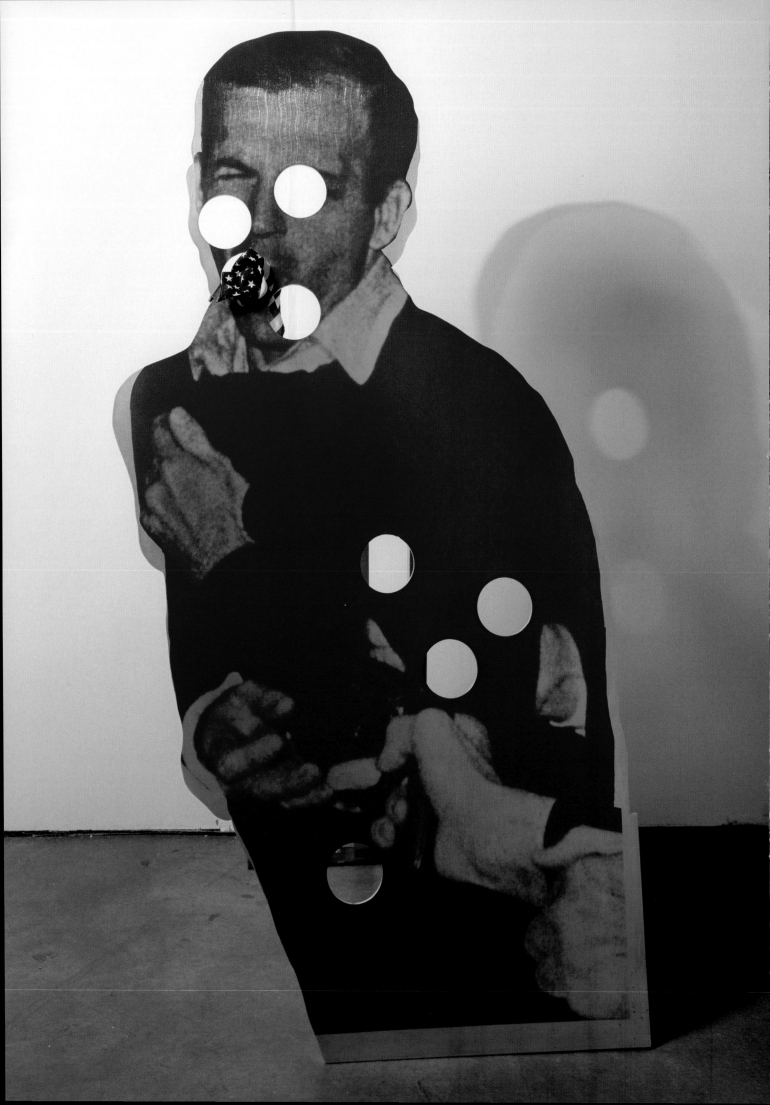

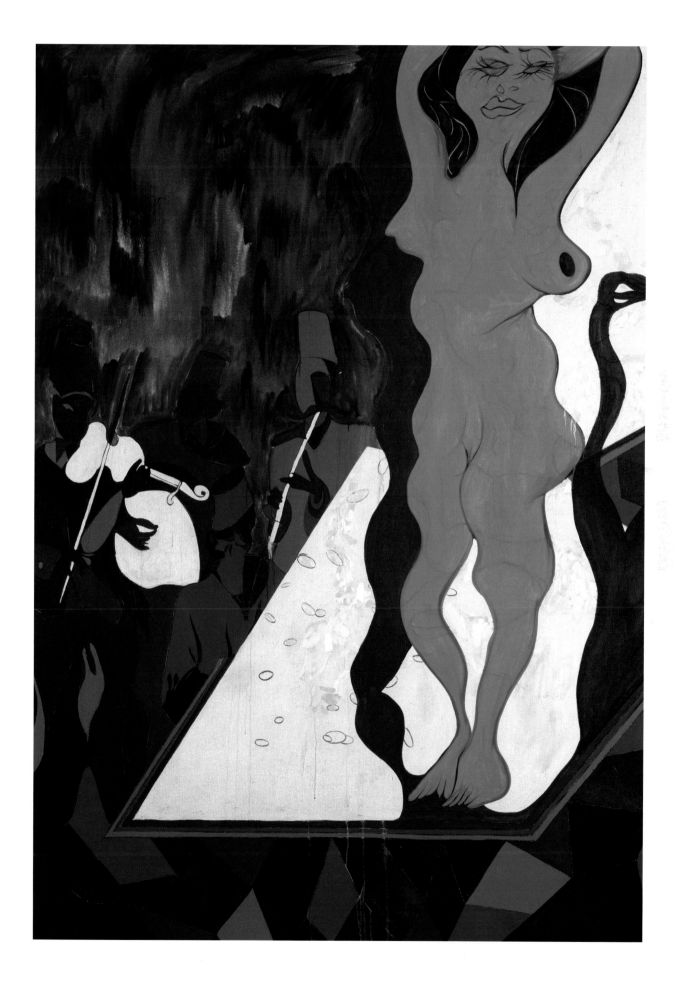

Opposite: Cady Noland, *Bluewald*, 1989. Screen print on aluminum and printed cotton flag, 72 x 33 1/2 x 35 1/2 in (183 x 85 x 90 cm)

Chris Ofili, *Thirty Pieces of Silver*, 2006, Oil, acrylic, and charcoal on canvas, 109 5/8 x 78 7/8 in (278.4 x 200 cm)

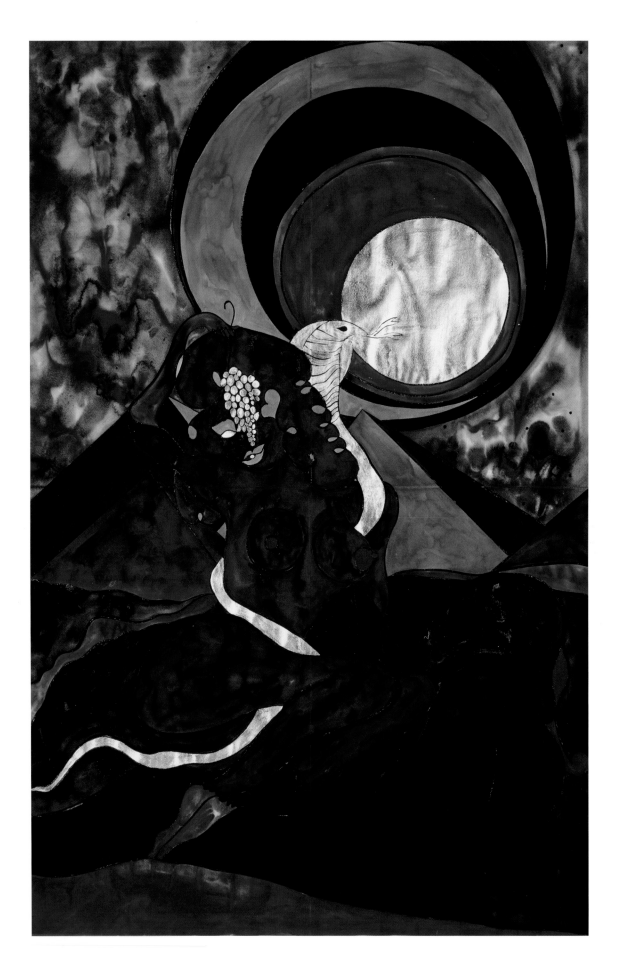

Chris Ofili, *Blue Damascus*, 2004. Charcoal, gouache, ink, and
aluminum on paper, unframed, 78 1/8 x 51 1/8 in (198.5 x 130 cm);
framed, 88 1/2 x 61 3/8 x 2 in (224.9 x 155.9 x 5 cm) (dyptich)

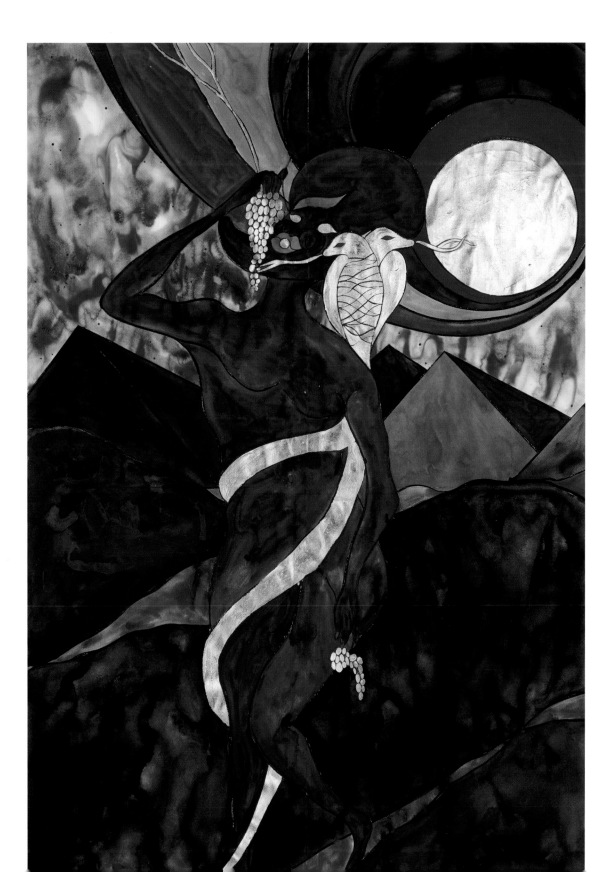

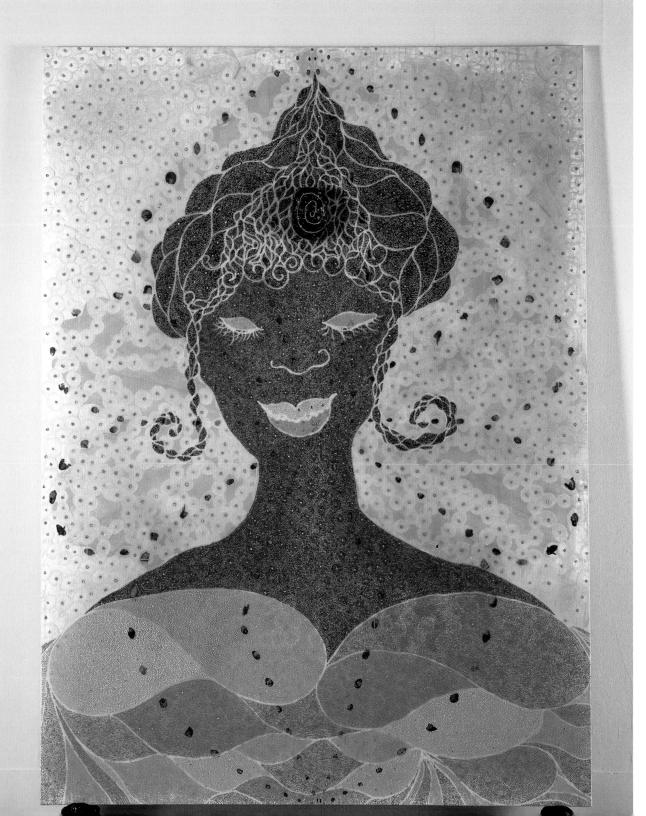

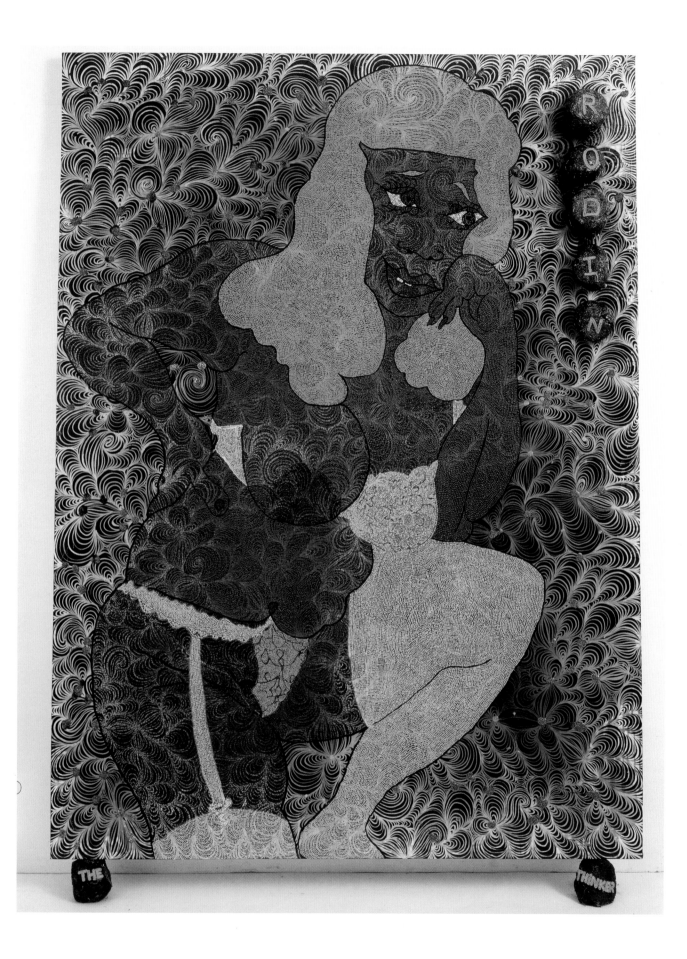

Chris Ofili, *Rodin... The Thinker*, 1997. Acrylic, oil, resin, glitter, map pins, and elephant dung on canvas, 96 x 72 x 5 1/8 in (244 x 183 x 13 cm)

Seth Price, *Untitled*, 2008. Vacuum-formed high-impact polystyrene
and synthetic enamel, 96 x 48 in (244 x 122 cm)

Seth Price, *Untitled (White Breast)*, 2008. Vacuum-formed high impact polystyrene, 96 x 48 in (244 x 122 cm)

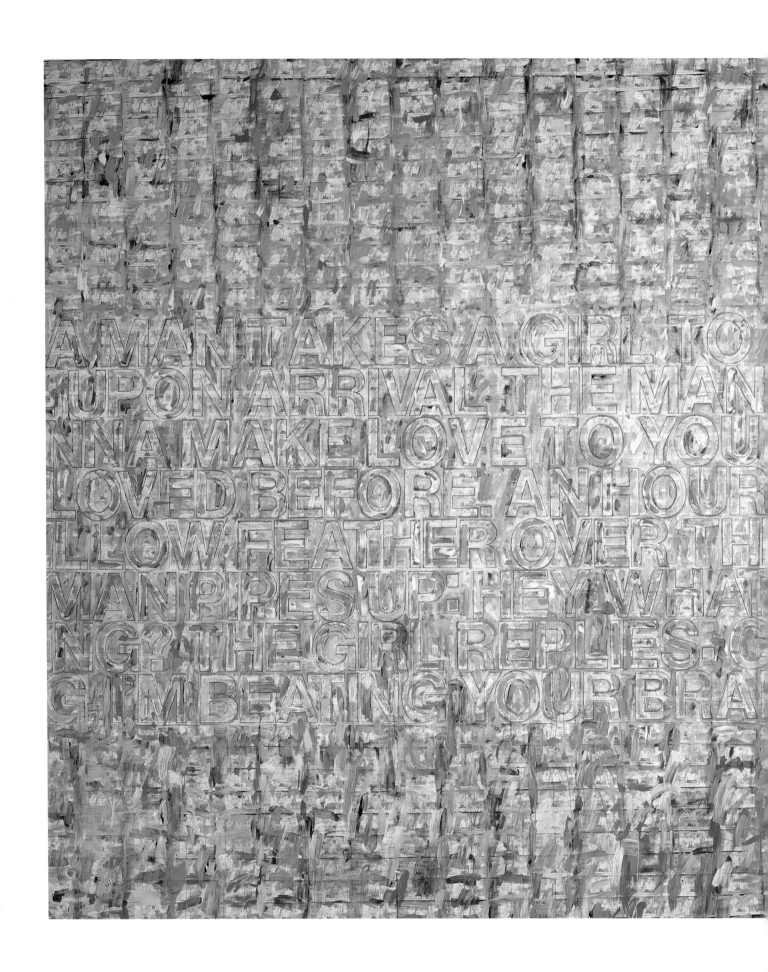

Richard Prince, *I'm in a Limousine (Following a Hearse)*, 2005–06. Acrylic
on canvas and cancelled checks, 112 1/8 x 200 in (284.9 x 508 cm)

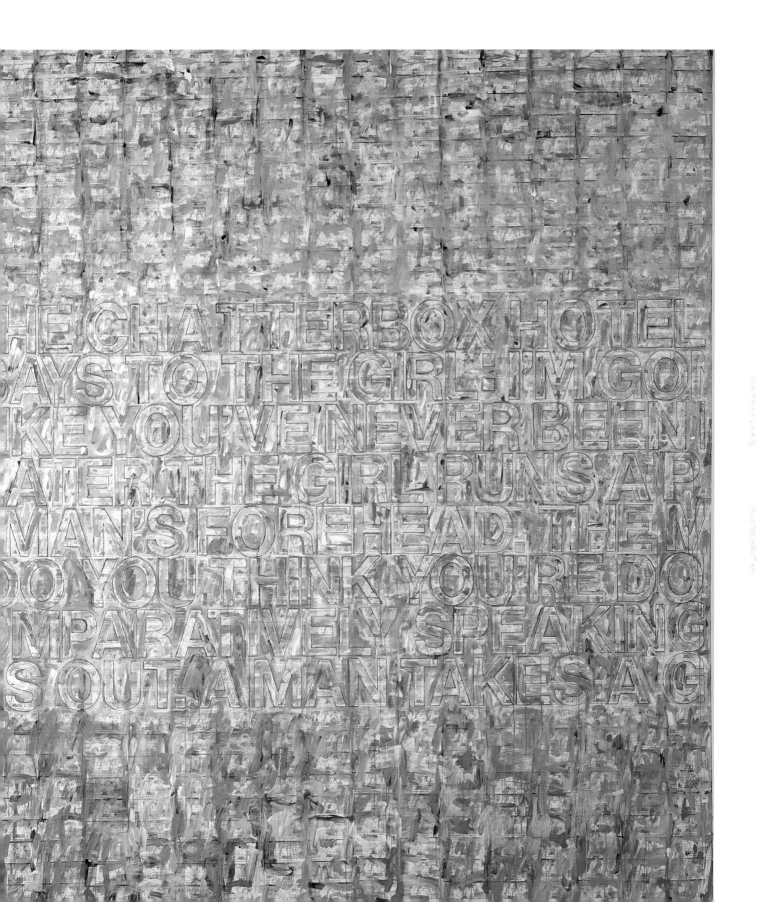

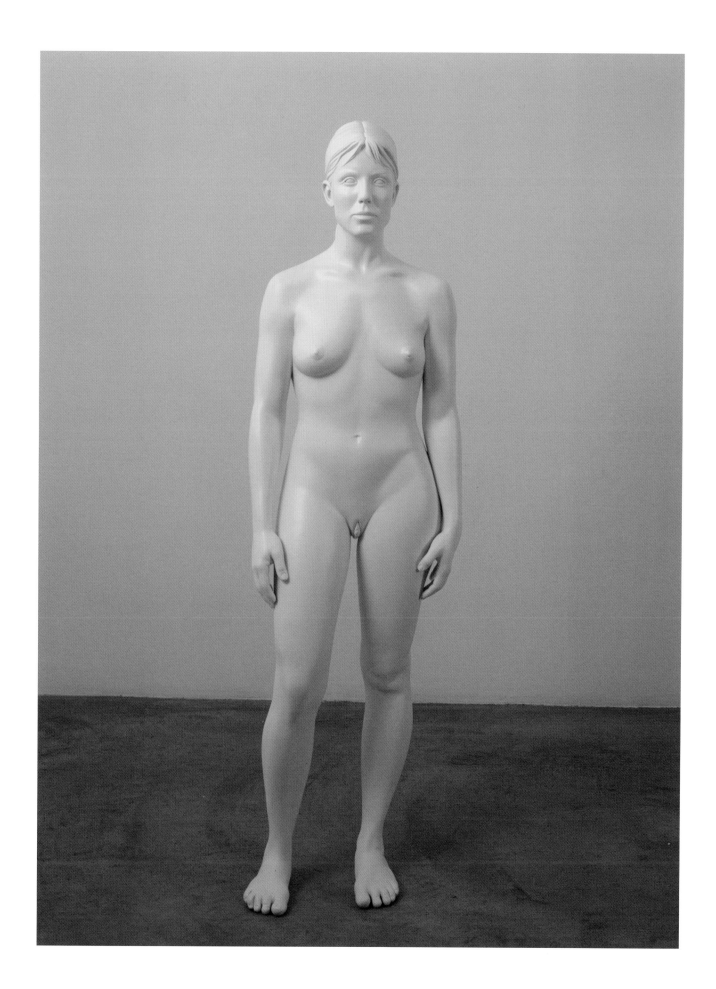

Charles Ray, *Aluminum Girl*, 2003. Aluminum and paint,
62 1/2 x 18 1/2 x 11 1/2 in (158.9 x 47 x 29.2 cm)

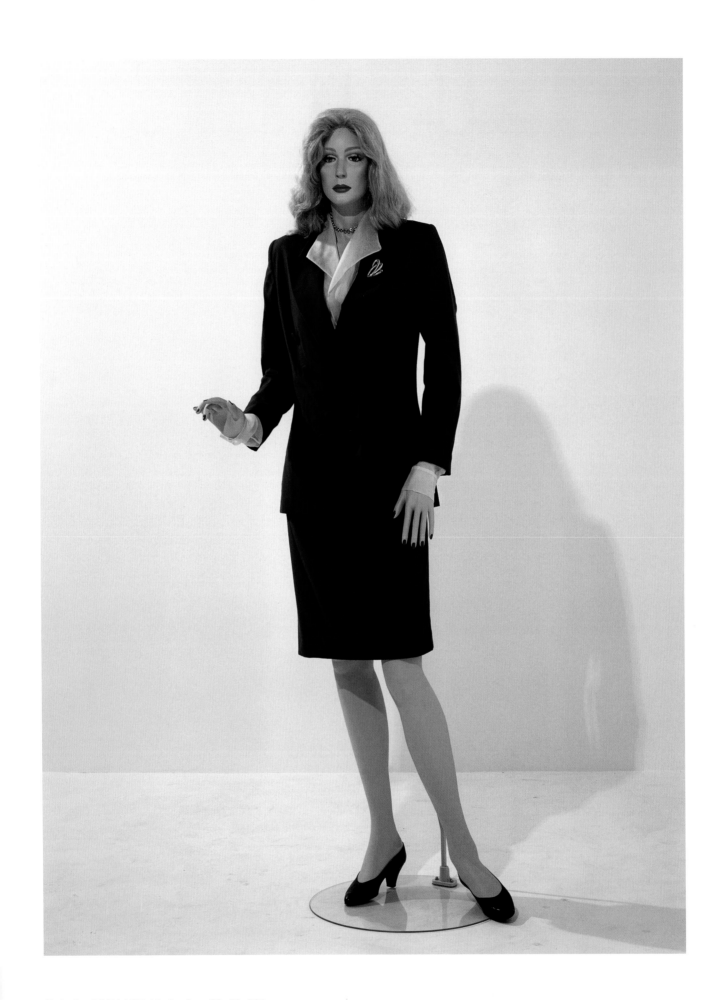

Charles Ray, *Fall '91*, 1992. Mixed mediums, 96 x 26 x 36 in
(244 x 66 x 91 cm)

Charles Ray, *Untitled*, 2006. Ink on paper, 40 1/2 x 22 1/2 in
(103 x 57 cm)

Jim Shaw, *Untitled (Ripped Face Drawing)*, 2003–04. Pencil on paper, 80 x 60 in (203 x 152 cm)

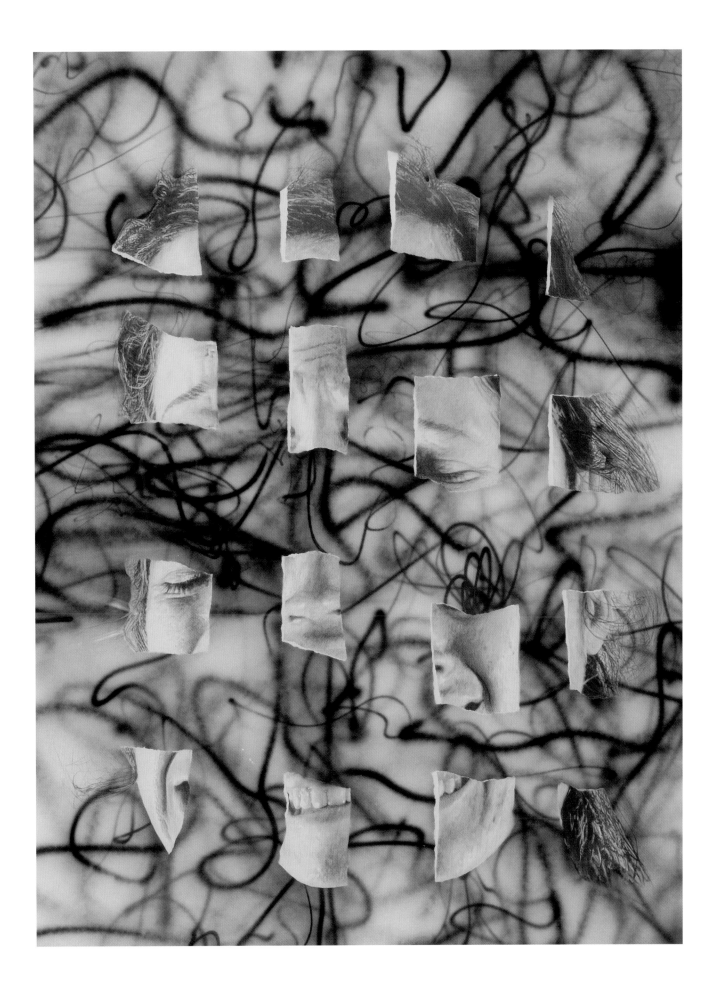

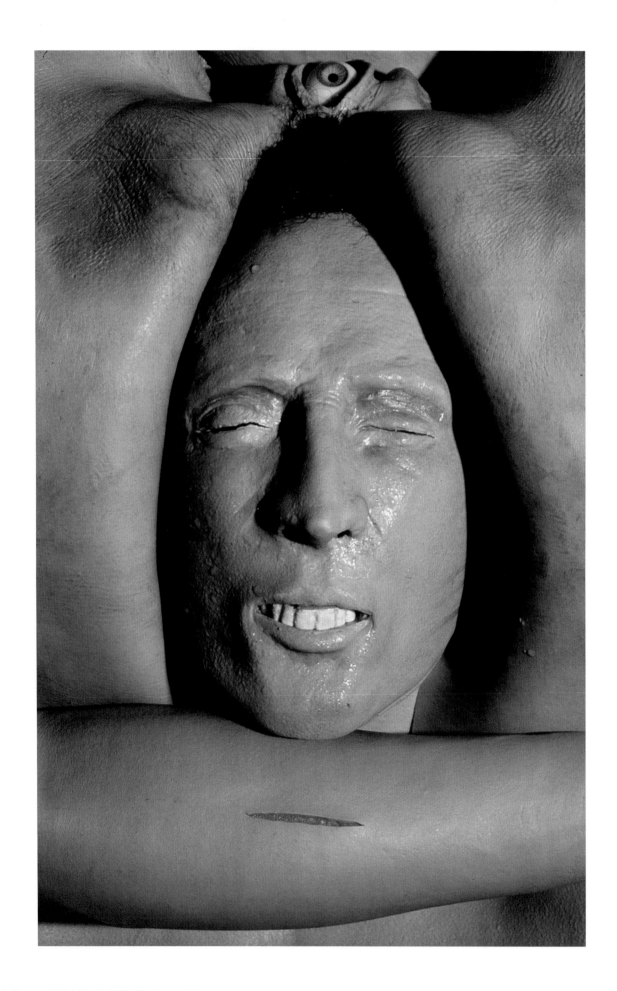

Cindy Sherman, *Untitled (Head)*, 1995. Cibachrome print,
49 1/2 x 72 1/2 in (125 x 184 cm)

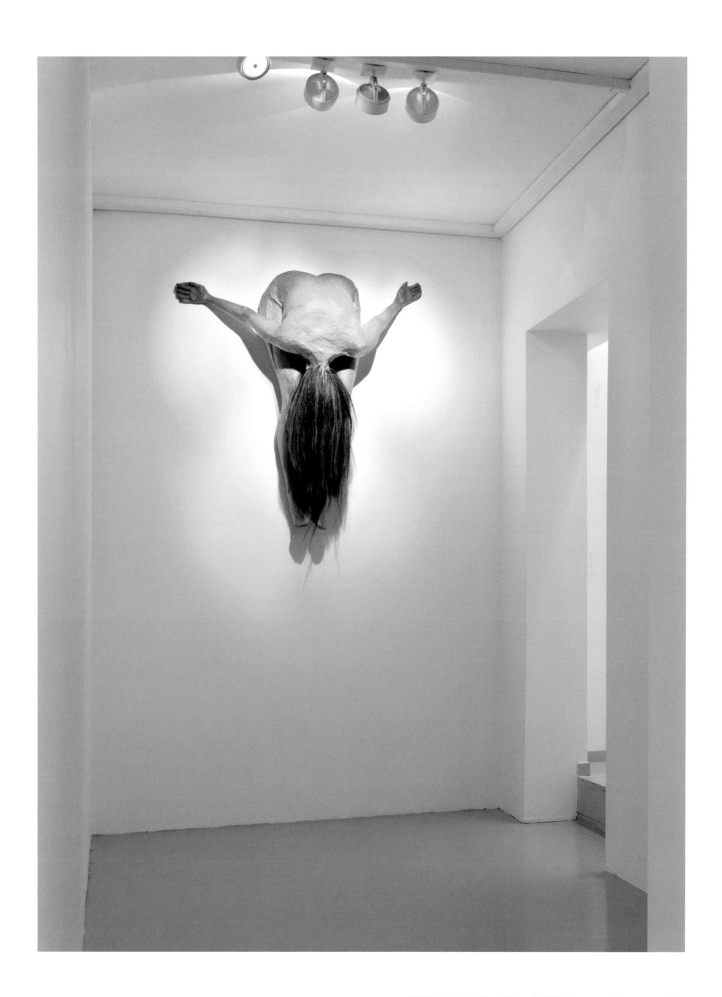

Kiki Smith, *Untitled (Bowed Woman)*, 1995. Brown wrapping paper, methyl cellulose, and horse hair, 53 x 18 x 50 in (134.8 x 45.8 x 127 cm)

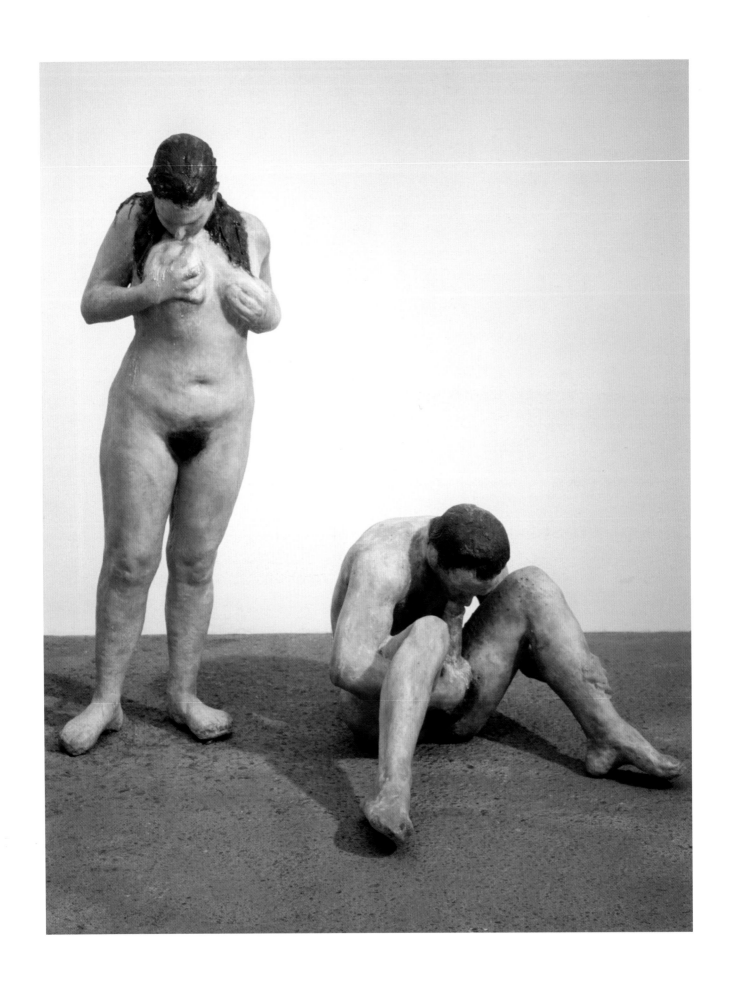

Kiki Smith, *Mother/Child*, 1993. Beeswax with hardener, cheese cloth, dowls, and powder pigments

Kiki Smith, *Intestine*, 1992. Cast bronze, 360 x 8 1/8 x 12 in
(914.4 x 20.9 x 30.5 cm)

Christiana Soulou, *Water* (details), 1982–85. Pencil, watercolor, and wax
crayon on paper, dimensions variable

X. Feetfew

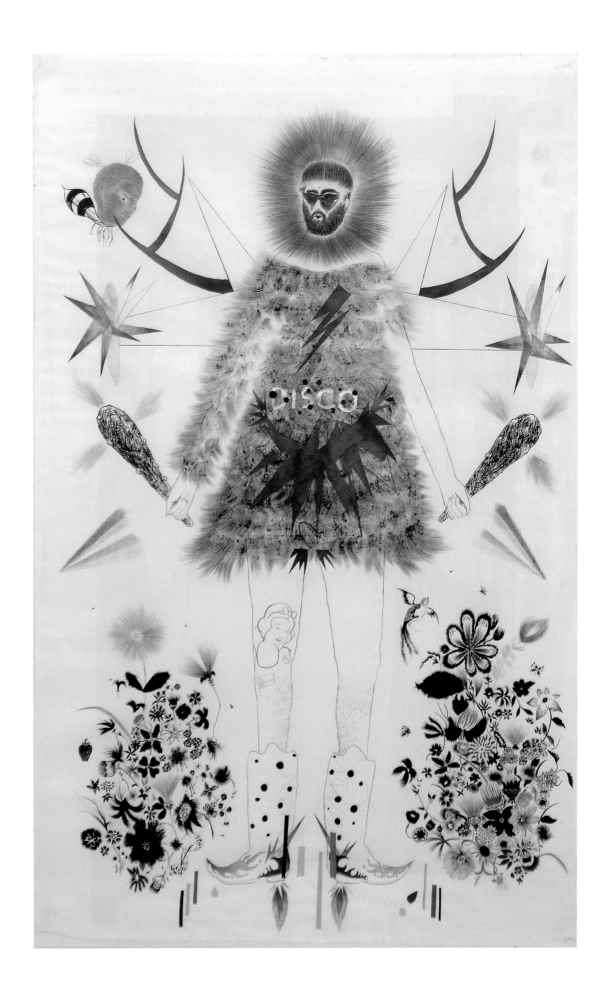

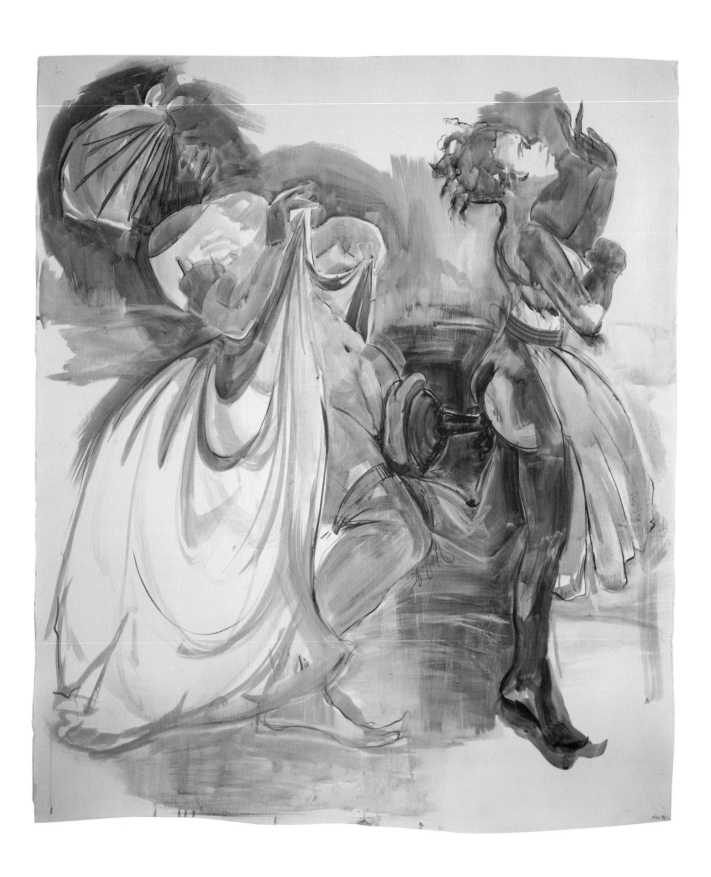

Kara Walker, *Pegged*, 1996. Gouache on paper, unframed, 60 x 51 1/2 in
(152 1/2 x 131 cm); framed, 64 1/2 x 56 1/4 in (143 x 164 cm)

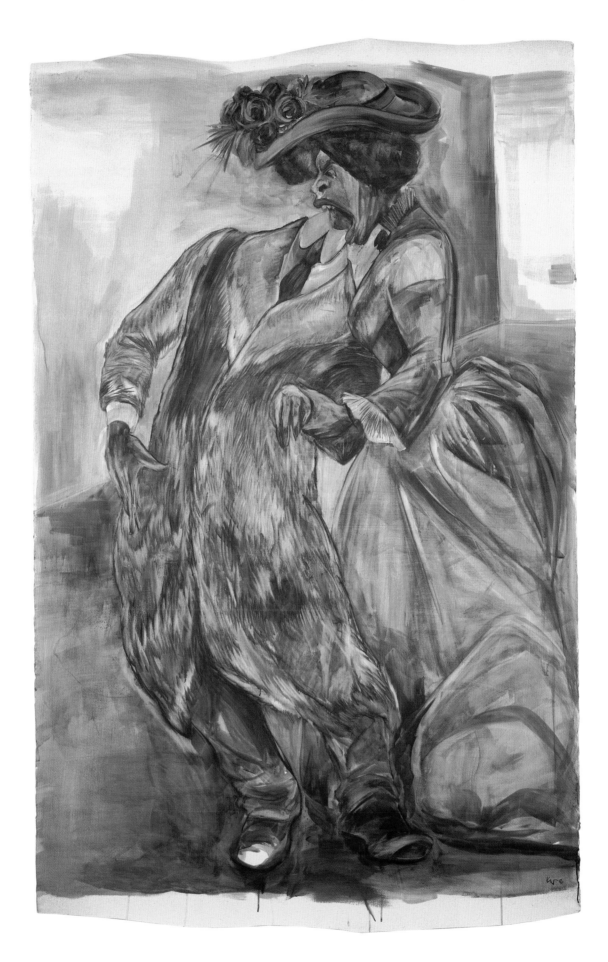

Kara Walker, *Philadelphia*, 1996. Gouache on paper, unframed,
80 1/2 x 51 1/2 in (152 1/2 x 131 cm); framed, 85 x 56 in
(143 x 164 cm)

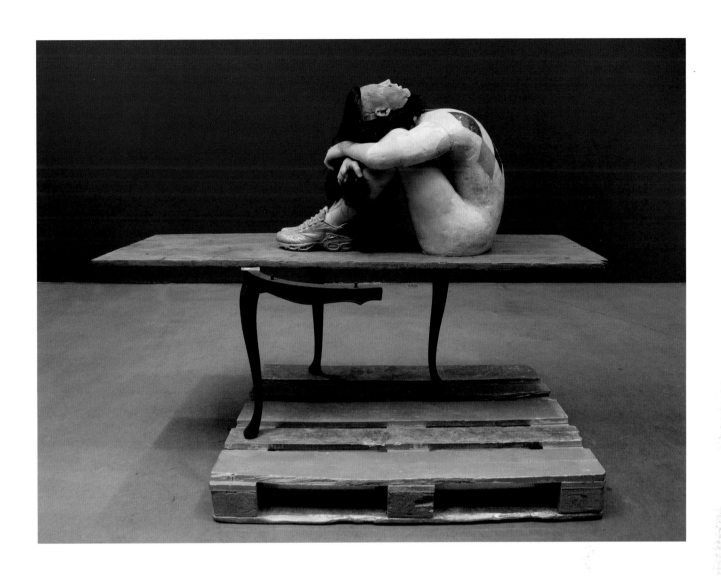

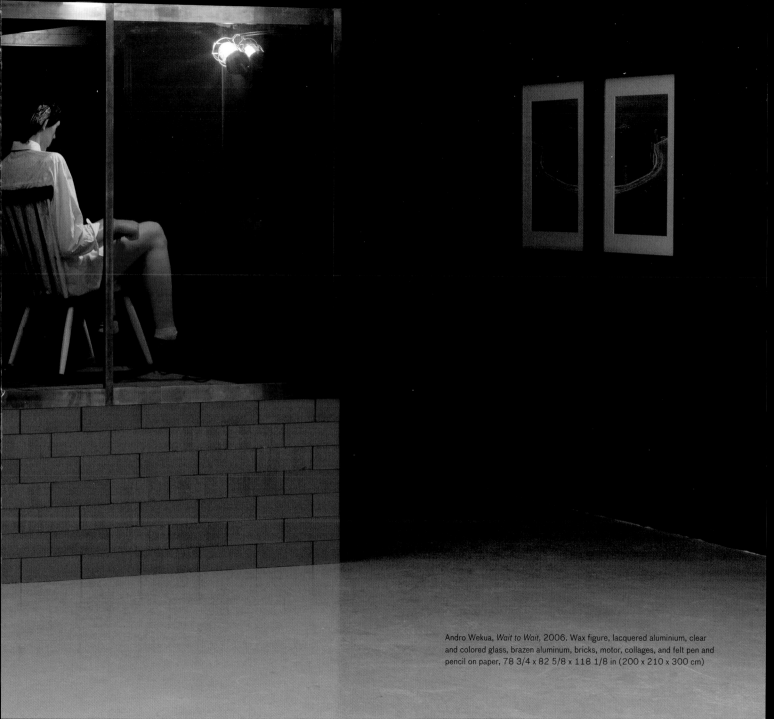

Andro Wekua, *Wait to Wait*, 2006. Wax figure, lacquered aluminium, clear and colored glass, brazen aluminum, bricks, motor, collages, and felt pen and pencil on paper, 78 3/4 x 82 5/8 x 118 1/8 in (200 x 210 x 300 cm)

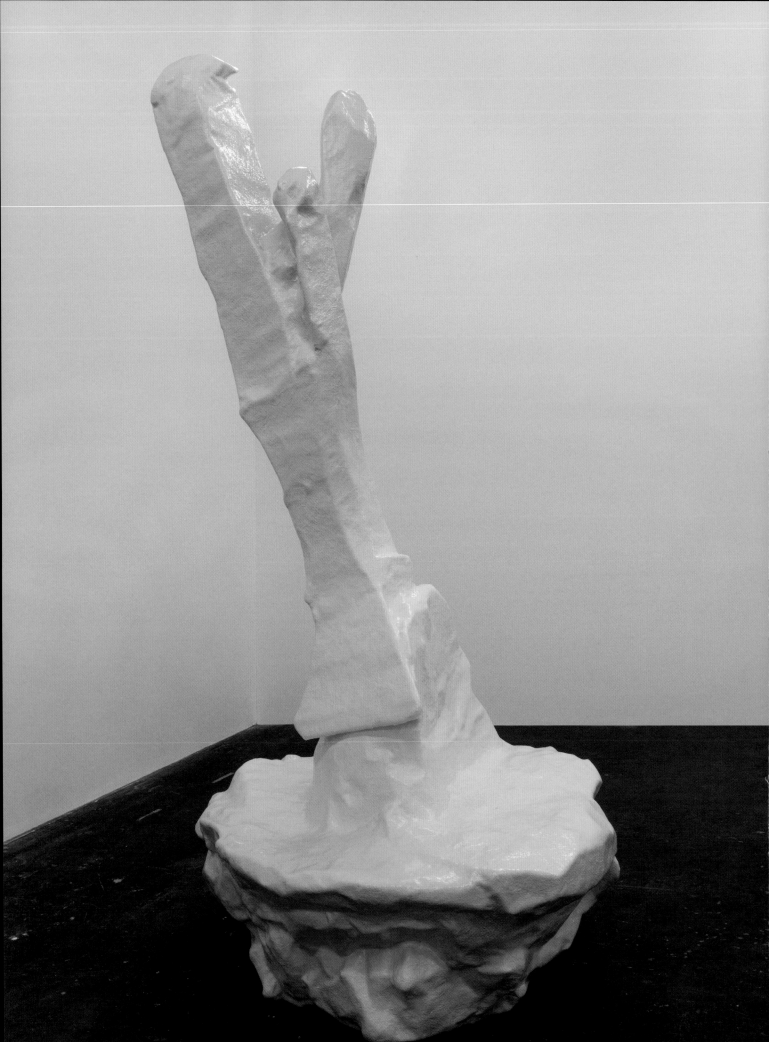

Opposite: Franz West, *Gartenpouf*, 2007. Styrofoam, epoxy resin, and
synthetic resin varnish, 114 1/4 x 63 x 63 in, (290 x 160 x 160 cm)

Christopher Wool, *Untitled*, 2000. Enamel on linen, 108 x 72 in
(274.3 x 182.9 cm)

Anthology

Peter Halley is a New York-based artist whose work was included in the 1988 exhibition "Cultural Geometry," curated by Jeffrey Deitch. The installation was designed by artist Haim Steinbach and was on view in Athens from January 18 through April 17, 1988. By having an artist conceptualize the installation, the exhibition inaugurated a curatorial model that would be replicated frequently at the DESTE Foundation.

Halley's contribution to the accompanying catalogue, a text titled "Notes on Abstraction," explores how the artistic move towards abstraction is reflected in the social sphere. Drawing his examples from organization techniques, capitalism, industry, and genetic engineering, Halley explores how abstraction plays out in contemporary culture, through the flattening of architecture, the careful calculation of statistics and averages, compartmentalization, and logic.

"Notes on Abstraction" was one of the fundamental texts for the definition of the so-called Neo-Geo movement, which brought together artists such as Haim Steinbach, Ashley Bickerton, Jeff Koons, and Halley himself: all artists of whose work Dakis Joannou was one of the earliest international collectors.

Notes on Abstraction

Peter Halley

There were the greats, Euclids, etc., but today everyone must work at trying to interpret the riddle of technology.

—Paul Virilio

The time has come to stop making sense—to replace History with myriad exaggerated theories of post-, para-, quasi-, and super-. History has been defeated by the determinisms of market and numbers, by the processes of reification and abstraction. These form the great juggernaut of modernity that has destroyed History by absorbing it, by turning each of History's independent concepts to serve its own purpose. Another kind of response is then called for. Ideas that themselves change or dissipate as they are absorbed, that are formed with the presupposition that they will be subject to reification. Only a rear-guard action is possible, of guerilla ideas that can disappear back into the jungle of thought and reemerge in other disguises, of fantastic, eccentric ideas that seem innocuous and so are admitted, unnoticed by the media mechanism, of doubtful ideas that are not invested in their own truth and are thus not damaged when they are manipulated, or of nihilistic ideas that are dismissed for being too depressing.

It seems that "the war babies," those born after 1937–38, were "born dead"—to use a motto favored by the Hell's Angels. The philosophism of "reality" ended some time after the bombs were dropped on Hiroshima and Nagasaki and the ovens cooled down.[1]

Marxian thought has always assumed that the breakdown of the pretenses of humanistic culture would yield a reality that was more responsive and coherent than that of humanistic illusionism. Yet behind the mask of humanism there exists not the truths of materialism but the nightmare scenarios of logic and determinism. There emerges a crystalline world responsive only to numerical imperatives, formal manipulation, and financial control.

Consider the 200 or so general reservations agents at Pacific Southwest Airlines in San Diego. The airline warns its agents that they are subject to "computer-assisted productivity measurement and telephone monitoring." Simply put, this means that the agents are electronically supervised from the moment they plug in their headsets to the moment they leave. They are expected to average 109 seconds a call, and eleven seconds between calls, during which time they catch up on paperwork. The computer also tracks break and lunch times. Agents are subject to demerits if they are "unplugged" for more than twelve minutes a shift.[2]

This text first appeared in *Arts Magazine*, summer 1987. It was then reprinted in *Cultural Geometry*, published by the DESTE Foundation, ©1988.

Detail of page from *Cultural Geometry*. Caption reads: "Monastery, Mount Athos"

Capital has always spoken of itself as a culture of flux, premised on ideas of change, evolution, and development. But capital is, in fact, a universe of stasis, governed by immutable self-perpetuating principles that gradually but incessantly push back all other realities in a process of ever-increasing purification. Ironically, the universe of pure capital, characterized by the model, by numerological truth, and by abstract relations, is a kind of realization of idealist philosophy. But the world of essences turns out to be dominated not by Spirit, but by the commodity. The abstract world turns out to be not a utopia, but a site of alienation and banality.

This is perhaps the real meaning of American culture: the image of immigration accross the ocean, of travel over the plane of water. That voyage entailed a process of erasure by which, through passage over an abstract plane, the specificity of Europe could be disengaged, leaving the laws of capital to play themselves out unfettered.

This is not to say, however, that America is the future. On the contrary, Europe is today the true locale of science fiction. The evidence is all there: the cars are faster, products are more rationally designed, the financial markets function with greater suppleness. Even Europe as nostalgic site of authenticity bespeaks its science-fictional character, as if it were the continent that "time had forgotten." World War II brought about another kind of disjunction with the past.

Programs called "worms" are capable of altering a system's fundamental operations or shutting it down entirely. They delete specific portions of a computer's memory, thus creating a hole of missing information. Another type of software demon, called a "virus," instructs the host machine to summon its stored files. Each time the machine does so, the program copies itself onto the software. The computer's memory can soon turn into a mass of confusion.[3]

Use value and exchange value. The idea of change in capitalism is premised on the idea that consciousness within capital can qualitatively change. Such change is embodied in the idea of a change from a society of use value (where men were men and horses were horses) to a society of exchange value, where illusion and manipulation are dominant. But when was this golden age of use value? Is it not possible that use value was an ideological invention of the nineteenth century? After all, the birth of modern capital in the Renaissance was based on trade in luxuries, in silk and in spices. It was based on the invention of bills of exchange. The first mass-produced objects were books.

The factories extend their flanks of fouler brick one after another, bare, with shutterless windows, like economic and colossal prisons. . . . And inside, lit by gas-jets and deafened by the uproar of their own labor, toil thousands of workmen, penned in, regimented, hands active, feet motionless, all day and everyday, mechanically serving their machines.[4]

As early as the Renaissance, certain structural features appear in capital that remain unchanged to the present day, while at the same time undergoing a continuous process of intensification. These devices are premised on the idea of the breakdown of existing limits of time and space, and replacing those limits with more malleable definitions. Paradigmatic of these devices was the invention of the bill of exchange, by which a merchant could buy or sell goods in one city by means of a note promising payment in another city at a later date. At the same time, corporations were first formed whose members were tied together by common business interests rather than by familial relationships. At this point also, transportation networks began to develop, with the emphasis on decreasing the time it took to travel or move goods from one place to another. The constant impetus has been to make time more easily manipulated, while specific spaces have become more interchangeable. The guiding principle has been to replace all other directives with the governing power of the market.

Should an American savage come to the Palais Royal, in half an hour he would be most beautifully attired and would have a richly furnished house, a carriage, many servants, twenty courses on the table, and, if he wished, a blooming Lais who each moment would die of love for him. Here are assembled all the remedies of boredom and all the sweet banes for spiritual and physical health, every method of swindling those with money and tormenting those without it, all means of enjoying and killing time. One could spend an entire life in the Palais Royal, and as in an enchanting dream, dying, say, "I have seen and known all."[5]

If capital is static, how then does one account for the appearance of change within capital? While capital's basic forces remain static and move towards establishing their pure hegemony, the economy of scales does change. As capital's domination becomes more and more complete, so does the level of alienation become intensified. The notion of a classical capitalism existing in the seventeenth century thus also comes under scrutiny. The idea of a classical capitalism would thereby become a completely purified capital of the future rather than a rudimentary capitalism of the past.

The biological model was not the most appropriate one for the history of things. Perhaps a system of metaphors drawn from physical science would have clothed the situation of art more adequately than the prevailing biological metaphors: especially if we are dealing in art with the transmission of some kind of energy; with impulses, generating centers, and relay points; with increments and losses in transit; with resistances and transformers in the circuit. In short, the language of electrodynamics might have served us better than the language of botany; and Michael Faraday might have been a better mentor than Linnaeus for the study of material culture.[6]

The appearance of change in capitalism is premised on two factors. First, increase in numerical scale produces a development in the character of institutions. Thus, a row of seventeenth-century houses in Amsterdam differs from Co-Op City in New York. Renaissance Florence differs from late twentieth-century Tokyo. The speed of the stagecoach differs from that of the Concorde. But structurally, each of these phenomena remains consistent with its predecessor. Secondly, each stage of technological and social development is based on a further step towards abstraction: a further severing of the ties between the goal to be achieved and material nature, a further tying of technology to the abstract reality of rational thought. Thus, to draw again from the example of transportation, one observes a progression from sailing ship, to steamer, to nuclear-powered submarine. In the development of money, one sees the progression from the precious-metal coin (bearing the likeness of the sovereign), to paper money (bearing the symbols of the state), to the plastic credit card (bearing the logo of the corporation).

Ed Debevic's is a zany 1950s diner where the cooks heap on the meatloaf, the waitresses wear saddle shoes and a brightly colored sign reads, "Ed's Chili Dog: The Cadillac of Chili Dogs." A half-mile south stands Shaw's Crab House, a dimly lit seafood emporium reminiscent of the haunts that gangsters frequented in the 1940s. On the north side of town, Un Grand Cafe, with its brass fixtures and festive paintings, recreates the fin de siècle gaiety of a Paris bistro. Although very different, these colorful restaurants have two things in common: they usually have lines out the door, and they are owned by Richard Melman, an irreverent forty-four-year-old restaurant impresario. . . . To get the atmosphere right, Mr. Melman pens a description of each proposed restaurant as if it were a movie treatment. For Ed Debevic's, he wrote that the year was 1952, when teenagers were not yet wild and Elvis was not yet a giant. Ed, a fictional character, was Polish and opened up his diner after serving in Korea.[7]

This idea of progressive abstraction combined with progressive numerical increase might be characterized by the term hyperrealization. Hyperrealization is usually used to describe the jump between industrial culture (the real) and post-industrial culture (which is hyperreal). However, one can draw from that chain of events a sequence that more generally describes the progression of epochs within capital. Each era becomes a hyperrealization of the preceding era, which in turn is assigned the value of reality.

This process of hyperrealization can be vividly seen in a single urban landscape—such as that of New York. The walk-up row house is hyperrealized into the large elevator-serviced apartment building. The corridors, plumbing, and electric systems of the brownstone multiply and proliferate into new configurations reflecting new hyperrealities of population, economics, and technology. In a similar way, the office building is transfigured. Scale is transformed from the four- or five-story commercial building, to early skyscrapers like the Woolworth Building, to the World Trade Center, with its massive height and floor space. Materials change from wood, brick, and stone, to steel and glass, to synthetic plastic panels. The early office towers emphasized high-relief in their façades—allowing natural light and shadow to play dramatically across their surfaces. In the postwar era, the curtain wall became flatter and flatter, and more and more reflective and glossy. The passage of light is de-emphasized, while the interior of the building became visually hidden by its mirrored reflective surface: on a symbolic level, as well, the office tower moves toward self-contained reality.

The use of this idea of hyperrealization is particularly helpful in the analysis of events in twentieth-century art. One may see Cubism as a hyperrealization of Cézanne, or Cézanne, for that matter, as a hyperrealization of Courbet. Similarly, one can understand Abstract Expressionism as a hyperrealization of prewar European modernism, or Frank Stella as a hyperrealization of Abstraction Expressionism. Each transition reflects a movement toward abstraction, in the social sense, from the previous norm. Thus, in each stage, form becomes both more empty and more generic. In certain cases, such as that of Abstract Expressionism, the scale of the work is even made to increase in a way that follows the increase in scale evident in the social landscape.

The modern conception of man as a machine is more eco-nomic than biological in its accent. It refers to the human robot rather than the human animal, and suggests an efficient control of the costly movements of the body, a submission to some external purpose indifferent to the individual. . . .[8]

Hyperrealization also offers a useful alternative to the polar concepts of influence and appropriation. If the idea of influence posits a historical, conscious relation-ship between one generation of artists and the next, and appropriation offers a denial of such ideas as historical hierarchies and the possibility of transformation, hyperre-alization implies that cultural change does occur. However, such changes are beyond the historical will of the artist and are subject instead to the movement of conditions within the social. Hyperrealization would differ, moreover, from the psychoanalytic idea of the "strong misreading," which implies as a source of change an Oedipal struggle between one generation and the next. Hyperrealization suggests that, regardless of the possible existence of such Oedipal conflicts, generational cultural change is caused by extra-individual, deterministic social forces.

Hyperrealization also helps explain the fixation with "The New" that is characteristic of modern culture. It is some-times said that The New is tied to the concept of original-ity. But The New is more profoundly linked (as is perhaps the cult of originality itself) to the process of hyperrealiza-tion. The New represents the hyperrealized state of some-thing that came before. Thus, consumer products are often labelled "New" to lend them the aura of hyperrealization. There are also periodically cultural movements entitled New or New Wave—in music, dance, or literature (there is even a New Humanism). Such labels announce the arrival of a phenomenon that seeks to be seen as a hyperrealiza-tion of the previous cultural norm. The prefix "pop" (as in pop culture) functions in a similar way.

The perfect heroes and heroines of this myth of modernity were the petite bourgeoisie. They appeared in many ways to have no class to speak of, to be excluded from the bourgeoisie and the proletariat and yet to thrive on their lack of belong-ing. They were the shifters of class society, the connoisseurs of its edges and wastelands. Thus, they became for a time the alter egos of the avant-garde—ironically treated, of course, laughed at and condescended to, but depended on for a point of insertion into a modern life.[9]

As the process of hyperrealization leads unceasingly to the closure of the system of capital, all the old organic categories begin to lose their meaning. The traditional dualities of life-and-death and male-and-female collapse into identities. There are today no longer any men or women, despite the seeming revival of those categories in the current decade. In fact, a figure like Sylvester Stallone is emphatically not male but only a generic sign for the idea of male, while Madonna is only a sequence of nostalgic representations of female. Likewise, the poles of life and death collapse into a state of non-life and non-death. No one either lives or dies. The possibility of life is negated by the imposition of me-chanical time and by regimentation, both physical and temporal. Meanwhile, death is replaced by disappearance and is negated by the manipulation of time within the recording media.

In the visual arts, the era of the early 1970s believed itself to be a great flowering of post-capitalist culture. It believed that the commodity and its mind-set would be replaced by performance and by site-specific works. The artist would perform in real time, enacting an example of non-alienated work. The artist would play out the role of the free subject, creating a model that would be emulated elsewhere in society. But the '70s represented actually not the flowering of a new consciousness, but rather the last incandescent expression of the old idealism of autonomy. After this, no time would be real, no labor would be living, no cultural expression would be outside the commodity system.

The artists of the '70s abandoned living in the traditional urban neighborhoods and began to inhabit underutilized manufacturing buildings in places like SoHo in New York. In so doing, they were rejecting all the problems of the established capitalistic urban order and were starting for themselves a new culture in these buildings where people had never before lived. Here, there would no longer be bourgeois apartments, but only open "spaces." Harmful commercial American food would be replaced by life-giving macrobiotic cooking. But this kind of "renovation," by which the commercial function of the old loft buildings was ignored and formally changed, was, in fact, a crucial factor in the modern city's transformation into its empty double. Suburbia, which had previously come to surround the old "modern" city from without, now began to take seed, like a virus from within, as these areas were turned into "bedroom communities."

[Howard Hughes] was the first one to close the empty circle, in the '30s, with his Lockheed Cyclone—note that it wasn't a Mystere or a Phantome, it was a Cyclone…. He came back to the same spot, New York. Howard Hughes was the Lindbergh of the end of the world, a hero of postmodernism. After he invested enormously in aviation, he set up movie studios. He had a hand in everything that appeared at that time having to do with speed, the airplane, and the cinema. He tried to enjoy his omnipresence in the world. First, he lived by having several apartments all over the world, each decorated the same way. Every day he was served the same meal, brought the same paper at the same times…. Then the situation became unbearable and he ended up a technological monk in the desert of Las Vegas, without getting out of bed. He spent the last fifteen years of his life shut up in a hotel tower, watching films, always the same ones, especially an old American film on the life of men shut up in Ice Station Zebra in the North Pole. He saw it 164 times.[10]

The consumer-credit corporation had acquired an investment banking and brokerage house. The needs of the brokerage house required that an extensive new computer facility be built. The corporation had originally planned to build the facility in the suburbs, where costs were lower, but a location was selected in the city after the city government had offered the corporation a site for free. The building was called the Financial Services Center. It was located next to a highway, for automotive access. Twin escalators ran up to a second-floor elevator landing. At night, car-service taxis would line up to take home late-working employees. But the computer center was also situated in an area of warehouse buildings that had been converted for residential use. Thus, "amenities" were required for the "community." Next to the building, which was a modern design, sheathed in prefabricated, textured concrete panels, in front of the parking area, a small park was built with lawns, nineteenth-century lampposts, and a wooden latticework pavilion supported by white Neo-Classical columns. Around the perimeter of the park were several tall metal poles, functional in design, without any historical decoration, on top of which were located video surveillance cameras, in beige enamel bulletproof casings.

There is a certain collapsing of the poles of capital and labor. The CEO, nominally the corporate leader, is captive to the status of the corporation's profits and stock price. The company's stock may, in turn, be held by a variety of institutions including, perhaps, union pension funds, which are presumably representatives of labor. Likewise, for labor, as it is cast in the role of the consumer, there is a move toward the leveling of hierarchies. Andy Warhol said, "You can watch TV and see Coca-Cola, and you can know that the President drinks Coke, Liz Taylor drinks Coke, and just think, you can drink Coke, too."

There is also a certain breakdown in the hierarchies of work. The impetus to power is replaced by an impetus to glamour. As Warhol also explained in 1975 (before airline deregulation): "Airline stewardesses have the best public image…. Their work is actually what the waitresses in Bickford's do, plus a few additional duties…. The difference is that airline stewardessing is a New World job that never had to contend with any class stigmas left over from the Old World peasant aristocracy syndrome." Most importantly, however, the heads of the system—the "captains of industry," the producers of popular entertainment, and the political leaders—no longer operate in a free field either. They too are prisoners of demographics, computer models, and market forces.

Life has been replaced by what Debord calls the "non-living." This is the space of dead labor where life no longer follows its own course and becomes alienated from itself. The role of living is transferred onto the figure of the celebrity who plays out the idea of autonomy with its free field of action. Life becomes solely a media image. Archeologists believe that in Aztec society, specially chosen youthful members of the nobility were given a year of pampered life and then sacrificed for the satisfaction of the gods. But the practices of contemporary culture are no less savage. When a person becomes a media celebrity, his or her life is no less literally taken away. The celebrity's organic time is put to use to create the generic image the media requires. The star "renounces all autonomous qualities in order to identify himself [or herself] with the general law of obedience to the course of things."

The very idea of organic time is superseded and replaced by a mechanized, segmented, digital time (that corresponds to the space of this system). The standard of chronological measurement has become the fate of vibration of the quartz crystal. Living time is transferred onto the sequential, segmented, linear mediums of visual and audio recording. First, film replaces organic time with its strings of mechanically timed sequential images. The videotape replaces film, further entrapping life into magnetically encoded lines of information. In audio, as well, sound is first transferred onto the phonograph record where it is mechanically reproduced by means of the linear track of the stylus, then onto magnetic tape, and finally onto the audio disk, where a light beam reads digitally encoded information. As the system is purified, it gains a para-spiritual quality: living sound becomes an alchemical amalgam of light-beams and numbers.

The same system that mediates life mediates death. The inscription of time onto these linear tracks allows it to be halted, repeated, or altered at will. With film and television technology, a scene from London in the 1930s, for example, can be replayed at any time and any place. The "action" never dies, but it loses its specificity as to time and place. Warhol, in particular, understood this process. This is what led him to undertake the constant activity of photographing, taping, and filming. In so doing, he took it upon himself to reenact the functioning of the media, its transformation of the organic moment into the media moment. It is nevertheless true that, for the time being, there is still some awareness of the organic death of the physical body. But this has become an event without meaning, an embarrassment. When possible, it is hoped that the bodies will just disappear, so as not to interfere with the reality of media time.

Life and death also lose their meaning as metaphors that describe culture. To speak of the death of modernism is to speak of an organic end in a culture in which the construct of the organic has become both dispersed and crystallized, in which endings are transformed into sequential continuities. Death is replaced by the process of hyper-realization. Classical art does not die. It is hyperrealized into modernism. Modernism, in each of its stages, is, in turn, hyperrealized into something else.

On the Sony, a two-dimensional space war faded behind a forest of mathematically generated forms, demonstrating the spatial possibilities of logarithmic spirals; cold-blue military footage burned through, lab animals wired into test systems, helmets feeding into fire control circuits of tanks, and war planes. Cyberspace . . . a graphic representation of data abstracted from the banks of every computer in the human system. Unthinkable complexity. Lines of light ranged in the non-space of the mind, clusters and constellations of data.[11]

There are religious overtones to these occurrences. The numerical systems become in and of themselves the bearers of meaning in the culture. In this sense, there are three great religious centers in the United States: Los Angeles, which is the new eternal city, the new Rome of the media; and Las Vegas and Atlantic City, which are pilgrimage towns where the populace goes in quest of numerical truth. Los Angeles is the Rome of media representations. In Beverly Hills, the houses of the stars are laid out with all the frozen splendor of the palaces of cardinals in Baroque Rome. Throngs go to Universal Studios and Disneyland to pay homage to these shrines of media reality. Las Vegas

and Atlantic City are the great sites of the vision quest. With the timeless and placeless casinos, the populace tests itself against the pure numerical games. Here the metaphysical lessons are learned, portends reveal themselves, fates are sealed.

Get back in touch with yourself by getting into a Kohler Masterbath. Now your private world consists of six climate sensations (sauna, whirlpool, sun, steam, wind, and rain), each to be conjured or banished at will. Program your climate in advance or change it from moment to moment.[12]

Along with life and death and men and women, sexuality also ceases to be a factor. The '60s and '70s were not so much a period of sexual revolution as a last florescent display of the idea of sexuality before its collapse into the ecstasy of numbers. Foucault claimed the ancien régime was a society of blood where martial courage, the willingness to die in war, was the ruling passion. He claimed that bourgeois culture invented sexuality, with its emphasis on procreation, familial cohesion, and sensual pleasure. If the sexual era has a historically determined beginning, it may also have an historically determined end. Today, the passions of the flesh are replaced by more abstract obsessions. There is the eroticism of speed, of the automobile and the airplane; there is the eroticism of numbers, of the financial markets and the personal computer; and there is the eroticism of the media, of the Walkman and of color television.

What seemed to be an environmental expedient turned out to be the key to creating a new kind of internal world—a theater that walled out all distractions and focused all attention on what the industry calls the "retail drama." Because it is cut off from the Earth's daily and seasonal rhythms, and because management demands that everything always looks new, the enclosed mall is timeless: because it is isolated from its surroundings everywhere, the mall is placeless. It is a malleable space in never-never land, linking the idea of shopping with the idea of entertainment.[13]

Throughout this century, artists have described the transformation of the organic body into the machine. Cubism, Futurism, and Duchamp (in *The Large Glass*) were all concerned with this transformation. Robert Smithson's early work is obsessed with the same notion of flesh becoming armor, with organic appendages becoming riveted tubes. Warhol, of course, said that he wanted to be a machine. The conceptual artists took this one step further, making art that approximated machine processes. Hanne

Darboven became a computer lost in its own calculations. Roman Opalka became a kind of human digital clock. Sol LeWitt anticipated computer-program trading on Wall Street with program sculpture.

All this reflects the literal loss of the human body in this century. The human figure becomes the statistical figure. The production line substitutes mechanical motion for organic motion. In medicine, medical engineering replaces human organs with electro-mechanical ones. Pills, whose appearance always retains a purist geometric and coloristic symbolism, are ingested to change metabolic function or mood. Genetic engineering, or course, completes this process. Not only is the basis of life explained as numerologically encoded data, but life is then subject to techno-mechanical manipulation whereby the laws of production finally replace reproduction. Each human life becomes a statistic, demographically useful in determining government policy, marketing strategies, and insurance rates. Previously, it was only the worker whose body was subject to compromise by the machine. Today, the whole social body willingly subjects itself to the same regimentation. There are the disciplining stainless-steel machines of the health club, the confined geometric spaces of the automobile, and the functionalism of the International Style.

Sol Yurick, in his book *Metatron*, has written of this system from a point of view that might be called a reverse structuralism. According to Yurick, it is not ancient, natural archetypes that are influencing the present system. Rather, pure capital itself is a perfect formal archetype that one can see crudely played out in traditional power structures. Thus, the present represents a disclosure of the play of pure financial and electronic systems, no longer encumbered by traditional mythology and symbolism.

Despite the contribution of Baudrillard, it is important to note that the significance of simulation is as a summary of the researches of the '60s and not as an original discovery in and of itself. Within the realm of criticism, simulation is a synthesis of the Debordian spectacle and the semiotic researches of Roland Barthes. But the precedents in the arts in the '60s are no less clear: The Beatles, after all, sang, "Strawberry Fields, nothing is real, nothing to get hung up about." Warhol said: "Nothing was ever a problem again, because a problem just meant a good tape, and when a problem transforms itself into a good tape it's not a problem anymore." The key contribution of Baudrillard is his detailed description of the functioning of a semiotic system without a referent.

The combination of darkness and enclosure of the gambling room and its subspaces makes for privacy, protection, concentration, and control. The intricate maze under the low ceiling never connects with outside light or outside space. This disorients the occupant in space and time. One loses track of where one is and when it is. Time is limitless, because the light of noon and midnight are exactly the same. Space is limitless, because the artificial light obscures rather than defines its boundaries.[14]

Progressively, all of the social is being transferred onto the electromagnetic digital grids of the computer. From long-distance telephone service, to air-traffic control, to banking, the flow of all communications, movement, and resources is channeled through the digital circuits. The computer chip becomes a universal gateway through which everything must pass. With computer graphics and synthesized voices and music, computers even gain a hand in rebuilding specific reality according to their own digital rules.

It is not generally acknowledged to what extent each individual is tied to these grids of computer communication. But the telephone line is an endpoint in a huge electronic network that enmeshes the entire globe. More importantly, credit cards, which are replacing the relative autonomy of currency, tie huge segments of the population into a kind of slavery of computer debt. One is lured into the system with the promise of a "credit line," the ability of the "user" to spend the computer money any time and any place. But, if the payments are not made, a kind of passive wrath comes down on the user, who is banished from the system and the grids. That is to be left as helpless as an excommunicated Christian in the Middle Ages.

Thus the social is finally becoming the site of "pure abstraction." Each human being is no longer just a number, but is a collection of numbers, each of which ties him or her to a different matrix of information. There is the telephone number, the social security number, and the credit card number. The financial markets, those huge arenas of abstract warfare, have completely detached themselves from any relationship with the material world. Currencies float. National boundaries crumble. The markets come to be governed by technical factors, by computer-controlled trading. The hero of the marketplace is no longer the engineer, who is still engaged in practical technology, but rather the financial wizard, the "number cruncher," the manipulator of purely abstract forces.

On an experiential level as well, the social moves onto the grids of circulation, each one embedded in the next. Each day, the "suburbanite" moves from subdivision to car to office building. The traveler moves from the grid of the urban streets to the transcontinental network of superhighways to the global network of air travel and back again. Sensual pleasure is replaced by abstract pleasure. Food is replaced by ambience. Space is replaced by amenities.

The history of abstract art is a reflection of the history of this transformation. With Cézanne, the materiality of the object comes to a poignant end. In Cubism, the burgeoning commodity culture of the new twentieth century and its inhabitants is transformed into a gray world of abstract planes and vectors. With Mondrian, a decade later, any reference to specificity is gone and the world is described as a utopian grid of abstract flows and forces. If Mondrian emphasized the systematization in this situation, Abstract Expressionism reflects the alienation to which this system gives rise. Systemized space is revealed as emptied of meaning. This is the reality with which the empty spaces of Rothko are filled. Thus the history of abstract art is the history of a real progression in the social. It is the history of the organization of the compartmentalized spaces and the formal systems that make up the abstract world.

Notes
1. Robert Smithson, "A Museum of Language in the Vicinity of Art," *Art International*, March 1968.
2. Harley Shaiken, "When the Computer Runs the Office," *New York Times*, March 22, 1987.
3. Jamie Murphy, "A Threat from Malicious Software," *Time*, November 4, 1985.
4. Hippolyte Taine, *Notes on England*, 1859.
5. Nikolai Mikhailovich Karamzin, *Letters*, 1790.
6. George Kubler, *The Shape of Time*, 1962.
7. Steven Greenhouse, "Eateries Aim to Entertain," *New York Times*, August 21, 1986.
8. Meyer Schapiro, "The Nature of Abstract Art," *The Marxist Quarterly*, 1937.
9. T. J. Clark, *The Painting of Modern Life: Paris in the Art of Manet and His Followers* (Princeton: Princeton University Press, 1985).
10. Paul Virilio with Sylvère Lotringer, *Pure War* (New York: Semiotext(e), 1983).
11. William Gibson, *Neuromancer* (New York: Ace Books, 1984).
12. Kohler magazine advertisement, 1987.
13. William Severini Kowinski, "Main Street in a Spaceship: The Covered Mall," *Smithsonian*, December 1986.
14. Robert Venturi, Denise Scott Brown, and Steven Izenour, *Learning from Las Vegas* (Cambridge, MA: MIT Press, 1972).

"Fusion Cuisine," organized by the DESTE Foundation and curated by Katerina Gregos, featured twenty-one women artists from Europe, Asia, Africa, and the Americas. On view in Athens from June 20 to October 30, 2002, "Fusion Cuisine" explored the diverse work produced by women today, questioning what it means to make art in a post-feminist era. Acknowledging the impossibility of a universal female point of view, "Fusion Cuisine" took up the plethora of perspectives and the heterogeneity of artwork made by women today.

In her essay "Now, Then, Now" for the accompanying catalgoue, Tillman writes about women's place in the art world, looking back to Surrealist Meret Oppenheim's opinions on group shows of women artists. Accounting for what has changed for women artists since Oppenheim's time, Tillman considers her own stance on the subject and in regards to the exhibition. This lyrical text provides a personal account of art history and the quickly changing place of women in the arts, where being in a group show of women no longer represents a stylistic connection but, if anything, a lack thereof.

Lynne Tillman is a Professor of English at the University at Albany. She has written five works of fiction: *Haunted Houses*; *Motion Sickness*; *Cast in Doubt*; *No Lease on Life*; *American Genius, A Comedy*; as well as the nonfiction *The Velvet Years: Warhol's Factory 1965–1967*.

Now, Then, Now
Lynne Tillman

This text first appeared in *Fusion Cuisine*, published by the DESTE Foundation, ©2002.

In the end, the particular accomplishments of each woman and her personality, which cannot be reduced to the common denominator of a group or sexual entity, have become not only possible but also proclaimed with great pride. It is because I am myself, and specifically myself, that I am able to introduce the contributions of women to a large segment of the world.

—Julia Kristeva[1]

I write in the present, but history and memory hold my hand. Now I want to take the reader's hand, to return to the recent past. But first imagine this: A photograph of surrealist artist Meret Oppenheim is tacked on my wall. I took it in 1978, when MO (she signed her work with her initials) was in New York City for an exhibition at the Eugenia Cucalon Gallery on 57th Street. MO's arms are crossed over her chest, she's wearing a white cotton Indian shirt, she's standing near a window, light is flooding in, or the film's overexposed. MO seems about to say something—I wish I knew what it was. History, memory, can't supply it. There is her deathless image. And, more, her work.

I met Meret Oppenheim in 1973, when I wrote about her for *Art and Artists* magazine, in an issue devoted to women artists.[2] It was the first major art magazine to feature women artists; it was my first adventure in journalism. MO refused to show her work in all-women exhibitions, and she made an exception to be interviewed for the issue. I'm not sure why. I hadn't heard of Meret Oppenheim until I was asked to write about her. The women's movement and feminism had found her, living and working in Switzerland, and re-presented and reclaimed her art for younger generations. Some recognized her for *Fur Teacup and Saucer*, which she made in 1936 in Paris, when she was twenty-two. Her work was exhibited in the 1950s and 1960s, but suddenly her name was mentioned more; suddenly her paintings and sculptures were given more attention.

MO was an audacious, brilliant artist, playful and inventive in different mediums; she was impassioned, independent, great-looking (Man Ray, for one, photographed her), well-read, vivacious, philosophical. MO's exacting resistances and principles, her exceptions, were exciting—and inspiring—to me. Before we met, all my questions had to be submitted to her in writing. She wrote answers but also amplified her thoughts as we sat in the kitchen of her studio in Paris. "Don't cry, work," she advised me, a very young, unpublished fiction writer who asked many questions. Her warning became the title of my story about her. Later, we corresponded, and she sent me small drawings with encouraging words on them. After she died in 1985, I framed the drawings, and they hang on my kitchen wall now.

In 1984, MO refused to allow even her images to be reproduced in a scholarly book on women Surrealists. I asked her why. MO didn't want, she wrote me, "this separation...it's really [as if] to make a show of coloured people in Western countries." To the book's publisher, she wrote:

"Male-centeredness" [is] "a situation that began probably before historical times which cannot be changed in some ten years, perhaps not in 100 years. Because it is such an important change, it has to be wanted by the whole mankind.... Once, before the war, I saw Duchamp at a dinner with friends. I asked him: 'Do you think that women can

1. Julia Kristeva, *Hannah Arendt* (New York: Columbia University Press, 2001), xiv.

2. *Art and Artists*, October 1973.

do the same as men?' 'Certainly,' he answered. But we all know less strong personalities even today have not this opinion.... All these representations of 'femme enfant,' 'femme fatale,' 'sphinx,' 'great mother,' 'nature,' 'muse,' are male projections onto women who have in reality nothing to do with these reveries. Of course, women also produce these kinds of projections: 'the mighty father,' 'superman,' 'the genius,' 'the hero,' 'the guru/leader,' etc. Personally, I consider the problem of female versus male as solved, although I know that many have not arrived at this point."

Now, looking at her image on the wall, I'm returning to MO's energy and ideas, her exceptions and questions, and wondering what are irrelevant and relevant differences and separations, between, for example, then and now. I'm also thinking about art by women whose work came of age in the '90s, whose work MO would never have seen, and who will be in an all-women exhibition in Athens, a first in Greece. "Is the problem solved?" as Meret declared. Or, maybe, I should ask, paraphrasing Gertrude Stein's deathbed words, Now, what is the question?

Things change, things stay the same, and context rules. Time's current product, the contemporary, is inflected by the new—technologies, mediums, geopolitical and scientific changes—and by history. The contemporary takes its own place, with its own layers and possibilities, but the layers aren't chosen, since time builds on itself. Art incorporates art, meaning is archaeological.

Now, in our time, an all-women exhibition isn't shocking, but it may be surprising for reasons different from those thirty-forty years ago, when MO would have objected. It may be surprising, because it doesn't seek to redress wrongs against women artists. Years ago, there were supposedly no great women artists or few important ones; women's art was rarely compared with men's. Big exhibitions would regularly exclude women or include just one. In art magazines, women received scant, often patronizing attention; serious critical consideration was reserved for major artists, who were usually men. There were exceptions, of course, and we can name them if we want. Then, an all-women show would call attention to a lack.

Now, it seems to me, this exhibition ["Fusion Cuisine"] signals a plethora of work by women who show and live around the world. And it commemorates and recognizes diversity and variety. Artists who are women don't make "art by women" in any simple sense of that term, and they never have. They make art informed by its time, its medias, by history, by other art, by the makers' psychologies, their cultures, by their differences from others, including other women, by their many identities, and by their being women, too, whatever that means to them in their lives and practices.

Now, to curate artists under a flag of sex, sexual preference, nation, or race doesn't corral easy ideas about like-mindedness or routine notions of sameness. Theorists and artists of the last thirty or so years have emphasized and insisted upon difference within difference. This demand has operated like a heuristic machine that destroys single-track thinking. In the 1970s, when MO refused separation, the mainstream women's movement emphasized "sisterhood." The term invoked a monolithic, universal sense of women, their unity and identity. I didn't like the term then, but now I'm mindful of what Primo Levi wrote in *The Wounded and The Saved*: "We cannot change our behaviour or that of others, driven at that time by the code of that time, on the basis of today's code."[3] Everything that occurs has its necessity—and its supporters and detractors—and depends upon what happened and what didn't, and all of this erupts into and merges with the present.

Now, Meret might still object to an all-women's exhibition, but I'd argue with her, if she were sitting across the desk from me (I wish she were), that it's different from then, it's not the only game in town, it's one of them. And, I'd tell her, when, in spring 2001, Thelma Golden at the Studio Museum in Harlem curated an exhibition of younger black artists, men and women, called "Freestyle," your analogy—"it's really [as if] to make a show of coloured people in Western countries"—didn't apply, because it didn't confirm prejudice, though it was, literally, a grouping that worried you. The range of styles and approaches contradicted singular ideas about race. Separation provided focus, nuance, or a lens—richly colored—through which to see work that was overwhelmingly of its time, inseparable from contemporary art forms. Race wasn't the only focus possible, but a category, idea, or tendency to consider and plunder. In the context, it was shredded as a claim to sameness.

People need acknowledgement for similarities, differences, and their individuality. Then, when I was ten, it never occurred to me that girls weren't intelligent and capable of doing whatever they wanted. I decided to become a writer at eight and was writing my first novel, when I read some essays by novelist Norman Mailer. He sarcastically dismissed "lady novelists." They were ludicrous to him, these women who wrote. Suddenly I realized there was trouble ahead for a girl, a writer. And, what was a lady, anyway? I suppose I became a feminist then. Stupid ideas, like Mailer's, might stop me, for one thing, from being taken seriously, just because I was born into a body about which I had no choice.

Now, freedom isn't an ambiguous concept, when you don't have it. Again, things change, and don't, but differently, all over the world; there's no uniformity or absoluteness to it. Some limits are invisible. MO declared, in a speech in Basel, in 1975: "I would even say that you have an obligation, as a woman, to prove through your

3. Primo Levi, *The Wounded and The Saved* (New York: Vintage International, 1989), 81.

way of life that you no longer consider valid the taboos that have kept women oppressed for thousands of years. Nobody gives you freedom, you have to take it."

Freedom, rights, desire is polyglot—spoken and written in different languages, on different tongues. Those of us who take our freedom and have legal freedoms need to understand our courage or lack of it, our inhibitions, our possibilities, and we must sometimes still steal whatever we need, to do what we want. This desire and energy— to do what we want—is where, often, work comes from. The intellect throbs with emotion, psychology fuses with or acts against society, body and mind discover antique resistances. With pleasure and pain, mental health and pathology, artists rock and roll, stop, reconsider, lie still, and wrestle with things bigger than themselves. We are often overwhelmed. And it is with and against what we know and don't know that we make our work.

The art in this exhibition covers a wide range of practices and uses everything—video, installation, performance, painting, sculpture, all the various media, different languages and techniques, new technologies, and concerns itself with architecture and space, the body and bodies in space, identity and identities, gender and sexuality, institutions and institutional analysis, cultural dissonances, violence, social realities, the written word and structures of meaning, information theories, the performative, the photograph as document, portrait, fragment, or digitized set-up. The art may be Conceptual, text-based, tactile, neo-Conceptual, concrete, abstract, minimal, or post-.... It's ironic, direct, cerebral, pissed-off, experiential, subtle, funny, physical, and frightening. It represents the polyglot present.

Now, its significance and meanings are up to viewers, who will be asked to move with as much freedom or with as many limits as these makers have; to contend with forces that live inside and outside them; to enter new spaces and inhabit them, imaginatively; to encounter questions of aesthetics, unruly cerebration, and the dance of the irrational (there are no steps), to see worlds of sense and sensation, and reckon with distant or immmediate psychological and social realities. I don't know what Meret Oppenheim would think of this work. But I believe that her art is part of this exhibition, her risks and her freedom are here now, too.

Photo of Meret Oppenheim by Lynne Tillman, 1978

Detail of page from *Fusion Cuisine*.

Jeffrey Deitch has worked with Dakis Joannou for years, playing a crucial role in shaping his collection as well as curating numerous exhibitions. Among others, Deitch curated "Artificial Nature" (1990) and "Post Human" (1992–93) at the DESTE Foundation, both of which were landmark exhibitions that explored the portrayal of the body as a machine, spurred by developments in genetic engineering and plastic surgery in the 1980s and '90s. Drawing from a widespread fear that the ethical ramifications of cloning and other human modifications would change the nature of life iteslf, Deitch observed how artists depicted bodies as streamline, mechanical, nearing perfection. Before the start of the twenty-first century and the events of 9/11 revealed the fragility of human life, Deitch captured a sensibility that would soon be replaced by an artistic tendency to destroy the human form, a theme Deitch subsequently explored in the exhibition "Fractured Figure" at the DESTE Foundation in 2008. Deitch's seminal text "Artificial Nature" brought to light the artistic response to the possibility of genetic modification, when human strength, especially in America, was at its climax, and before the ideal of progress became eclipsed.

Jeffrey Deitch was recently appointed Director of the Museum of Contemporary Art, Los Angeles. As a private art dealer, he ran Deitch Projects for fourteen years in Manhattan.

All images that appear on pages 141-182 are spreads from *Artificial Nature*, edited by Jeffrey Deitch and Dan Friedman, published by the DESTE Foundation, ©1990.

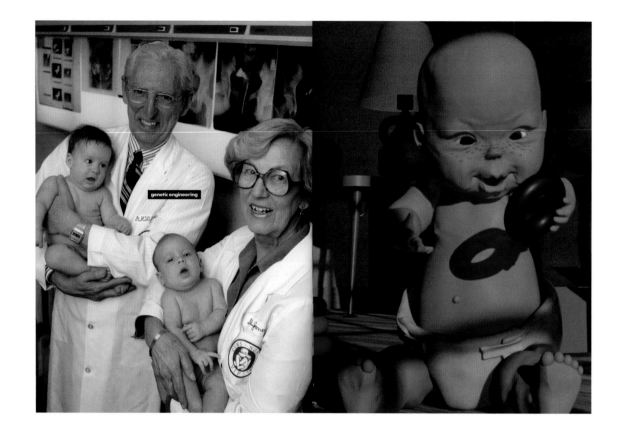

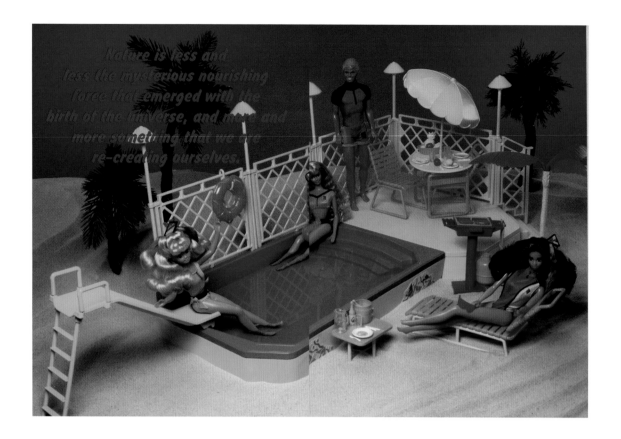

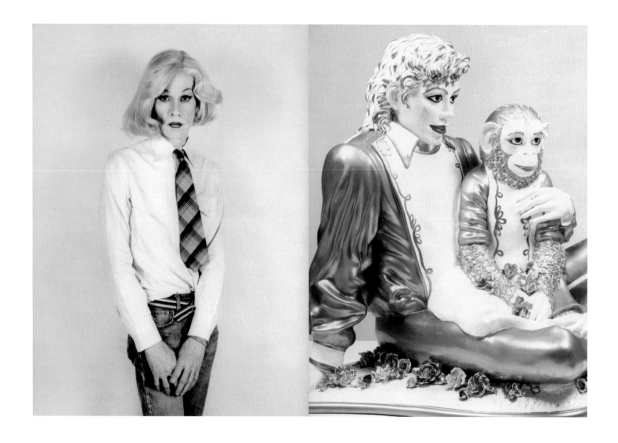

Jeffrey Deitch and Dan Friedman

147

man-made improvements

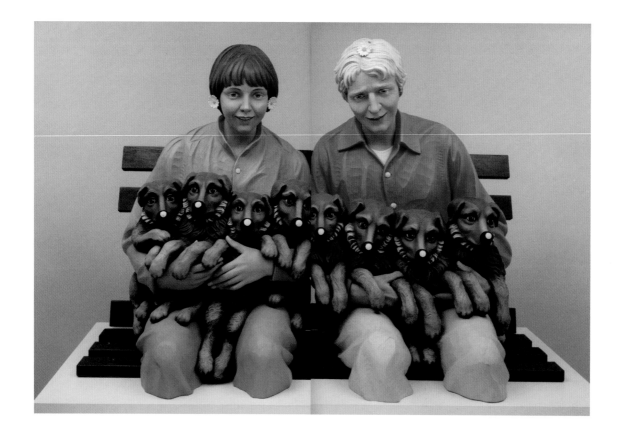

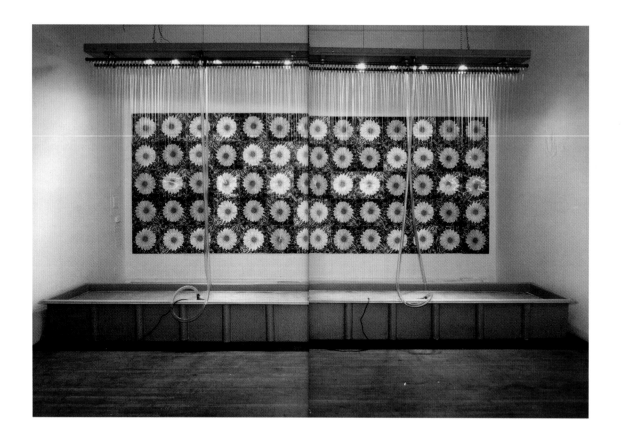

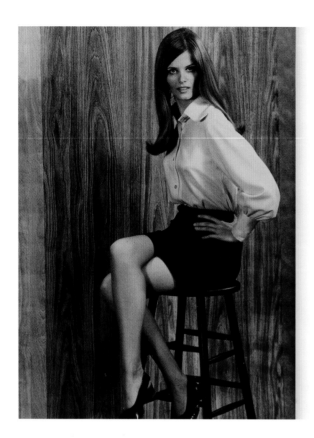

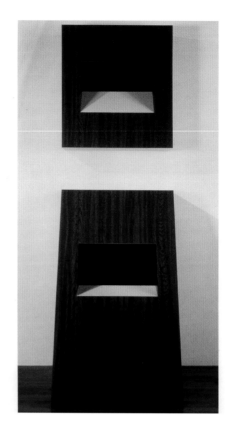

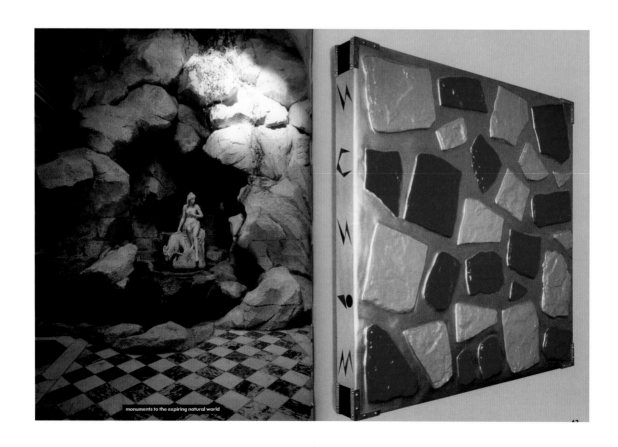

monuments to the expiring natural world

Artificial Nature
Jeffrey Deitch

This text first appeared in *Artificial Nature*, 1990.

Could it happen that the next generation will be our last generation of real humans? The temptation to use the rapid advances in biotechnology to genetically "improve" our offspring could prove to be irresistible. Within thirty years, the older generations may have to cope with a race of **superhuman** teenagers who were genetically engineered to look like plasticized versions of aerobic instructors. Once the technology is accessible, can parents be held back from trying to give their children blonder hair, enlarged sexual organs, or whatever else they think might make them more "perfect"? Even without **biotechnology**, the burgeoning **self-improvement** industry is encouraging an increasing number of people to re-create themselves through plastic surgery, liposuction, hair transplants, and other cosmetic operations. Before we know it, we could find the world divided into two classes of people: "**new, improved**" humans in the wealthier countries, living in a seamless, **artificially enhanced** environment, and "old" humans, still struggling with the vicissitudes of "natural" nature.

Nature is less and less the mysterious nourishing force that emerged with the birth of the universe, and more and more something that we are re-creating ourselves. From the greenhouse effect that could change our climate, to the **green revolution** that has spawned supercharged strains of grains and vegetables, nature is being reconstituted. For today's average city dweller, nature is more often than not something to be experienced on television, or on a Club Med vacation. There are still many people who earn their living from the land and the sea, and for whom nature is very real. For the rest of us, however, nature is an increasingly artificial experience.

Art and nature have been inextricably linked ever since the cave paintings of Lascaux. *Nature has traditionally been the ultimate inspiration and challenge for the artist who, depending on his or her orientation, sought to imitate it, improve upon it, or interpret it.* Our conception of nature has often been derived, in fact, from the vision of artists. Our sense of what nature is has been shaped and reshaped by artists of successive generations, such as Leon Battista Alberti, Claude Lorrain, J.M.W. Turner, and the Impressionists. Not only have artists studied nature for centuries, they have also looked to it for the revelation of basic truths. An immersion in nature and its forms gave artists, scientists, and philosophers a deeper picture of reality.

An artist can still pack a portable easel and hike into the mountains to sketch a small section of wilderness, but a truly contemporary artist might be better advised to seek truth in nature in a strip mine or in the visitors' center of a game preserve. To immerse oneself in nature today is to uncover layers of chaotic exploitation and **man-made "improvements.**" *Genuine nature may now be more artificial than natural.*

From the genetic reconstitution of human beings, to the growth of a kind of **worldwide suburbia**, we are slowly but steadily replacing what we knew to be nature with a new kind of **artificial nature**. It is not just that an average person can easily go through years of life breathing air-conditioned air, playing football on Astro Turf, and the like, but that a new model of reality is replacing our old sense of the natural order. The jungle ride at Disney World may in fact be **more real to most people** that the real jungle in the Amazon. Artificially colored and genetically enhanced oranges are perceived to look and taste better than the genuine article. *More and more people are becoming more comfortable in the simulated world than in the real one.*

A younger generation is being raised on the simulated reality of computer games, a kind of **conceptual nature** that is actually way beyond most of the wildest science fiction of the 1950s. What sense of reality will develop in the minds of teenagers who spend hours at computer screens, feeling that they are actually flying airplanes or driving racing cars? What will be their model of reality as many of them grow up to spend their entire careers working and communicating through computers?

Representing nature today is not easy for the artist, who sees nature being **re-created** every day by the likes of geneticists, computer programmers, and real-estate developers. Plastic surgeons, farm managers, and all kinds of **ordinary people** are now making the kind of aesthetic decisions that only artists and architects once made. Particularly in the fast-approaching era of genetic engineering, the kinds of aesthetic choices once made only by artists will be central choices for society. *Artists who can grasp the new technology may have a much more direct opportunity to redefine our idea of nature than they did when their media were limited to painting and sculpture.*

The ability of artists to redefine our conception of nature is actually nothing new. *The natural world was never before overrun with the kinds of artificiality that now permeates it, but one's conception of it has always been a man-made construct.* Even the generations of artists who strove to depict absolute truth in their renderings of nature tended to spiritualize it, romanticize it, or intellectualize it. In the early Renaissance, artists like Giovanni di Paolo depicted nature as an amorphous, **spiritualized** realm. In the High Renaissance, after the invention of perspective, nature began to be portrayed and to be thought of as something more rational and ordered. In the early seventeenth century, artists like Claude Lorrain helped to invent a new Romantic vision of nature, while Poussin created a classicized, conceptualized natural realm. In the eighteenth century, artists like Hubert Robert and François Boucher portrayed nature as an arena of **fantasy**, completely **removed from the harsh realities** of the peasants' life. Their vision corresponded to Marie Antoinette's make-believe farm at Versailles, and helped to define the world view of the ancien régime nobles who had become more and more alienated from the life of the ordinary people who worked the land.

A succession of artistic movements from the late-eighteenth to the mid-nineteenth century redefined nature again. The spiritual Romanticism of Caspar David Friedrich, for instance, resonated through German nineteenth-century **culture**. The Realist and plein-air painting movements brought the pleasurable sensations and the brute realities of nature back to the new urban middle class, the first mass audience to form its vision of nature from the works of art as much as from direct experience. The Impressionists, particularly Claude Monet and Pierre-Auguste Renoir, portrayed nature as an arena of leisure, a playground for the vacationing city dweller. *By the 1870s, the urban middle class was increasingly likely to view nature not as the grand nourishing force behind life, but as something pleasant to visit on the weekend.*

Toward the end of the nineteenth century, a group of related artistic movements loosely referred to as Post-Impressionism radically redefined nature again, intellectualizing and systematizing it, as in the Pointillism of Georges Seurat, and **spiritualizing it** and **infusing it with emotion**, as in the Vitalism of Edvard Munch and the proto-Expressionism of Vincent van Gogh. Much of the most advanced art moved towards Symbolism, with nature being portrayed from the emotions and imagination of the artist as much as from direct observation. This began a shift that led into the abstraction of nature that has characterized the twentieth-century artistic vision.

Like the invention of perspective and the beginning of the scientific view of the natural world in the High Renaissance, the invention of abstract art at the beginning of the twentieth century marked a major shift in how our society viewed itself and its world. The development of Cubism and **geometric abstraction** coincided with the opening of a whole new universe of knowledge through the field of theoretical physics and its applications. It also coincided with the

maturity of industrial society and the increasing alienation of the urban population from the natural world. Food and fuel began to arrive all **packaged** and processed, without much evidence that they were products of the natural world, if in fact they weren't actually synthetic. Other than as a vacation destination, nature became something that the city dweller could take for granted and forget about, while industry progressively plundered it to produce the products that insulated people from it even further.

After nature had been **Surrealized** by artists like Max Ernst, internalized by artists like Jackson Pollock, and **plasticized** by artists like Roy Lichtenstein, we reached a point in the late 1960s where both Modern art and the natural world itself looked as if they were beginning to expire. Art critics began to speak about the end of Modernism, while environmentalists began to speak about the end of nature. The **radical spirit** of 1968 was well expressed by Robert Smithson, whose Non-Sites were **monuments to the expiring natural world** and portrayals of the disconnection between civilization and nature. They were also monuments to the end of conventional representational and illusionistic art.

The postmodern artist now confronts a **Post-Natural nature**. *On one side there is the pessimistic view that we have nearly depleted our natural resources and are on the verge of destroying what's left of our forests and our atmosphere. Then there is the optimistic argument that our advancing technology will allow us to purify our air, de-salinize our water, and otherwise construct a complex life-support system to keep our fading planet alive. Whatever happens, for better or for worse, nature as our ancestors knew it may soon be finished.*

The simulated realm of television and film is the foundation on which much of the world's population has built its sense of reality. The rapid integration of new types of **computer-simulated** experiences into the education system and into the workplace will make it increasingly difficult for people to differentiate between the artificial and what was formerly understood as the real. Television networks are even beginning to broadcast simulated news as if it were the real thing. The widening acceptance of mood-altering drugs, from marijuana to Prozac, has made a **chemically induced high** the normal state of mind for millions of people. *It is not at all unusual for a well-adjusted person to mellow out on Valium and spend the weekend interacting with the rest of the world mainly through television* and computerized communications services. People can even maintain active artificial social lives by calling "900" numbers for simulated phone sex and singles' party lines.

In creating a vision of nature, today's artists, unlike their predecessors of previous generations, are confronting an

environment that it may no longer be possible to describe as natural. An accurate rendering of the landscape might include more concrete than vegetation, and more junked automobiles than flowers. An ever-increasing percentage of our world is becoming covered by the same depleted, almost **characterless landscape** that is neither rural nor urban, with patches of asphalt, mounds of landfill, and a sky laced with electrical wires. *The environment has become so artificial that the traditional aspiration of the artist to "reveal the truth" in what he or she sees may have become impossible.* The true has been twisted into the false.

Artists like Robert Smithson, with his sculptures of dirt and mirror fragments, Andy Warhol, with his camouflage paintings, and Richard Artschwager, with his wood-grained Formica sculptures, have become the godfathers of a new generation of artists studying the artificiality, the urgent realities, and the ironies of the **contemporary** environment. Working independently, a group of younger artists from Japan, Europe, and America has begun to create a new kind of "**landscape painting**" that is constructed not with paint and canvas, but from the industrial materials out of which our environment is being reconstituted. Ashley Bickerton's *Seascape*, for instance, is the ideal art object for our contemporary world. Built to float, in case the greenhouse effect causes sea levels to rise, it is filled with the **waste products** of its own construction. It is an appropriate ironic commentary on modernist self-reflexivity as well as on our environmental plight. Martin Kippenberger's giant rubber blob pumped up with air from a discarded vacuum cleaner is perhaps as good a portrayal of our **atmosphere** as John Constable's early-nineteenth-century cloud studies were of his. Tatsuo Miyajima's *sculptures of electronic digital counters depict an ominous countdown that reflects our contemporary structure of time.* Jeff Koons's electric-blue *String of Puppies* held by their "**New Age**" owners gives an eerie indication of the **mutations** that may be induced by genetic engineering. His smooth porcelain *Michael Jackson and Bubbles* is a portrait of the new consciousness of self, demonstrating how one can reshape one's body through exercise and plastic surgery.

Artists of previous generations redefined nature through their vision, but the new biotechnology may be putting the artists of today's generation in a situation where not just nature, but life itself, is being redefined. It is difficult to imagine what kind of image of the natural world people will have in the approaching age of **genetic engineering**, but it certainly will be very different from the image that we have today. It is possible that we are again entering an era of tremendous change, as in the first two decades of or century. The exploding technology of computer science and **artificial intelligence**, along with

the advances of biological science, may bring as strong a degree of change in the way we live as did the airplane and the automobile.

As modern art paralleled the direction of science and industry in its exploration of the basic structures of natural materials and systems, the advanced art of the next decade will most likely reflect the new world created by the synthesis of new life forms by genetic engineering and the artificial realities developed by computer science. As in the past, it will probably be the artists who are best able to sense and visualize the resulting changes in consciousness and create a new vision that will begin to redefine the way we see. *The changes in our perception of reality resulting from these new technologies of synthesis and simulation are likely to lead to profound changes in the way artists and everyone else begin to interpret and understand the world.*

For centuries, art, poetry, philosophy, and other humanistic disciplines were linked by one overriding concern, the search for "**truth**." In Modernism, in particular, the effort to shed the layers of artifice and reveal the true structure of the work of art and the true qualities of its component materials was central to the artist's concern. Both morally and aesthetically, the belief in truth was one of the most essential elements of the artistic enterprise. Now, with the direction of science toward the creation of artificial life forms and a computerized **virtual reality**, and with the emphasis on image, rather than substance, in communications and in the marketing of everything from automobiles to politicians, the **traditional** search for truth has perhaps become obsolete. *There is no longer one absolute reality, but the possibility of multiple realities, each one as "real" or as artificial as the others.* With landscaped parking lots no more or less real than a forest preserve, and a genetically "improved" baby no **more or less real** than an old-fashioned one, there is no longer the absolute truth of nature remaining after all the layers are peeled back. It may be that the end of Modernism not only coincides with the end of nature, but with the end of truth.

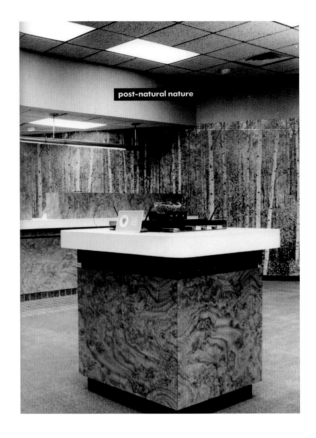

160

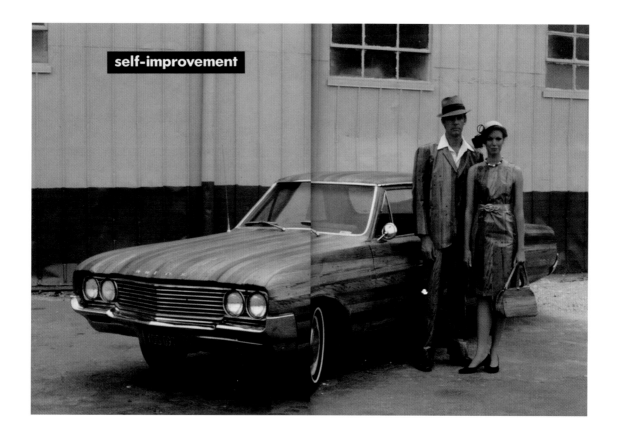

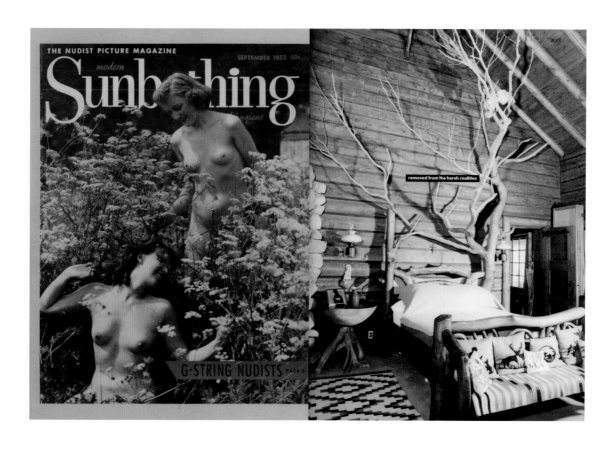

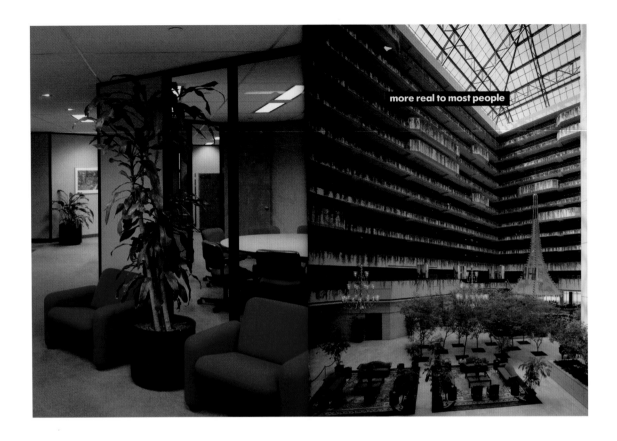

more real to most people

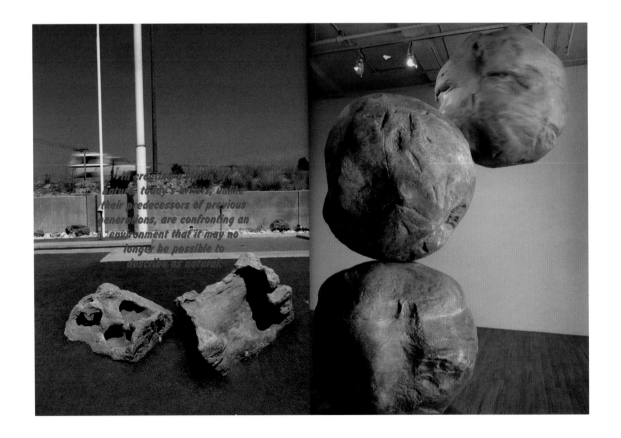

I'm creating ... nature ... today's artists, unlike their predecessors of previous generations, are confronting an environment that it may no longer be possible to describe as natural.

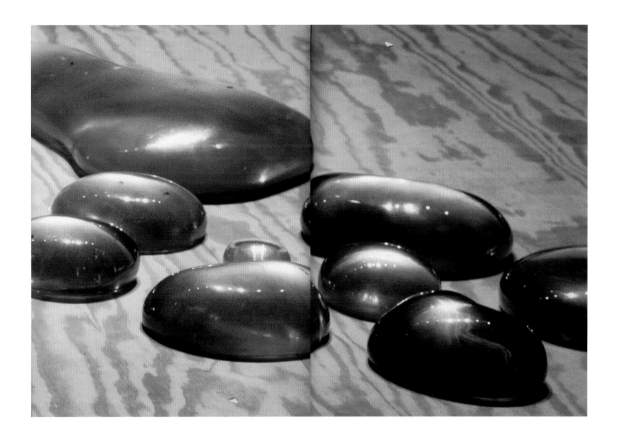

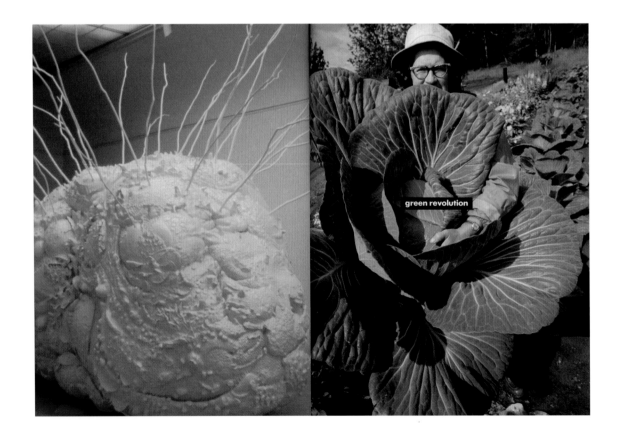

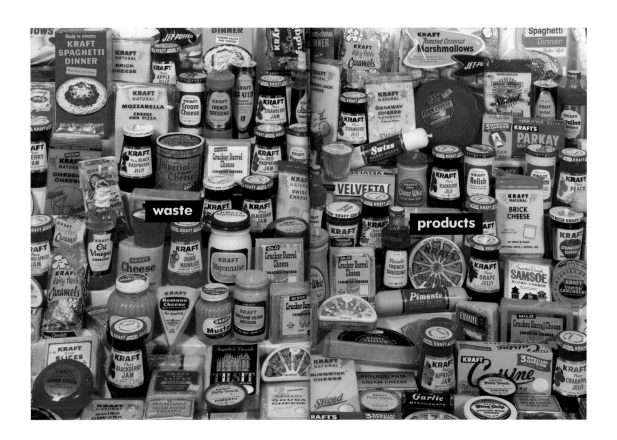

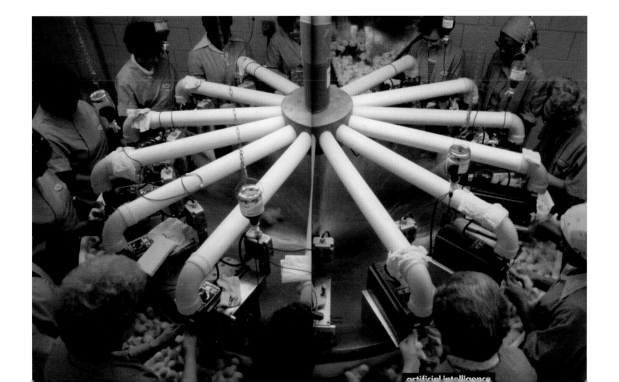

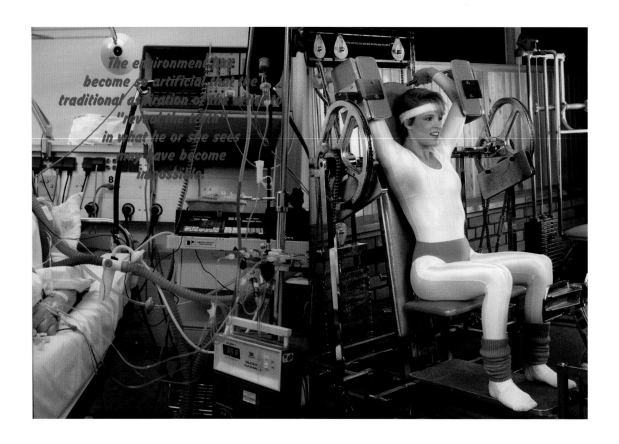

The environment has
become so artificial that the
traditional aspiration of the viewer to
"recognize himself"
in what he or she sees
...may have become
impossible.

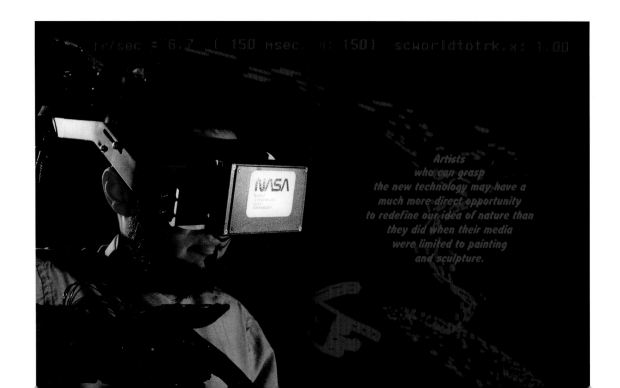

Artists
who can grasp
the new technology may have a
much more direct opportunity
to redefine our idea of nature than
they did when their media
were limited to painting
and sculpture.

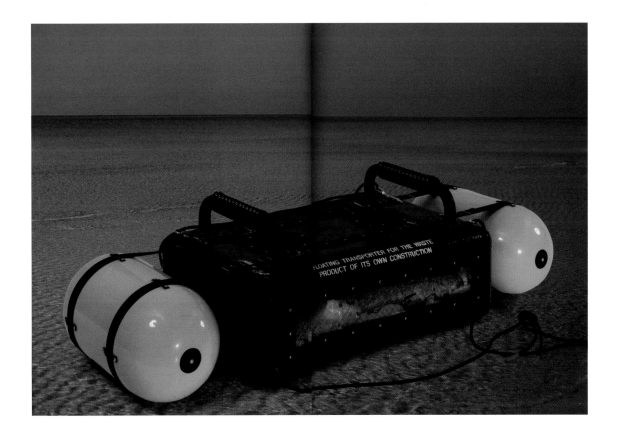

*It is not at all unusual
for a well-adjusted person to
mellow out on Valium and spend
the weekend interacting with
the rest of the world
mainly through
television....*

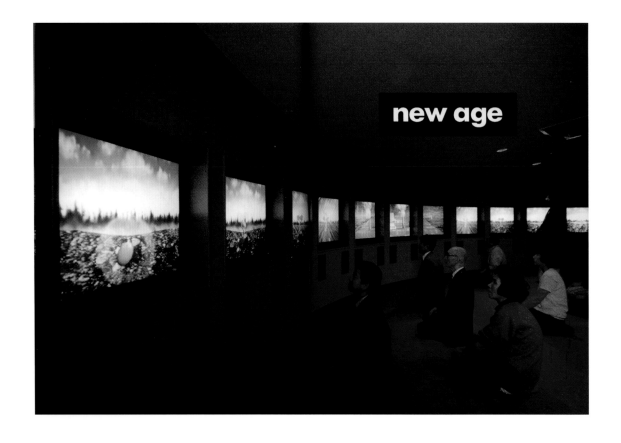

new age

168

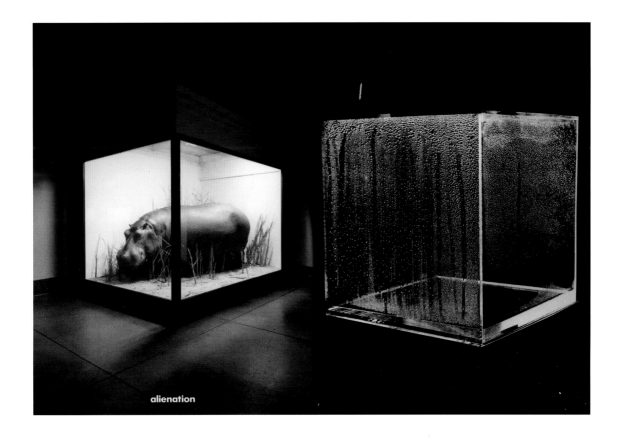

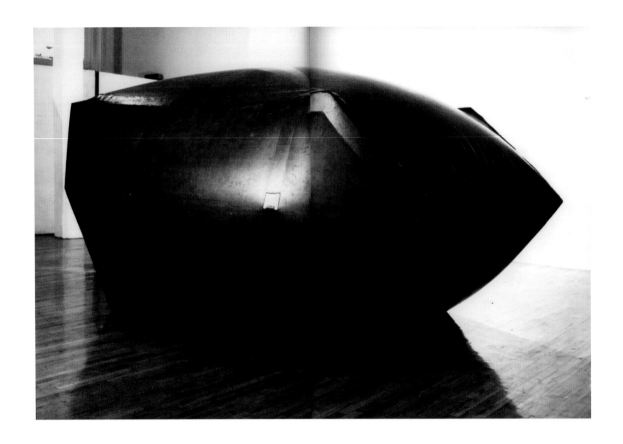

The changes in our perception of reality resulting from these new technologies of synthesis and simulation are likely to lead to profound changes in the way artists and everyone else begin to interpret and understand the world.

...sculptures of
electronic digital counters
depict an ominous countdown that
reflects our contemporary
structure of time.

more or less real

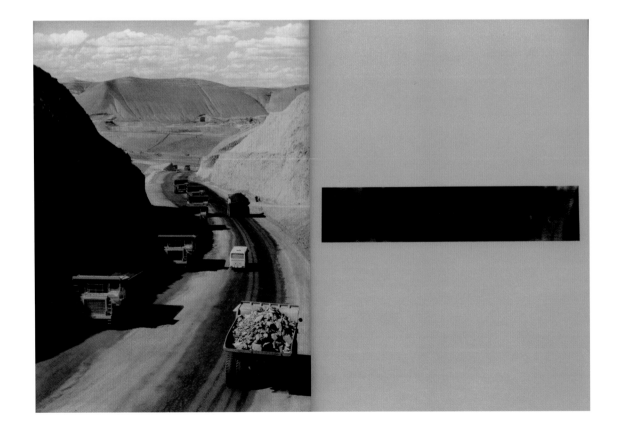

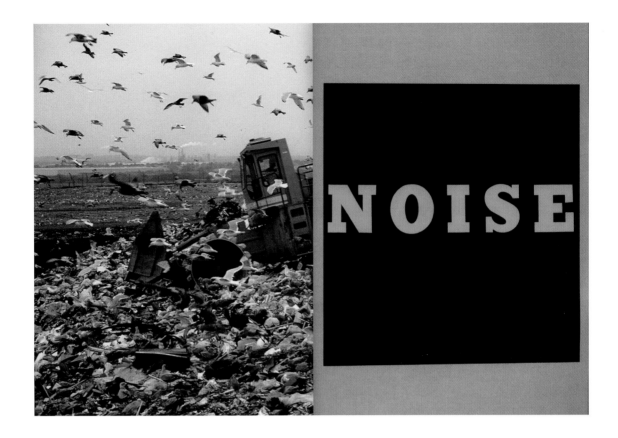

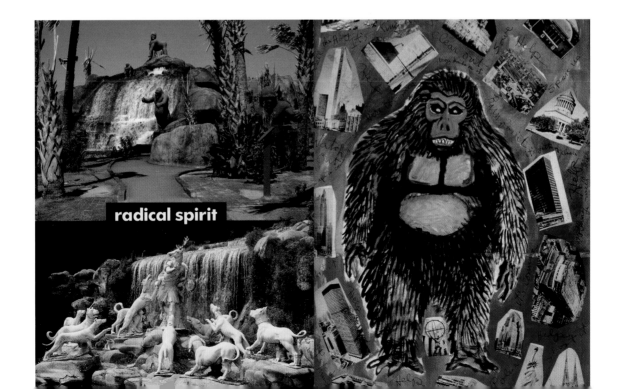

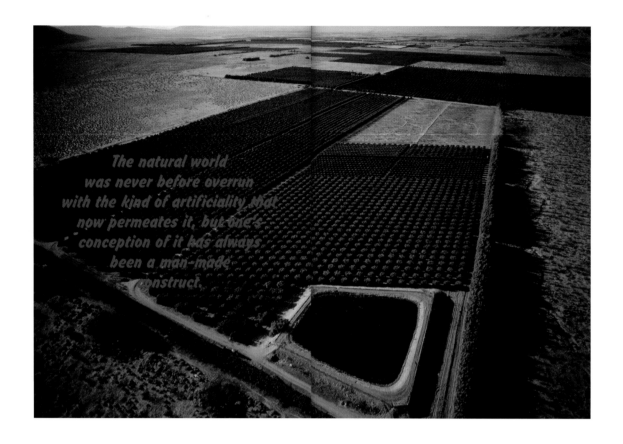

The natural world
was never before overrun
with the kind of artificiality that
now permeates it, but one's
conception of it has always
been a man-made
construct.

geometric abstraction

Nature has
traditionally been the ultimate
inspiration and challenge
for the artist who, depending on his
or her orientation, sought to
imitate it, improve upon
it, or interpret it.

characterless landscape

worldwide suburbia

RALPH LAUREN
COUNTRY

Genuine nature
may now be more artificial
than natural.

Nancy Spector is Chief Curator at the Solomon R. Guggenheim Museum in New York, where she has worked since 1989. In 2004, she co-curated "Monument to Now," an exhibition of works from the Dakis Joannou Collection, which was on view in Athens from June 22 through December 31, coinciding with the 2004 summer Olympics. "Monument to Now" brought to the foreground a number of artistic tendencies in contemporary art, including a renewed interest in narrative, illusion, and iconic images. The exhibition highlighted work that addressed the human condition as well as popular culture.

Spector's contribution to the catalogue, "Fifteen Minutes Is No Longer Enough," takes up mass media—specifically television—and the construction of American consciousness and self-perception towards the end of the twentieth century. Her insights on censorship, trauma, and the structure of information dispersal resonate strongly with the artworks she discusses, such as Cady Noland's *Bluewald* and Johan Grimonprez's film *Dial H-I-S-T-O-R-Y*. Drawing her examples equally from Joannou's collection, contemporary politics, and television programs, Spector's argument contextualizes the artworks in the Dakis Joannou Collection within the greater dystopia of American media.

Fifteen Minutes
Is No Longer Enough
Nancy Spector

and tea on hand-prepared *washi* paper
38,1 x 32 cm/15 x 12 5/8 in. framed

...d murder of Lee Harvey
...adcast live on national
...wo days after he assas-
...nt John F. Kennedy. He was

This text first appeared in *Monument to Now*, published by the DESTE Foundation, ©2004.

Detail of page from *Monument to Now*.

The cold-blooded murder of Lee Harvey Oswald was broadcast live on national television just two days after he assassinated President John F. Kennedy. He was gunned down by Jack Ruby in the basement of the Dallas city jail while awaiting transfer to the county facility on November 24, 1963. This crime was recorded and simultaneously transmitted as part of a media marathon that commenced right after the assassination and ended with the president's funeral four days later. During that period, the television networks provided twenty-four-hour coverage, obsessively documenting every detail without a single commercial break.[1] The country was transfixed; nine out of ten Americans watched as this drama unfolded in real time, joined in a kind of collective disbelief and mourning facilitated by electronic media.[2] The first presidency to capitalize on the mythmaking capacities of television—with the studied construction of "Camelot" for the camera—met its end in the living rooms of millions of American viewers. Unlike typically scripted television, however, this story offered no closure. On the contrary, it ushered in decades of doubt and dissent for a nation whose own, self-defining narrative was beginning to unravel.

Cady Noland specializes in the disruption of the American dream. Her unruly sculptures, assembled from

1. Tom Engelhardt, *The End of Victory Culture: Cold War America and the Disillusioning of a Generation* (Amherst: University of Massachusetts Press, 1998), 182.
2. Ibid.

the flotsam of a degenerate and degenerating society—discarded Budweiser beer cans, handcuffs, rubber tires, empty wire baskets, aluminum barriers, chrome car parts, and walkers—reflect a world coming undone. Her photographic portraits, culled from the mass media, enlarged, and silkscreened onto thick aluminum sheets, highlight cult icons, like Patty Hearst and Oswald, from America's tabloid-saturated imagination. Noland's photographic sculpture *Bluewald* (1989) depicts Oswald at the moment of his own assassination; Ruby's .38 special is pointed directly at his stomach. The cut-out figure is perforated with seven holes, three of which obscure Oswald's face as he turns to stare at his murderer and the flashbulbs beyond. Cast with a bluish tint, the portrait appears as if illuminated by the nocturnal light of a television set in a darkened room, an insomniac's refuge with its 24/7 programming. With *Bluewald* and its conflation of violence, spectacle, intrigue, and voyeurism, Noland aptly targets a cultural phenomenon peculiar to the United States, which has its roots in the political and social upheavals of the 1960s and continues to flourish in our millennial world.

The 1960s was a decade of great disillusionment and great mobilization. The escalation of the Vietnam War and the assassinations of President Kennedy, Robert F.

Kennedy, Martin Luther King, Jr., and Malcom X all contributed to an erosion of public trust in the government. The overarching illusion of the U.S. as a benevolent world force was beginning to crumble. The nation's perception of itself as a "victory culture," informed by the triumphs of two world wars, was increasingly undermined as the debacle of America's involvement in Vietnam came under ever greater scrutiny.[3] The anti-war movement, coupled with epic human-rights initiatives—including the women's liberation movement, civil rights demonstrations, and the Stonewall Rebellion, which inaugurated the modern-day gay and lesbian rights movement—marked a sustained, multivalent attack on the status quo. The country's "dominant fiction"[4] of a victorious government acting in the interests of its citizens in a transparent process accessible to all was debunked with each national catastrophe. In 1968 alone, the assassinations of Kennedy and King, the My Lai massacre,[5] the Tet offensive,[6] and the violent riots at the Democratic National Convention in Chicago (which culminated in the much-publicized Chicago Seven trial[7]) signaled a crisis in the national consciousness. The U.S. government seemed utterly unscripted, and, unlike today, much of the media refused to echo any propagandistic, patriotic jargon put forward by the administration. Television anchors criticized the Vietnam War on air; Walter Cronkite, whom President Lyndon Johnson once described as "Mr. Average Citizen," announced on CBS after a visit to Southeast Asia that the war was "mired in stalemate."[8] But this journalistic independence was relatively short lived. By and large, the military strategists and hawks in government felt betrayed by the American media, which reiterated and further inflamed the country's deep ambivalence over a war with an elusive enemy and no apparent exit strategy. During the ensuing decades, the autonomy of print and broadcast journalism gradually diminished as media conglomerates consolidated independent stations, and the military increasingly controlled access to combat zones during wartime. This deliberate restraint on the freedom of the press culminated in the 1991 Persian Gulf War, which was a government-produced media spectacle resembling the abstraction of a video game. The raw footage that once pulled a nation through the days following the Kennedy assassination was replaced by the slick, heavily mediated spin that constitutes our television culture today.

The drift from television news as (allegedly objective) information to packaged entertainment can be dated to the end of the 1960s when the concept of "Happy Talk News" was introduced by an ABC-affiliate station in Chicago to boost its ratings. This involved a shift from the single "talking head" reading from what was presumed to be investigative reportage to casual banter between coanchors in order to humanize and ameliorate the onslaught of horrific news stories that marked the era. "Happy Talk" rhetoric

3. Engelhardt's *The End of Victory Culture* analyzes this phenomenon and its political repercussions in great detail from the mid-1940s to the Persian Gulf War. Much of the sociopolitical commentary presented here is indebted to Engelhardt's penetrating study.
4. See Kaja Silverman, *Male Subjectivity at the Margins* (New York and London: Routledge 1992), for her discussion of the "dominant fiction," a cultural contract in place for centuries that secures patriarchal power.
5. On March 16, 1968, in the village of My Lai on the Battambang Pennisula in Quangngai Province, South Vietnam, American soldiers killed 502 people, including more than 170 children. Countless women raped, 300 houses were destroyed, and 870 head of cattle killed. More than twenty months went by before true accounts of the atrocity were published by the American media after a prolonged military cover-up.
6. During the Tet Holiday in 1968, the North Vietnamese launched a synchronized attack on more than one hundred targets throughout the South, including Saigon. In order to take back the conquered regions, the U.S. resorted to air strikes, nearly leveling many of its targets.
7. Anti-war protesters used the convention as a platform. What began as peaceful demonstrations ended in violent skirmishes with the police. As the riots escalated, Mayor Daley called in the troops. In total, 11,900 Chicago police, 7,500 Army regulars, 7,500 Illinois National Guardsmen, and 1,000 FBI and Secret Service agents were stationed in the city. Police and other authorities used force to keep the demonstrators away from the delegates' headquarters. At the close of the convention, authorities claimed that 589 people had been arrested and more than 119 police and 100 demonstrators injured.
8. Engelhardt, *The End of Victory Culture*, 243.

Detail of page from *Monument to Now*.

masked the irresolution of the nation's current conflicts and further fragmented any news deemed incendiary, such as the coverage of the civil rights and antiwar movements. In his three-channel video installation, *Evening* (1994), Stan Douglas charts this historical moment—the birth of infotainment—by juxtaposing broadcasts of the evening news from three different Chicago-area network affiliate stations from two moments in time: January 1, 1969, and January 1, 1970. Rather than simply appropriating footage from the original programs (which in fact is not archived), Douglas scripted and directed a performance based on actual events of the period. The anchors discuss, to varying degrees, the release of three prisoners of war by the Viet Cong; the reinstatement of Adam Clayton Powell in Congress after being investigated for the misappropriation of Congressional funds; the My Lai trials; Mayor Richard Daley's delay in appearing at the trial of Abbie Hoffman during the Chicago Seven hearings; and the initial inquest into the assassination of Black Panther deputy chairman Fred Hampton. The not-so-subtly fictionalized stations, "WAMQ—The News That Matters" (NBC), "WBMB" (CBS), and "WCSL—Your Good News Station" (ABC), each reveal their transition to the relative trivialization of major news stories over the one-year

span represented.[9] Douglas's carefully calibrated fugue of simultaneous broadcasts—creating a polyphony of sound interrupted only by commercial breaks indicated by "place ad here" signs—invokes the mind-numbing repetition of televised news, which is perpetuated today in our "all-news, all-the-time" cable stations: CNN, FOX, MSNBC, and Bloomberg.

The propensity of the media to deliver the news—however tragic or trivial—in short, digestible "sound bites," which are then incessantly repeated until a story has lost its broadcast value, creates a rhythm that is analogous to the symptoms of trauma. Derived from the Greek word for wound, trauma is an acute psychic injury with physiological manifestations. Although it was recognized for hundreds of years, trauma is particularly linked to the twentieth century. In fact, it is almost inextricable from modernity and its attendant technological advances, which have brought both boundless invention and mass destruction.[10] The modern comprehension of trauma dates to the late nineteenth century, when railway travel—with its unprecedented speed, noise, pollution, and potential for catastrophic accidents—created widespread apprehension. The great velocity of the locomotive destabilized and forever altered perceived coordinates of time and space. Even Sigmund Freud suffered from railway phobia. The twentieth century gave rise to horrors facilitated by technological progress on a scale unimaginable by previous generations: two world wars; ethnic, religious, and ideological genocide; nuclear explosions and their fallout; deterioration of the world's fragile ecosystem; the proliferation of fatal illnesses caused by industrial contaminants; aeronautic disasters; and international terrorism. Traumatic experience of such events cannot be processed or contextualized through normal channels of description, interpretation, or memory.[11]

Trauma is thus theorized as nonrepresentational, beyond language, that which cannot be narrated. In *The Writing of the Disaster*, Maurice Blanchot relates that "the disaster… is what escapes the very possibility of experience—it is the limit of writing….The disaster describes. Which does not mean that the disaster, as the force of writing is excluded from it, it is beyond the pale of writing or extratextual." [12]

The traumatic experience cannot be forgotten, but at the same time it cannot be sufficiently remembered, articulated, assimilated. This twilight state between past and present, in which the traumatic event refuses to recede and is relentlessly reencountered in altered form—flashbacks, nightmares, depression, obsession, paralysis, violence, and/or guilt—is a condition of utter disassociation. Officially acknowledged in 1980 by the American Psychiatric Association as a specific pathology (albeit one with a wide range of often conflicting symptoms), post-traumatic stress disorder (PTSD) is manifest today on both the individual and cultural levels. Vast portions of

9. In a recent study of 100 local television newscasts in fifty-six cities by the Rocky Mountain Media Watch, it was reported that local crime occupied 30 percent of what little time was actually devoted to the news (40 percent). Commercials consumed an almost equal amount of time (36 percent). Sports and weather filled 22 percent; anchor chatter, 2 percent. See Lawrence K. Grossman, "Why Local TV News Is So Awful," *CJR* (Columbia University, N.Y.) (November–December 1997), <www.cjr.org/year/97/6/grossman.asp/>.
10. The literature on trauma is vast, spanning psychoanalytical studies to film theory. The works consulted for this essay include: Cathy Caruth, ed., *Trauma: Explorations in Memory* (Baltimore and London: Johns Hopkins University Press, 1995); Kirby Farrell, ed., *Post-Traumatic Culture: Injury and Interpretation in the Nineties* (Baltimore and London: Johns Hopkins University Press, 1998); Ruth Leys, *Trauma: A Genealogy* (Chicago and London: University of Chicago Press, 2000); and *Trauma and Screen Studies*, special issue of *Screen* (London) 42, no. 2 (summer 2001), ed. Simon Frith, Annette Kuhn, and Jackie Stacy.
11. This text deals only with cultural-scale trauma and not the individual trauma resulting from infantile sexual trauma (such as fear of castration) or childhood abuse.
12. Maurice Blanchot, *The Writing of the Disaster*, trans. Ann Smock (Lincoln and London: University of Nebraska Press, 1986), 7.

a society can be afflicted with the psychic wounds associated with widespread trauma; the collective unconscious may be entirely altered by atrocity. Examples abound in the twentieth century: the Holocaust, apartheid, the Cultural Revolution in China, the Vietnam War, the AIDS epidemic, and the civil wars in Central America, Liberia, and Rwanda, to name only some of the most egregious and world-transforming events of the not-so-distant past.

In today's world, the perpetual onslaught of information—no matter how sanitized or diffused it may be—reflects the repetition compulsion inherent to post-traumatic stress disorder. Footage from national disasters like the Challenger and Columbia explosions or the devastation of the terrorist attacks on 9/11 was replayed again and again over the course of months, as if the incessant visual recurrence of the events would somehow provide clues to their meaning. The media's endless obsession over intrigue, crime, and tragedy, like the O.J. Simpson trial or the JonBenet Ramsey murder, works less to provide closure than to deflect our real inability to articulate a narrative that effectively portrays the cataclysmic impact of trauma. Attempting to actually tell the story of catastrophe has its own inherent dangers, however; narration can aestheticize, fictionalize, and/or fetishize an event that

imensions vary 914,4 x 20,3 x 30,5 cm/360 x 8

A

ology (albeit one with a wide
ptoms), post-traumatic stre
y on both the individual and
society can be afflicted wit

otherwise refuses to cohere. In fact, some cultural theorists propose that the only way to appropriately address a phenomenon too painful to remember, but too profound to forget, is through modernist representational strategies such as fragmentation, circularity, abstraction, and disassociation.[13]

This idea has had great resonance in recent visual culture. After decades of conceptually oriented art, much of which interrogated codes of representation, a generation of artists emerged during the 1990s that incorporated storytelling in their work. For many, such as Matthew Barney, Mariko Mori, Matthew Ritchie, Katy Schimert, and Shahzia Sikander, the narrative structure itself has served as a medium in its own right, providing a new kind of raw material with which to craft individual cosmologies, however eccentric or obscure. For others, narrative is only hinted at, obliquely suggested through isolated fragments. Robert Gober's disembodied legs and torsos are allusive part-objects—at once erotic and uncanny—imbued with an ever elusive content. They appear as mute symbols for a world of indescribable horror or incredible possibility—where bodies split apart and rejoin to form hybrid beings, where a man may give birth to a grown boy, and people become one with watery, subterranean realms of sewers and drainage systems. In the sculpture *Two Spread Legs* (1991), phantom limbs, cast from wax with trompe-l'oeil exactitude and outfitted with men's trousers, socks, and shoes, protrude from the wall in an anatomically impossible split. The gulf between the left and right legs suggests even further fragmentation than the initial, unsettling appearance of amputation. As in all of Gober's richly suggestive work, this piece operates on more than one connotative level. The splayed legs can also function as an invitation, like open arms, to a potentially (homo)erotic encounter. Similarly, *Untitled (Boy Coming Out of Man)* (1995), a surreal birth tableau set inside a glowing fireplace, is at once horrific and oddly propitious. While fire is destructive, it is also a primal force, and in this light the sculpture begins to envision a self-propagating universe. Gober achieves an analogous, double-edged effect with *Untitled (Basement Door)* (2001), an architectural fragment taken from vernacular domestic design, but suggestive of other worlds. This sculpture of an external entrance into an underground chamber is carved directly into the floor. The two entry flaps are open, revealing a set of descending stairs that lead to a closed yellow door; a glowing light emanates from behind. The theme of excavation is a recurrent motif in Gober's art: sculptures and drawings invoking underground sewers and the culverts that feed them allude to human conditions of fluidity and connectedness as well as unconscious states of terror and transmutation. *Untitled (Basement Door)* Gober has created an equally mysterious work, one that entices as a passage to either redemption or some unknown, personal hell.

13. Such is the thesis put forth by Hayden White, "The Modernist Event," in Vivian Sobchack, ed., *The Persistence of History: Cinema, Television, and the Modern Event* (New York and London: Routledge, 1996), 17–38.

14. In 1996, the Global Aids Policy Coalition estimated that in 1990 some ten million people were infected worldwide. By 1996, they cited some 30.6 million infected, noting that the pandemic would only worsen, with its greatest toll in developing nations. See William Harver, "Interminable AIDS," in Linda Belau and Peter Ramadanovic, eds., *Topologies of Trauma: Essays on the Limit of Knowledge and Memory* (New York: Other Press, 2002), 37.

15. For example, the controversy that arose when four American performance artists—Karen Finley, Tom Fleck, Holly Hughes, and Tim Miller—sued the National Endowment for the Arts after grants awarded them in 1990 were rescinded on grounds of indecency reveals how disruptive an arena the dystopic body and its representations can be. Federal monies were denied the artists on the pretense that public funding should not support "obscenity." First amendment rights aside, what the right wing, fundamentalist faction of the government regarded to be pornographic about these artists' works was less about nudity, profanity, and references to bodily excess (phenomena with little shock value anymore) than the fact that they made manifest—in the most graphically visual and visceral terms—the embattled state of the body. The deliberate outrageousness of much performance art made this work an easy target for conservative politicians seeking tokens of moral degeneracy in order to bolster platforms that preached "family values" premised on xenophobia, homophobia, and misogyny. In this intellectually regressive climate, a veritable crusade was launched against almost any artwork—from photographs by Robert Mapplethorpe to sculptures by Kiki Smith—that openly questioned the body as a unified subject, protested coercive attitudes toward sexuality, and celebrated the polymorphousness of desire.

16. The following descriptions of the shows are taken from the program's official Web site, <www.jerryspringer.com/>: "Volita will reveal a horrible secret to her daughter, Silina. She has been sleeping with Silina's boyfriend, Marcus, for 6 months! Silina begs Marcus not to leave her, but even her confession that

While Gober's work has always circulated around the dystopic state of American culture—particularly his early, handcrafted, hauntingly empty sinks, cribs, beds, and dog baskets—his introduction of disembodied limbs during the early 1990s invoked, however indirectly, a current crisis in the body politic. Like works by other artists, such as Felix Gonzalez-Torres and Kiki Smith, that addressed issues of corporeality, Gober's severed legs—some punctured by open drains, others sprouting candles—reflect a time in which the physical body itself became a highly contested site. The AIDS epidemic, by then reaching global proportions, had focused social paranoia and intolerance on the diseased body.[14] Because of the early association between homosexuality and AIDS, this body was considered "perverse" by nature of its perceived "otherness." Explicit artistic representations of the body—as anything but the normative, unigender, heterosexual, law-abiding (preferably white) being—proved to be profoundly disturbing to a culture gripped with fear and loathing of a disease yet to be comprehended medically, ethically, or socially.[15] The impulse for contemporary artists to represent the vulnerable and embattled body through elision, fragmentation, or metaphor stemmed less from a desire to avoid censorship than from an attempt to invoke what is essentially without form, to articulate what is singularly inexpressible—the body in pain, the silence of illness, the isolation of death.

It is ironic that while visual artists were turning to an aesthetics of absence to convey the prevalence of trauma in contemporary society, mainstream culture was witnessing an explosion of ever more explicit media attention to trauma—on both the personal and public levels. By the end of the 1980s, a new television genre had emerged: the confessional talk show. Introduced in 1986 when Oprah Winfrey launched her particular brand of compassionate, intrapersonal interviews during her pilot season, the genre quickly proliferated and mutated into the most debased programming ever envisioned by the television networks. The talk shows that followed in quick procession—the *Jenny Jones Show* (1989) and the *Jerry Springer Show* (1991), to name only the most popular—appeal to the lowest common denominator with episodes devoted to sexual betrayal, sexual perversion, petty crime, and incest. Guests tell their sagas, often directly confronting those they have hurt the most, swindled, or used. Goaded by a live audience desperate to witness conflict—like the bloodthirsty spectators of the gladiator games in ancient Rome—the shows' participants often come to blows. In episodes devoted to subjects like "I'm Stealin' My Daughter's Man!" and "Explosive Family Affairs" (Springer, September 11 and 12, 2003), people reveal and flaunt the darkest of secrets.[16] The confessional talk show, along with its recent offspring reality TV, has effectively erased any vestige of a boundary between the public and the private spheres.

mmed less from a desire to
t to invoke what is essen-
is singularly inexpressible—
s. the isolation of death.

Detail of page from *Monument to Now*.

she's pregnant will not sway him from her mother! Next... Nikki's brother, Billy, is not happy to find out that his sister is a prostitute. He's even more disgusted when Nikki's boyfriend comes out to defend her! Then... Sharon and Nick are here to make Sharon's husband, Bryan, understand that Sharon is leaving him. Sharon loves Nick and will even accept his proposal of marriage!" (Sept. 11, 2003). "Siblings, Brandy and Chris have a lot of explaining to do.... They've been sleeping together for two years! Both of them will be confronted by Chris' wife, Brandy's husband and even their own mother! Next... A different Brandy promised her husband, Won, she'd stop sleeping around with women. But she'll confess today that she' back to her old ways... with his sister!" (Sept. 12, 2003).
17. Quoted from <www.judgejudy.com/>.
18. Frank Rich, "The Irresistible Rise of Telephilia," *New York Times*, June 8, 2003, Arts and Leisure section, <www.nytimes.com/>.

(quasi-mythological realms to begin with). Even the legal system, which purportedly protects one's right to privacy, has gotten into the act. *Judge Judy*, a highly popular, nationally syndicated program on the air since 1996, televises courtroom dramas. A sampling of trials presented for the week of September 8–12, 2003, includes the following: "A Colorado mailman demands that his ex-girlfriend pay for the breast augmentation surgery he bought for her," "A pregnant woman from North Carolina claims she was kicked in the stomach during a fight with another woman over a gas pump," and "A Minneapolis man claims he loaned his ex-girlfriend thousands in her struggle to regain custody of her youngest daughter."[17]

In American culture today, people will apparently do just about anything to appear on television. Afflicted with what *New York Times* critic Frank Rich has called an advance case of "telephila,"[18] average Americans are desperate enough to confess their innermost secrets, compete in the most humiliating competitions, and conduct the most private of rituals like choosing a mate in front of millions of viewers. The immense popularity of Reality TV programs like *Survivor*, *Who Wants to Marry My Dad?*, *Extreme Makeover*, *I Want a Divorce*, *Freshman Diaries*, *Temptation Island*, and *Dog Eat Dog* proves that,

have hurt the most, swindled
ice desperate to witness cor
ators of the gladiator games
:ioants often come to blows.

Detail of page from *Monument to Now*.

an from North Carolina claim
during a fight with another w
eapolis man claims he loane
struqqle to reqain custodv of

Detail of page from *Monument to Now*.

to many, television has become the barometer of their self-worth. It offers that momentary brush with celebrity that Andy Warhol so prophetically announced when he said that "in the future everyone will be world famous for fifteen minutes."[19] That illusory fifteen minutes, it seems, is no longer enough. People are clamoring for any kind of public exposure that will, they think, elevate their daily existence to that of a Hollywood celebrity. Maurizio Cattelan's installation *Spermini* (1997), comprising 500 latex masks of the artist's face, humorously invokes this seemingly insatiable, culture-wide urge for notoriety. In his onanistic celebration of the self, Cattelan pokes fun at the masturbatory impulse, equating autoerotic pleasure with both the expenditure and multiplication of one's being.[20] While probably not intended as a subtext of the piece, the correlation between masturbation, wasteful expenditure, and the endless duplication of one's image slyly alludes to the absurd ends individuals will go to in order to participate in the electronic flow of reality TV, with its delusion of self-importance and fame.

America's obsession with television extends well beyond the desire for instant celebrity. It marks a new kind of relationship to the "real." For some time now, society has utilized the media as its mirror, representing itself to itself, sensationalizing the effects of trauma but minimizing critical information about its causes. The superficiality of current news reportage, coupled with the inanity of the confessional talk show and reality programming, have inured viewers to the depth and complexity of modern life. Television's carefully packaged "reality" has come to seem more real, more valid, more vivid than daily existence for its ever growing audience. The television-addicted Gladney family in Don DeLillo's *White Noise* (1985)—which reserves every Friday night to collectively watch the spectacle of suffering broadcast into their living room—has become a paradigm for today: "That night, a Friday, we gathered in front of the set, as was the custom and the rule, with take-out Chinese. There were floods, earthquakes, mud slides, erupting volcanoes. We'd never been so attentive to our duty, our Friday assembly…. We were… silent, watching houses slide into the ocean, whole villages crackle and ignite in a mass of advancing lava. Every disaster made us wish for more, for something bigger, grander, more sweeping."[21]

When true disaster strikes the town where the Gladneys live in the form of a toxic railway spill, people are actually disappointed, even outraged, when no media coverage of their evacuation materializes. Without the validation of broadcast television, victims of the catastrophe felt the depth of their experience was discounted: "At seven p.m. a man carrying a tiny TV set began to walk slowly through the [evacuation center], making a speech as he went…. 'There's nothing on network,' he said to us. "Not a word, not a picture. On the Glassboro channel

19. Andy Warhol, Kasper König, Pontus Hultén, and Olle Granath, eds., *Andy Warhol* (Stockholm: Moderna Museet, 1968), unpaginated.
20. *Spermini* is used to illustrate an excerpt from Philip Roth's *Portnoy's Compaint* (1969) on the adolescent angst and pleasure associated with masturbation included in Francesco Bonami, Massimiliano Gioni, Nancy Spector, et al., *Maurizo Cattelan* (London: Phaidon, 2003), 102–105.
21. Don DeLillo, *White Noise* (New York: Viking Critical Library, 1998), 64.
22. Ibid., 161–62.
23. The term is Mark Selzer's. See his "Wound Culture: Trauma in the Pathological Public Sphere," *October* 80 (spring 1997), 3–26.

we rate fifty-two words by actual count. No film footage, no live report. Does this kind of thing happen so often that no one cares anymore? Don't those people know what we have been through…. Are they telling us it was insignificant, it was piddling? Are they so callous…. Don't they know it's real? Shouldn't the streets be crawling with cameramen and soundmen and reporters…. Even if there hasn't been great loss of life, don't we deserve some attention for our suffering, our human worry, our terror? Isn't fear news?"[22]

DeLillo's acerbic conflation of voyeurism and exhibitionism in relation to television perfectly encapsulates the telephilic condition contaminating our culture. Nothing is considered valuable or real unless broadcast by the media, no matter how exaggerated or frivolous it may appear. In the recent past, this truth has been aggressively exploited by politicians and terrorists alike. Television has become a propagandistic tool, promoting a campaign of fear and intimidation that serves (inadvertently) both those in power and those seeking to destroy that power. Johan Grimonprez's film *Dial H-I-S-T-O-R-Y* (1997)—a gripping montage of television footage recording acts of global terrorism from the 1950s to the early 1990s—is prescient in its analysis of how terror feeds the media, which in turn feeds our contemporary "wound culture."[23] The film takes as its subject the history of hijacking from the earliest seizures of flights to Havana as explicit political gestures to the anonymous suitcase bomb that brought down Pan Am Flight 103 over Lockerbie, Scotland, in 1988. Graphic disaster scenes are intercut with cameo appearances by world leaders, public figures, and terrorists alike: Richard Nixon, Fidel Castro, Yasir Arafat, Che Guevara, Nikita Khrushchev, along with members of the Baader-Meinhof group and the PLO. The documentary footage—which shows the evolution of television technology, from black-and-white to color—is collaged with excerpts from older newsreels, the scene of the flying house from *The Wizard of Oz*, instructional films about terrorism deterrence, and video fragments showing airport interiors. The visuals are set to a disco soundtrack (compiled by composer David Shea) punctuated by excerpts from DeLillo's *White Noise* and *Mao II* (1991). Songs like "Do the Hustle," which accompanies the final sequence of planes plummeting from the sky, are interspersed with a fictional DeLillion conversation between a terrorist and a novelist about the fact that today acts of terrorism are providing a new, profound narrative capable of penetrating and transforming the cultural consciousness, a goal typically belonging to the literary realm. For DeLillo, in a society anesthetized by repetition, superficiality, and flagrant consumption, terror may be the only significant act. Even so, in this post-9/11 world, we have seen how unimaginable terror can itself be used to fulfill society's insatiable need for celebrity

and the most trivial forms of entertainment. Grimonprez understood as much; *Dial H-I-S-T-O-R-Y* ends with footage of a hijacked plane crashing into the ocean that was unintentionally recorded on a camcorder by vacationing newlyweds who were immediately invited to appear on CNN's *Larry King Live* to relate their experience of the tragedy.

The events of 9/11 and their continuing aftermath seem intended for television consumption. The perpetrators of the attacks choreographed a suicidal mission designed to insure maximum international media coverage, which, in turn, transformed a geographically specific massacre into a global-scale assault. Terrorism has no recognized boundaries.[24] While tragically real, events related to the destruction of the World Trade Center, the invasions of Afghanistan and Iraq, and the continuing terroristinitiated violence around the world seem scripted for the TV viewer: from George W. Bush's carefully staged "Top Gun" appearance on the *Abraham Lincoln* aircraft carrier to announce (erroneously) the "mission accomplished" in Iraq, to Osama Bin Laden's periodic pronouncements of doom on Al-Jazeera, which are immediately picked up by the international press. The political and commercial exploitation of 9/11 was not lost on cultural provocateur Tom

24. See Bill Schaffer, "Just Like a Movie: September 11 and the Terror of Moving Images," *www.senseofcinema.com/contentws/01/17/symposium/schaffer/html*. "By seizing control of four planes, [the terrorists] also commanded our perception, acting as voluntary directors of their own death scenes, orchestrators of a worldwide special effects display. The deliberate choice of the World Trade Centre [sic] as target announced a suicidal-homicidal will that could not be bargained with at any level. The implied promise that all viewers are potential victims added a frightening 'interactive' dimension to the spectacle."
25. The model concentration camp was exhibited as part of the show *Mirroring Evil: Nazi Imagery/Recent Art* at the Jewish Museum in New York, where it garnered great controversy by inflaming art critics and Holocaust survivors alike.

Sachs, whose handcrafted bricolage work examines the marketing of modernist phenomena, from Le Corbusier's International Style architecture to Hello Kitty children's toys. Under his signature label of "cultural prosthetics," Sachs created a major art world controversy in 1998 when he fashioned a miniature German death camp inside a Prada merchandise box for an exhibition at the Jewish Museum in New York.[25] In reaction to 9/11, he created the sculpture *Two Boeing 767s* (2001), large-scale, foam-core models of the aircraft used as missiles to down the Twin Towers. Created shortly after the crisis—with the speed and seeming callousness that is a hallmark of Sach's artistic persona—the two planes hover in parallel formation like bloated souvenirs of an indescribable horror. They function as early reminders of how 9/11 would be mourned, manipulated, and consumed by disparate factions all over the world.

Cattelan, art-world prankster par excellence, posited a different response to the implications of 9/11. As in all of his conceptual practice, the sculpture *Frank and Jamie* (2002) is at once comical and somber. Two perfectly crafted, life-size, wax effigies of New York City policemen, one with arms crossed casually across his chest, lean against the wall staring into the distance. All is seemingly well except for the fact that the two figures are upside-down, balancing on their NYPD caps. Their parallel poses and identical uniforms create a human analogy to the symmetrical architecture of the World Trade Center towers. Cast in wax, like all the historical characters immortalized in Madame Tussaud's uncanny mausoleum to fame, *Frank and Jamie* forms an unlikely memorial to the victims of 9/11 and the unstable world left in its wake. Master of the poignantly disarming gesture—like his ersatz homeless figures huddled in a corner or the lifeless (taxidermied) dogs "sleeping" on chairs—Cattelan interrupts reality with a dose of reality. His all-too-human monument to 9/11 reminds us that ours is a culture without a coherent narrative; we are now living in a world literally downside-up. Even the powers that be and their most effective mouthpiece, broadcast television, can no longer make sense of it.

In 1999, Nicolas Bourriaud founded, with Jérôme Sans, the Palais de Tokyo in Paris. While he served as a Director, he co-curated "Translation" with Jérôme Sans and Marc Sanchez; the exhibition was on view at the Palais de Tokyo from June 23 to September 18, 2005. Drawn from the Dakis Joannou Collection, the exhibition featured work by twenty-two artists and the installation was orchestrated by M/M (Paris), a collective comprised of artist/designers Michael Amzalag and Mathias Augustyniak. In "Altermodern Glossary," his contribution to the accompanying catalogue, Bourriaud explores a term to encompass art after postmodernism: altermodern. Specifically meant to address shifts in art-making in the twenty-first century, altermodern is a proposed means to discuss modernity today on a global scale, the prefix "alter" referring to otherness and multiplicity. Bourriaud expanded on this idea when he designated it the theme for the 2009 Tate Triennial, which he curated and titled "Altermodern."

Bourriaud's significant contributions to the field of contemporary art include his books *Relational Aesthetics* (1998) and *Postproduction* (2001). His impulse to synthesize and contextualize developments in contemporary art, including postulating new language to describe such changes, has put his ideas at the forefront of the theoretical discourse. Bourriaud's most recent book, *The Radicant* (2009), accompanies and fleshes out his idea of altermodernism.

Altermodern Glossary
Nicolas Bourriaud

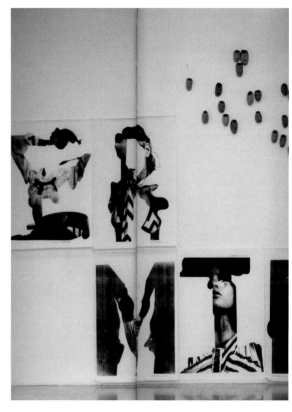

This text first appeared in *Translation*, published by the DESTE Foundation, ©2005.

Detail of page from *Translation*.

Altermodern

As Michel Foucault explains, each era produces a specific form of modernity. From planetary uniformity to the chaotic proliferation of cultural products, the new century is not lacking in new problems and new paradigms. A corresponding modernity and a new formulation of the modern spirit are awaited.

The term "postmodern" implied a position in reaction to the past; overtaking modernism, postmodernism was in fact situated on the same mental plane by developing an "End of History" rhetoric (Francis Fukuyama). "Alter-" is categorically opposed here to "post-": it is not a question of marking the passing of any historical moment but of fixing the parameters of a new object of thought, of constructing the framework for an attitude which, while reclaiming the emancipating ambition of modernity, does not reproduce the symptoms.

"Altermodern" means to invent—here and now—alternatives to cultural standardization; to produce differences and singularities; to place translation at the center of thought processes. The "altermodern" is exocentric and even centrifugal: it keeps its distance from ancient "centers."

Archipelago

The culture is becoming an archipelago: it no longer offers entire continents but islands of thought, linked by more or less opened-up routes. There is no longer a totality or a common project but separated fragments. The artist has become the voyager par excellence. Navigating the culture, s/he becomes a "semionaut" who links together the isles of the worldwide cultural archipelago. An archipelago of thought is a collection of singularities linked by navigation.

Adventure

1. Unforeseen and surprising event.
2. Hazardous enterprise.
3. Passing romantic liaison.

Connotations: risk, danger.
(Venture: run a risk.)
We might thus define adventure, as an artistic concept, as the combination of an experiment (a test, an experimentation that implies the existence of the artist) and of the notion of the Kairos (the opportunity that presents itself, the encounter). Modernity is the adventurous, or even adventuring, by definition.

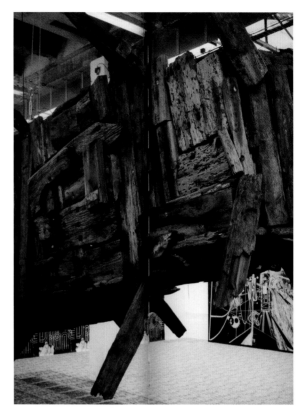

Detail of page from *Translation*.

Contemporary

Modernity is the contemporary to which a project is added. Since the era of Enlightenment, it has been a global emancipation project of peoples and individuals and the refusal of their enclosure within unchangeable frameworks and enslaving traditions. But what is the project today? To live together?

Creole
Creolization

There is no cultural soil nor roots; globalization transforms the world into a uniform surface, a purely present tense (the contemporary) in which history plays the role of folklore or theme for an amusement park. Thus our planet might be compared to a Polynesia colonized by a powerful Empire. In these Antilles in the form of a shopping mall, in these generalized Maldives, we can but become "Creoles": operating encounters, cutting and crafting of cultures, but horizontally, without concern for the soil in which they shall take hold; trying to replant roots in shallow soil. The Creole culture is ultimately an imaginary culture born of mythical tales and outpourings of memories of a distant culture redeployed in arid soil. The masterful *Chinatown Wishing Well* (1999) by Mike Kelley could be the manifesto for this new Creole-ness. It is not therefore a question of "Creolitude": Edouard Glissant places "identity-relation" above nostalgia for Africa and refers to Creolize French rather than write in Creole, for which he is bitterly reproached by a new generation of post-colonial writers. "Creolization" is a process, as opposed to this "Creole-ness" which attempts to fix an identity.

Diversity

In his "Essay on Exoticism" (1904–18), Victor Segalen defines the "feeling of exoticism" as "the notion of difference; the perception of diversity; the knowledge that something is not oneself." According to Segalen, exoticism is therefore "the feeling we have of diversity." This faculty to "feel diversity" also implies the acceptance of the unknown, the impenetrable and the incomprehensible without fusing with it. Because for Segalen, it is necessary "to marry one of the parts," in other words not to renounce one's own history.

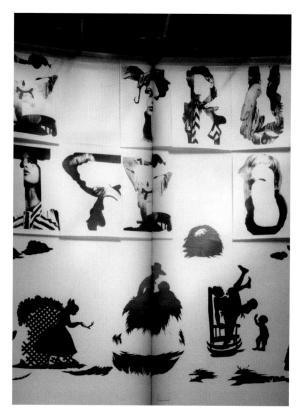

Detail of page from *Translation*.

Expedition

The methods of artistic production that today hold a particular importance include investigation, inquiry, and expedition. Within this framework the artist confronts the unrepresentable and opaque nature of the contemporary world. The material of the expedition is information. The collection of data founds the practice of those "topocritical" artists (geographers of information) who explore social sediments or the most ordinary archives. *L'Expédition Scintillante: A Musical* (2002) by Pierre Huyghe, or the film *Untitled* (2005) by Philippe Parreno and Rirkrit Tiravanija, are part of this attempt to renew the form of the voyage of discovery: in the name of which learning and working methods might we today go in search of an object (since "terra incognita" no longer exists)?

Entropy

According to Segalen, "it is the sum of all internal and undifferentiated forces, all static forces and all the basic forces of energy. (…) I see entropy as a monster more terrible than nothingness. Nothingness is of ice and coldness. Entropy is warm. (…) Entropy is pasty. A warm paste." Segalen writes that we are obliged to recognize that "the exotic tension of the world is decreasing." Diversity is exhausted and the world is becoming uniform. Such are the political and aesthetic stakes of the altermodern: to try to make sure that the world does not flow backwards but continues to produce singular forms. According to Claude Levi-Strauss, in his report for UNESCO, "Race and Culture (1071)": "despite its urgent practical necessity and the fine elevated morals that it assigns, the struggle against all forms of discrimination participates in the same movement that is pushing humanity towards a world civilization and destroying those old particularities which created the aesthetic and spiritual values that make life worth living."

Globalization

Karl Marx defined human history as an exponential move-
ment of interdependence and interaction between groups
and individuals. Increasingly linked it is what explains the
"relational" horizon on which current art is drawn. But
what exactly does "globalization" suggest to us? A global
economy is one that is capable of functioning on a plan-
etary scale and in real time. So is there a global culture
capable of "functioning on a planetary scale"? Such is the
issue for the years to come, given that cultures are increas-
ingly close to one another. They are in collision.

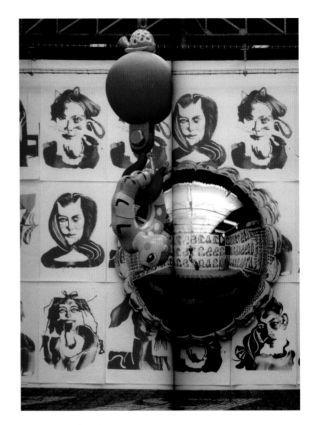

Detail of page from *Translation*.

Lasting Development

The altermodern subject is no longer the consumer of
the world but rather an "experimentor." It is necessary
to post-produce the world, to branch production towards
the multiplication of uses and practices. Modernism is
inseparable from representations such as the explosion,
combustion, and wasting of energy (Peter Sloterdijk).
However, the twentieth century produced another form
of thought based on recycling: from the inventory of "timid
energies" by Marcel Duchamp to the actions of Fluxus.
Enough progress: today is there an art of zero growth?

Multiculturalism

Within the normative framework of "Multiculturalism,"
a good non-Western artist should testify to his "cultural
identity." S/he thus presents himself or herself straight
off as being spontaneously alienated by his or her con-
text, thus effectively creating a contrast between the artist
from a "peripheral" country (for whom it is only necessary
to show his or her difference in order to be interesting)
and the artist from the "center" (who should show critical
distance in relation to the principles and formats of his
or her globalized culture). This phenomenon is known
as reification. According to the multiculturalist ideology,
an Algerian or Vietnamese artist has the implicit duty to
make images based on his supposed "difference" and the
history of his country and if possible in terms of Western
codes and standards, such as video for example which to-
day represents the ideal "green card" for the Western mar-
ket, a sort of technological preparation, the de-territorial
medium of choice.

Postproduction

The world imagination is an imagination of "postproduction": by this I mean all artists who create works based on pre-produced objects, whether they be other artworks, films, social forms, or industrial products and so on. Everything is already in place: the artist merely links the signs, having become a "semionaut." The incessant subjection to the unfurling of objects from the cultural industry is another phenomenon of our era: artists from Dakar to Tokyo work with a dense jungle of quotations and forms which make up our daily life, an avalanche of products unimaginable just thirty years ago. The postproduction of invading forms of contemporary culture represents the right to create, as opposed to the figure of the consumer, affirming that of the producer who introduces something human into the mechanism of marketing.

Detail of page from *Translation*.

Radicant

Radicant means "belonging to the root." We use the term radicant to describe a plant that puts down roots as it advances (ivy for example). We might connect this term to the rhizome as referred to by Gilles Deleuze and Felix Guattari, at the interior of which "all points are in contact with each other," whereas the radicant traces a line and progresses without the possibility of going back, except to cross its former roots and produce another form. The radicant anchors itself wherever it can: no surface can resist it as long as it can cross it.

Singularity

An object, a sign, or a form that cannot be reduced to a preestablished category, and which resists being appropriated by larger groupings. The programmed destruction by the artist of its community being, of that which links it to social abstractions—even if singularity sometimes brings new communities into being.

Stream

The Internet infers a method: navigation, whether reasoned, intuitive or by chance, in the same way as it provides a metaphor for the state of world culture: the image of a liquid ribbon, to the surface of which it is a question of learning to pilot the thought bouncing from site to site and from reference to reference. This ribbon-form "prevails" in contemporary production. A piece by Jason Rhoades, for example, cannot be read as a formal block. Our eyes must unroll it, following it like a chaotic text and accompany it in its flux. (See also: Nari Ward, Chen Zhen.)

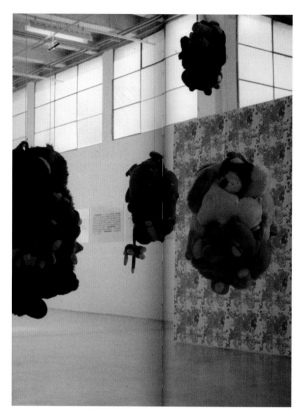

Detail of page from *Translation*.

Traceability

The tragic episode of "mad cow disease" inscribed the term in everyone's mind: if we wish to describe the contemporary world, it has become necessary to establish the "traceability" of phenomena which we examine. It is thus a question of leading the inquiry back to the threads of forms and their genealogy.

Translation

The act of passing from one linguistic system to another, decoding/recoding, constituting the cornerstone of a new modernity.

Universalism

The notion of "jurisprudence" allows us to escape from empty abstractions which structure the contemporary aesthetic and to rid us of the false opposition between universalism and relativism. There is no Beauty in itself, but rather contexts and relations (cultural fields, as Pierre Bourdieu would put it) at the interior of which the artworks are more or less intense, generating more or less activity and thought. Which particular artwork, in a particular context, will appear insignificant, insipid or repetitive, which one will, on the contrary, show itself to be the bearer of new questions? What need have we to seek absolute values? Every aesthetic is circumstantial. We should not seek a global aesthetic either in an adulterated universalism or in a patchwork of particularities, but rather in the study and discussion of circumstances, in other words, "in fine," in the judgments of jurisprudence which force us to look at the surroundings rather than concentrating on objects.

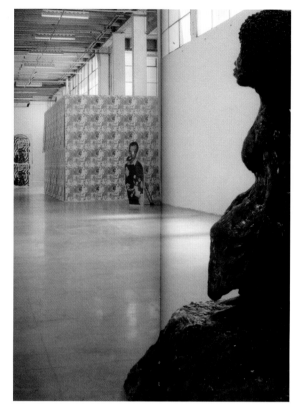

Detail of page from *Translation*.

Žižek, Slavoj

"Everything happens as if critical energy had found a substitution outlet in the struggle for cultural differences that leave the basic homogeneity of the capitalist world-system intact." (From Slavoj Žižek, *A Plea for Intolerance*.)

Works in the Exhibition

As of February 2, 2010

Height precedes width precedes depth

PAWEŁ ALTHAMER

Schedule of the Crucifix, 2005
Oak, leather, and metal with performance
Cross: 98 1/2 x 78 3/4 x 6 in (250 x 200 x 15 cm)
Ladder: 86 5/8 in (220 cm) high

Nomo, 2009
Metal helmet, wooden spear, metal structure covered with
sponge and dressed in old clothes, ski boots, and golden paint
Approximately 90 1/2 x 27 1/2 x 27 1/2 in (230 x 70 x 70 cm)

DAVID ALTMEJD

The Cave, 2008
Wood, mirror, paint, and glue
187 x 36 x 36 in (475 x 91 x 91 cm)

The Giant, 2006
Foam, resin, paint, fake hair, wood, glass, decorative acorns,
and taxidermy of 3 fox squirrels and 4 grey squirrels
114 1/8 x 59 7/8 x 40 1/8 in (290 x 152 x 102 cm)

JANINE ANTONI

Saddle, 2000
Full rawhide
25 1/2 x 32 1/2 x 78 1/2 in (65 x 83 x 199 cm)

ASSUME VIVID ASTRO FOCUS

Tom Cruising, 2005
Wallpaper installation, dimensions variable

Untitled/Untitled (Brown Sound), 2005
Ink on acetate
12 x 9 in (31 x 23 cm)

Untitled/Untitled (Eye in Pyramid), 2005
Ink on acetate
12 x 9 in (31 x 23 cm)

Untitled/Dick Fruit, 2005
Ink on acetate
12 x 9 in (31 x 23 cm)

Untitled/Hairy Tatoum, 2005
Ink on acetate
12 x 9 in (31 x 23 cm)

TAUBA AUERBACH

Crumple VI, 2008
Acrylic and inkjet print on canvas
96 x 128 in (244 x 325 cm)

MATTHEW BARNEY

Matthew Barney, *Cremaster 1 Choreographic Suite*, 1996
Acrylic, Vaseline and pencil on paper, with vinyl floor tile, and
patent vinyl within self-lubricating plastic frames
Suite of 12, each 18 3/4 x 17 5/8 x 2 3/4 in (48 x 45 x 7 cm)

VANESSA BEECROFT

Ein Blonder Traum, 1994
2 Hi8 tapes, 2 VHS tapes, and 13 Polaroids taken
during performance
Dimensions variable

ASHLEY BICKERTON

F.O.B., 1993
Fiberglass, enamel paint, and steel
82 x 31 x 29 in (208 x 79 x 74 cm)

JOHN BOCK

Maltratierte Fregatte, 2006/07
Installation of mixed mediums, dimensions variable; video
Maltratierte Fregatte, 66:41 min; and video *Untergang der
Medusa*, 9:37 min

MARK BRADFORD

*Let's Make Christmas Mean Something
This Year*, 2007
Collage of mixed mediums on canvas
102 x 144 in (259 x 366 cm)

MAURIZIO CATTELAN

All, 2007
White Carrara marble
Overall: 11 7/8 x 78 3/4 x 339 1/2 in (30 x 200 x 862 cm)

Mother, 1999
Gelatin silver print
39 3/8 x 44 3/4 in (100 x 114 cm)

Now, 2004
Polyester resin, wax, human hair, clothes, and wood
33 1/2 x 88 5/8 x 30 3/4 in (85 x 225 x 78 cm)

PAUL CHAN

Orgy Before Man and Storm, 2003
Archival inkjet print
44 x 78 in (113.8 x 83.8 cm)

Buildings as Monuments as Graves I, 2003
Archival inkjet print
44 x 78 in (112 x 198 cm)

DAN COLEN

Nostalgia ain't what it used to be (The Writing on the Wall), 2006
Oil paint, acrylic paint, acrylic medium on papier mâché,
Styrofoam, and Polyfoam on MDF base with burkas
Approximately 94 7/8 x 46 7/8 x 46 7/8 in (241 x 119 x 119 cm)

Holy Shit (Mirror), 2006
Oil on wood
48 x 35 1/2 in (90 x 122 cm)

NIGEL COOKE

Silva Morosa, 2002–03
Oil on canvas
72 x 96 in (183 x 244 cm)

ROBERTO CUOGHI

Pazuzu, 2008
Epoxy, solvent varnish, fiberglass, polystyrene, and steel
234 1/4 x 116 1/2 x 98 1/2 in (595 x 296 x 250 cm)

Megas Dakis, 2007
Print on cotton paper
28 3/4 x 25 in (73 x 63.5 cm)

NATHALIE DJURBERG

It's the Mother, 2008
Clay animation, video, and music by Hans Berg, 6 min

Tiger Licking Girl's Butt, 2004
Video, 2:15 min

HARIS EPAMINONDA

Nemesis 52, 2003
Video, 13:07 min

URS FISCHER

Noodles, 2009
Oak, aluminum composite panel, screws, gesso, ink, and acrylic
96 x 72 x 1 1/4 in (244 x 183 x 3 cm)

What if the Phone Rings, 2003
Polychromed wax
41 3/4 x 56 x 18 1/8 in (106 x 142 x 46 cm)

Cioran Handrail, 2006
Epoxy resin, pigment, and enamel
Approximately 137 7/8 x 338 5/8 x 49 1/4 in (350 x 860 x 125 cm)

ROBERT GOBER

Two Spread Legs, 1991
Wood, wax, leather, cotton, human hair,
and steel
11 x 35 x 27 1/4 in (28 x 89 x 70 cm)

Untitled, 2008–09
Beeswax, cotton, leather, aluminum pull tabs, human hair,
and oil paint
28 x 22 x 19 3/4 in (71 x 56 x 50 cm)

The Scary Sink, 1985
Enamel paint on plaster, wire lathe, wood, and steel
62 1/4 x 55 1/5 x 55 1/2 in (158 x 141 x 141 cm)

Corner Bed, 1987
Enamel paint, wood, cotton, and wood
43 3/4 x 76 3/4 x 41 3/8 in (111 x 195 x 105 cm)

Pitched Crib, 1987
Enamel paint on wood
38 1/4 x 73 1/4 x 50 1/2 in (97 x 186 x 128 cm)

MATT GREENE

The Orifice, 2006
Oil, acrylic, enamel, and graphite on canvas
70 x 120 in (178 x 305 cm)

That We So Not Appear to Fly is of Little Consequence, 2006
Acrylic, ink, and collage on canvas
96 x 120 in (244 x 305 cm)

666, 2004
Ink on paper
45 x 85 in (114 x 216 cm)

MARK GROTJAHN

Untitled (Creamsicle 681), 2007
Colored pencil on paper
64 1/2 x 47 3/4 in (164 x 121 cm)

ADAM HELMS

Untitled, 2007
Ink on Mylar
14 1/2 x 12 in (37 x 30 cm)

Untitled, 2007
Ink on Mylar
14 1/2 x 12 in (37 x 30 cm)

JENNY HOLZER

Selections from the Survival Series, 1984
LED sign
6 x 60 x 7 in (15 x 152 x 18 cm)

ELLIOTT HUNDLEY

Garland, 2007
Wood, plastic, paper, pins, porcelain, ceramics, wire, string,
glue, primer, spray paint, silk, coral, magnifying lenses, and
found objects
64 x 92 x 55 in (163 x 234 x 140 cm)

MIKE KELLEY

Brown Star, 1991
Stuffed animals, steel, and string
Dimensions variable

Cave Painting, 1984
Synthetic polymer on twelve sheets of paper
Overall 144 x 192 in (366 x 488 cm)

TERENCE KOH

Untitled (Chocolate Mountains), 2006
Styrofoam, fiberglass, and white-chocolate icing
141 3/4 x 70 7/8 in (360 x 180 cm) (2 parts)

JEFF KOONS

One Ball Total Equilibrium Tank, 1985
Glass, iron, water, and basketball
64 1/2 x 30 1/2 x 13 1/4 in (164 x 77 x 34 cm)

LIZA LOU

Super Sister, 1999
Cast polyester resin and glass beads
82 3/4 x 35 x 34 in (210 x 91 x 86 cm)

NATE LOWMAN

Black Maxima, 2005
Silkscreen ink and latex on canvas
38 in (96.5 cm) diameter

Blue Pastiche, 2005
Latex and Flashe on canvas
20 in (50.8 cm) diameter

MARK MANDERS

Unfired Clay Figure, 2005-06
Iron chairs, painted epoxy, wood, and mixed mediums
59 x 118 x 88 1/2 in (150 x 300 x 225 cm)

Wednesday Box, 2002
Mixed mediums
85 7/8 x 39 3/8 x 11 7/8 in (218 x 100 x 30 cm)

PAUL McCARTHY

Untitled (Jack), 2002
Red silicon rubber
23 5/8 x 23 5/8 x 18 1/8 in (60 x 60 x 46 cm)

Paula Jones, 2007
Fiberglass
82 x 57 1/2 x 107 in (208.3 x 146 x 271.8 cm)

DAVE MULLER

January 2007, According to NY Times (with the Beatles), 2006
Acrylic on paper
83 1/2 x 79 1/2 in (212 x 202 cm)

TAKASHI MURAKAMI

Inochi, 2004
Fiberglass, resin, and iron
55 1/8 x 23 x 11 1/2 in (140 x 58.4 x 29.2 cm)

TIM NOBLE AND SUE WEBSTER

Black Narcissus, 2006
Black polysulfide rubber, wood, and light projector
Sculpture: 15 x 28 3/8 x 23 5/8 in (38 x 72 x 60 cm)
Plinth: 12 x 12 x 36 in (30 x 30 x 91 cm)

Masters of the Universe, 1998–2000
Translucent resin, fiberglass, plastic, and human hair
54 x 27 x 31 in (137 x 68 x 79 cm)

CADY NOLAND

Bluewald, 1989
Screen print on aluminum and printed cotton flag
72 x 33 1/2 x 35 1/2 in (183 x 85 x 90 cm)

CHRIS OFILI

Inner Visions, 1998
Acrylic, oil, polyester resin, glitter, collage, map pins, and
elephant dung on canvas
96 x 72 in (244 x 183 cm)

Rodin... The Thinker, 1997
Acrylic, oil, resin, glitter, map pins, and elephant dung on canvas
96 x 72 x 5 1/8 in (244 x 183 x 13 cm)

Thirty Pieces of Silver, 2006
Oil, acrylic, and charcoal on canvas
109 5/8 x 78 7/8 in (278.4 x 200 cm)

Blue Damascus, 2004
Charcoal, gouache, ink, and aluminum on paper
Unframed 78 1/8 x 51 1/8 in (198.5 x 130 cm);
framed, 88 1/2 x 61 3/8 x 2 in (224.9 x 155.9 x 5 cm)
(diptych)

SETH PRICE

Untitled (White Breast), 2008
Vacuum-formed high impact polystyrene
96 x 48 in (244 x 122 cm)

Untitled, 2008
Vacuum-formed high-impact polystyrene and synthetic enamel
96 x 48 in (244 x 122 cm)

RICHARD PRINCE

I'm in a Limousine (Following a Hearse), 2005–06
Acrylic on canvas and cancelled checks
112 1/8 x 200 in (284.9 x 508 cm)

CHARLES RAY

Fall '91, 1992
Mixed mediums
96 x 26 x 36 in (244 x 66 x 91 cm)

Revolution Counter-Revolution, 1990/2010
Carved wooden elements, steel, fabric, and mechanical
elements
115 x 164 x 164 in (292.1 x 416.6 x 416.6 cm)

Untitled, 2006
Ink on paper
41 3/8 x 25 1/2 in (105 x 65 cm)

Untitled, 2006
Ink on paper
40 1/2 x 22 1/2 in (103 x 57 cm)

Untitled, 2006
Ink on paper
30 x 22 7/8 in (58 x 76 cm)

Aluminum Girl, 2003
Aluminum and paint
62 1/2 x 18 1/2 x 11 1/2 in (158.9 x 47 x 29.2 cm)

TINO SEHGAL

This Is Propaganda, 2002

JIM SHAW

Untitled (Ripped Face Drawing), 2003–04
Pencil on paper
80 x 60 in (203 x 152 cm)

CINDY SHERMAN

Untitled (Head), 1995
Cibachrome print
49 1/2 x 72 1/2 in (125 x 184 cm)

KIKI SMITH

Untitled (Bowed Woman), 1995
Brown wrapping paper, methyl cellulose, and horse hair
53 x 18 x 50 in (134.8 x 45.8 x 127 cm)

Mother/Child, 1993
Beeswax with hardener, cheese cloth, dowls, and powder pigments

Untitled (Skin), 1992
Cast aluminium
28 1/4 x 50 1/4 in (72 x 128 cm)

Intestine, 1992
Cast bronze
360 x 8 1/8 x 12 in (914.4 x 20.9 x 30.5 cm)

CHRISTIANA SOULOU

Water, 1982–85
Pencil, watercolor, and wax crayon on paper
21 x 16 1/4 x 1 3/4 in (53.5 x 41.5 x 4.5 cm) each

JANNIS VARELAS

My dad is stronger than yours, Rainbow Rocket Bill and Friend, 2005
Pencil, charcoal, oil, glitter, and collage on paper
92 1/2 x 59 in (235 x 150 cm)

KARA WALKER

Pegged, 1996
Gouache on paper
Unframed, 60 x 51 1/2 in (152.5 x 131 cm)

Philadelphia, 1996
Gouache on paper
Unframed, 80 1/2 x 51 1/2 in (152.5 x 131 cm)

John Brown, 1996
Gouache on paper
Unframed, 65 x 51 1/2 in (152.5 x 131 cm)

B'Rer, 1996
Gouache on paper
63 x 51 1/2 in (160 x 131 cm)

Allegory, 1996
Gouache on paper
63 3/4 x 51 1/2 in (162 x 131 cm)

Leaving the Scene, 1996
Gouache on paper
59 5/8 x 51 1/2 in (155.5 x 131 cm)

Missionary Sketch for African't, 1996
Gouache on paper
65 3/8 x 51 1/2 in (166 x 131 cm)

Duet, 1996
Gouache on paper
Unframed, 62 x 51 1/2 in (157.5 x 131 cm)

Untitled, 1996
Cut paper and gouache on paper
68 3/4 x 52 1/4 in (174.7 x 132.8 cm)

GILLIAN WEARING

Signs That Say What You Want Them to Say..., 1992–93
Chromogenic print
47 1/4 x 31 3/8 in (120.1 x 79.8 cm)

ANDRO WEKUA

Wait to Wait, 2006
Wax figure, lacquered aluminium, clear and colored glass, brazen aluminum, bricks, motor, collages, and felt pen and pencil on paper
78 3/4 x 82 5/8 x 118 1/8 in (200 x 210 x 300 cm)

Sneakers 1, 2008
Wax figure, aluminum-cast table and pallet, Akrystal board, and ceramic shoes
59 x 72 7/8 x 39 3/8 in (150 x 185 x 100 cm)

FRANZ WEST

Gartenpouf, 2007
Styrofoam, epoxy resin, and synthetic resin varnish
114 1/4 x 63 x 63 in, (290 x 160 x 160 cm)

CHRISTOPHER WOOL

Untitled, 2000
Enamel on linen
108 x 72 in (274.3 x 182.9 cm)

Contributors' Biographies

Nicolas Bourriaud is a French curator and art critic. He was appointed the Head of the Scientific Department at the French Ministry of Culture in 2010. From 2007 to 2009, Bourriaud was the Gulbenkian Curator for Contemporary Art at Tate Britain, London, where he curated "Altermodern," the 2009 Tate Triennial. He was Advisor for the Victor Pinchuk Foundation, Kiev, from 2004 to 2007. Prior to that, in 1999, Bourriaud co-founded Palais de Tokyo, a premier venue for contemporary art in Paris, and was a co-director with Jérôme Sans through 2006. Before the Tate Triennial in 2009, Bourriaud curated numerous exhibitions including the Second Moscow Biennale (2007), the First Moscow Biennale (2005, co-curator), the 2005 Lyon Biennale, "GNS" (Palais de Tokyo, 2003), "Playlist" (Palais de Tokyo, 2004), and "Aperto" at the 1993 Venice Biennale. Bourriaud has written *Relational Aesthetics* (1998), *Formes de vie. L'art moderne et l'invention de soi* (1999), *Postproduction* (2002), and most recently *The Radicant* (2009).

Jeffrey Deitch is the incoming director of the Museum of Contemporary Art, Los Angeles. Deitch has been active as an art critic and exhibition curator since the mid-1970s. He has contributed to *Arts*, *Art in America*, *Artforum*, and numerous other publications, and served as the first American Editor of *Flash Art*. He received an Art Critic's Fellowship from the National Endowment for the Arts in 1979. He has written numerous catalogue essays including projects for the Museum of Modern Art of the City of Paris, the Stedelijk Museum, Amsterdam, and the Whitney Museum, New York. His essay "The Art Industry" was included in the catalogue for "Metropolis," an exhibition at the Martin-Gropius-Bau, Berlin in 1991. Deitch's first important curatorial project was "Lives," a 1975 exhibition about artists who used their own lives as an art medium. He has curated several exhibitions of contemporary art for the DESTE Foundation in Athens including "Cultural Geometry" in 1988, "Artificial Nature" in 1990, "Everything That's Interesting Is New" in 1996, and "Fractured Figure" in 2007. He was a member of the curatorial team for the DESTE Foundation's "Monument to Now" exhibition in 2004. He curated the exhibition "Strange Abstraction" for the Touko Museum in Tokyo in 1991. His most ambitious exhibition was "Post Human," which opened at the FAE Musée d'Art Contemporain in Lausanne in June 1992, and traveled to the Castello di Rivoli in Torino, the DESTE Foundation in Athens, the Deichtorhallen in Hamburg, and the Israel Museum in Jerusalem. He also curated one of the sections of "Aperto" at the 1993 Venice Biennale. In 2001, he curated "Form Follows Fiction" at the Castello di Rivoli, Turin. He is co-author of a monograph on Keith Haring, published by Rizzoli in 2008, and wrote the introduction to Jean Michel Basquiat, *1981: The Studio of the Street*, published by Charta in 2007.

Deitch opened a commercial gallery, Deitch Projects, in 1996, which produced more than 250 projects by contemporary artists.

Massimiliano Gioni is the Director of Special Exhibitions at the New Museum in New York and the Artistic Director of the Nicola Trussardi Foundation in Milan. He is currently the director of the 8th Gwangju Biennale (Gwangju, 2010). Gioni curated "Of Mice and Men," the 4th Berlin Biennial for Contemporary Art (Berlin, 2006) with Maurizio Cattelan and Ali Subotnick. In 2004 he curated Manifesta 5 (San Sebastian, Spain, 2004) with Marta Kuzma. He was part of the curatorial team of "Monument to Now" (Athens, 2004) and "The Fractured Figure" (Athens, 2007), two exhibitions originated by the Dakis Joannou collection, with which Gioni frequently collaborates. In 2003, for the 50th edition of the Venice Biennale, Gioni curated "The Zone," a temporary pavilion for young Italian art. Since 2003, he has been directing the Trussardi Foundation, a nomadic museum that has staged solo exhibitions, special projects, and interventions in abandoned buildings, public spaces, and forgotten monuments of the city of Milan. For the Fondazione Trussardi, Gioni has organized exhibitions by, among others: Paweł Althamer, John Bock, Maurizio Cattelan, Martin Creed, Tacita Dean, Elmgreen and Dragset, Urs Fischer, Fischli and Weiss, Paola Pivi, Anri Sala, and Tino Sehgal. At the New Museum, since 2008, Gioni co-curated the inaugural cycle of exhibitions "Unmonumental" with Richard Flood and Laura Hoptman; he organized Paul Chan's first institutional exhibition in America, and curated "After Nature," in 2008. With Lauren Cornell and Laura Hoptman, he curated "The Generational: Younger Than Jesus," a 2009 exhibition on a new generation of artists, all born around 1980. Recently, he curated "Urs Fischer: Marguerite De Ponty."

Gioni has published articles in *Artforum*, *Flash Art*, *Frieze*, *Parkett*, and *Art Press*, and contributed to numerous other magazines and catalogues. With Cattelan and Subotnick he runs *The Wrong Times* and *Charley*, two magazines produced by the Wrong Gallery, which he co-founded in 2003.

Born in 1953, **Peter Halley** studied at Yale University and at the University of New Orleans. Since 1980 Halley has lived and worked in New York City. Halley has had one-person museum exhibitions at the CAPC Musee d'Art Contemporain, Bordeaux (1991), the Museo Nacional Centro de Arte Reina Sofia, Madrid (1992) and the Museum of Modern Art, New York (1997), among many others. His work has been exhibited in galleries in Chicago, London, Madrid, Moscow, New York, Paris, Rome, Seoul, and Tokyo. Recent exhibitions include Mary Boone Gallery in New York and Galerie Forsblom in Helsinki. Since the mid-1990s, Halley has produced site-specific installations for gallery and museum exhibitions and as permanent public works. In 2008, he completed a large permanent installation of digital prints for the Gallatin School of Individualized Study at New York University. From 1996 to 2006, Halley published *index magazine*, which featured interviews with creative people. He has also written on art and culture throughout his career. In 2001, he received the Frank Jewett Mather Award from the College Art Association for his critical writing. Since 2002, Halley has been the Director of Graduate Studies in Painting and Printmaking at the Yale University School of Art. In 2009 he was awarded an endowed chair, the William Leffingwell Professorship of Painting, at Yale.

Nancy Spector is Chief Curator of the Solomon R. Guggenheim Foundation and Museum, where she oversees the acquisition strategy for the permanent collection and the global exhibition calendar for the institution and its affiliates. She has organized exhibitions on conceptual photography, Felix Gonzalez-Torres, Richard Prince, and Matthew Barney's "Cremaster" cycle. She co-organized "Moving Pictures" and "Singular Forms (Sometimes Repeated)." She was one of the curators of "Monument to Now," an exhibition of the Dakis Joannou Collection, which premiered in Athens as part of the Olympics program. She was Adjunct Curator of the 1997 Venice Biennale and co-organizer of the first Berlin Biennale in 1998. Under the auspices of the Deutsche Guggenheim Berlin, she has initiated special commissions by Andreas Slominski, Hiroshi Sugimoto, and Lawrence Weiner as well as a special exhibition comparing the work of Joseph Beuys and Matthew Barney. She has contributed to numerous books on contemporary visual culture with essays on artists such as Maurizio Cattelan, Luc Tuymans, Douglas Gordon, Tino Sehgal, and Pierre Huyghe. She has served as a regular columnist for *Frieze* magazine. In 2007 she was the U.S. Commissioner for the Venice Biennale, where she presented an exhibition of work by Felix Gonzalez-Torres. Spector is a recipient of the Peter Norton Family Foundation Curators Award. She recently organized a group exhibition entitled "theanyspacewhatever" for the Guggenheim and a large-scale exhibition of Tino Sehgal's work.

Lynne Tillman is a novelist, short story writer, and critic. Her fifth novel, *American Genius, A Comedy*, was published by Soft Skull Press (2006). The Millions voted it one of the twenty "Best Books in the Millennium (So Far)." Her previous novels are *Haunted Houses* (1987), *Motion Sickness* (1991), *Cast in Doubt* (1992), and *No Lease on Life*, a 1998 finalist for the National Book Critics Circle Award in fiction and a *New York Times* Notable Book of the Year. Tillman has published three nonfiction books, including an essay collection, *The Broad Picture* (1997) and *The Velvet Years: Warhol's Factory 1965–67* (1995), based on photographs by Stephen Shore, and three story collections, most recently, *This is Not It* (2002), stories and novellas written in response to the work of twenty-two contemporary artists. She is a co-editor of *Beyond Recognition: Representation, Power, Culture—Writings of Craig Owens* (University of California, 1992). In 2008, *Love Sentence*, a novella, was published by Nothingmoments Press. Tillman's fiction has been included in anthologies, such as *New York Writes After 9/11*, *Life as We Show It*, *The Penguin Book of New Stories*, *High Risk*, and *Wild History*. Her writing has appeared in *Cabinet*, *The Happy Hypocrite*, *Conjunctions*, *Bomb*, *Tin House*, *McSweeney's*, *Black Clock*, *Aperture*; and her essays in *Artforum*, *Art in America*, *Frieze*, *Aperture*, *Nest*, the *New York Times* Arts and Leisure section, and the *New York Times Book Review*. In 2006 Tillman was awarded a Guggenheim Fellowship, and her papers were acquired by New York University's Fales Library. Tillman is Professor/Writer-in-Residence at The University at Albany. She is fiction editor of *Fence* magazine and on the boards of Housing Works Bookstore and café, The International Advisory Committee for the Wexner Prize, and PEN American Center.

About the DESTE Foundation

The DESTE Foundation for Contemporary Art is a nonprofit institution based in Athens, Greece. The Foundation was established in 1983 by collector Dakis Joannou, together with curators Adelina von Fürstenberg and Efi Strousa. Ever since, DESTE has been organizing exhibitions and supporting projects and publications internationally.

Through an exhibition program that promotes emerging as well as established artists, the DESTE Foundation aims to broaden the audience for contemporary art, to enhance opportunities for young artists, and to explore the connections between contemporary art and culture.

From its inception until 1998, the DESTE Foundation has organized and supported exhibitions in Greece, Cyprus, and Switzerland, including "Cultural Geometry" (1988), "Psychological Abstraction" (1989), "Artificial Nature" (1990), "Post Human" (1992–93), and "Everything That's Interesting Is New" (1996). In 1998 the DESTE Foundation moved to its first permanent space in Neo Psychico, Athens, where the exhibitions "Global Vision" (1999), "Jeff Koons' A Millennium Celebration" (1999–2000), and "Tim Noble and Sue Webster's Masters of the Universe" (2000) took place. As part of the Athens 2004 Cultural Program, the DESTE Foundation organized "Monument to Now"; featuring more than sixty participating artists, it was curated by Dan Cameron, Jeffrey Deitch, Allison Gingeras, Massimiliano Gioni, and Nancy Spector.

Since January 2006, DESTE has been housed in a renovated former sock factory in Nea Ionia, Athens. The exhibition program was inaugurated by "Panic Room" (2006–07). Recent exhibitions include "Fractured Figure" (2007–08) and "A GUEST + A HOST = A GHOST" (2009).

Apart from the shows that draw on works from the Dakis Joannou Collection, the DESTE Foundation has also initiated a number of ongoing projects including the DESTE Prize, awarded biannually to an emerging Greek artist. DESTE has also established the Contemporary Greek Artists' Archive, a resource for curators and researchers, as well as a specialized art library which is open to the public.

Acknowledgments

We would like to thank the incredibly talented people who made this project possible.

At the New Museum, we would like to express our appreciation to John Hatfield, Deputy Director; Shari Zolla, Head Registrar; Hendrik Gerrits, Exhibition Manager; and Joshua Edwards, Production and Installation Manager, for all of their work to carefully orchestrate the shipping and installation of the artwork. In the external affairs department, Karen Wong and Gabriel Einsohn worked with enthusiasm and creativity, overseeing public information and printed matter. The New Museum's media consultant, Andrea Schwan, played a vital role. Special thanks to Regan Grusy, Director of Development, for her commitment to this project. Adam Glick, Executive Assistant, started just in time to see this catalogue off, and for that we appreciate his willingness to adapt quickly. Thanks to Lynn Maliszewski, Curatorial Intern, for helping with Tino Sehgal's piece, and to Abigail Scholar, Curatorial Intern, especially for her help with the catalogue. Above all, Jarrett Gregory, Curatorial Associate, deserves special recognition for coordinating the many details of the exhibition and the catalogue. She also contributed her considerable writing and editing skills, along with Sarah Valdez, who co-edited the publication.

At the DESTE Foundation, we are greatly indebted to Regina Alivisatos, Administrator; Natasha Polymeropoulos, Registrar; Eugenia Stamatopoulou, Conservator; and Kleio Silvestrou, Assistant Conservator for all of their help. At Jeff Koons's studio, we extend very special thanks to Gary McCraw and Lauran Rothstein for graciously liaising with the Museum.

We would like to thank all of the artists' assistants who helped to make individual installations and projects possible: in particular Darren Bader, Claudia Carson, Ina Meier, Alex Hudson, and Collin LaFleche.

Thanks to Purtill Family Business for designing such a special catalogue and for always making the process an inspired and pleasurable experience.

Thanks to authors Nicolas Bourriaud, Jeffrey Deitch, Peter Halley, Nancy Spector, and Lynne Tillman for graciously allowing us to reprint their texts in this context.

Above all, we would like to thank Dakis Joannou for agreeing to this exhibition at the New Museum and for sharing these great works of art with the American public. Finally we are especially grateful that Jeff Koons accepted our invitation to curate this exhibition, and for the creativity and vision he has brought to it. This is a once-in-a-lifetime collaboration that we feel fortunate to have been part of and to have helped make happen.

Lisa Phillips and Massimiliano Gioni